Memoirs of an Art Dealer

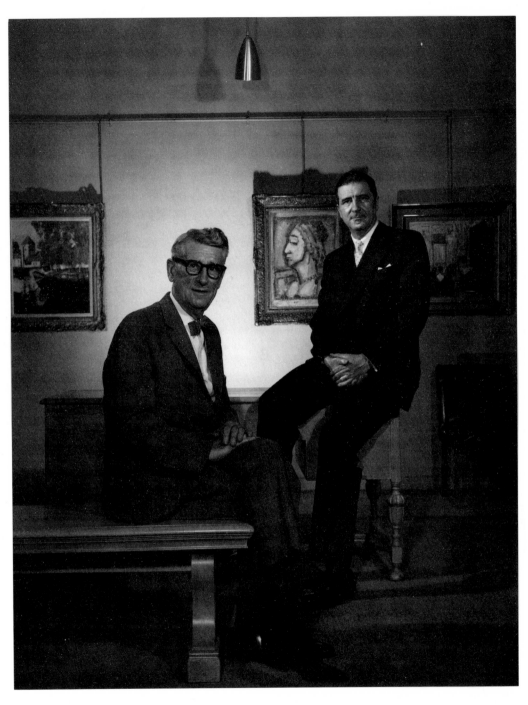

G. Blair Laing with his father, A.R. Laing, in their gallery
on Bloor Street West, Toronto, 1955. *Robert McMichael*

Memoirs of an Art Dealer

G. Blair Laing

McClelland and Stewart

Copyright © 1979 by G. Blair Laing

The Canadian Publishers
McClelland and Stewart Limited
25 Hollinger Road
Toronto M4B 3G2

Printed and bound in Canada

CANADIAN CATALOGUING IN PUBLICATION DATA

Laing, G. Blair, 1911-
Memoirs of an art dealer

ISBN 0-7710-4569-7

1. Laing, G. Blair, 1911- 2. Art dealers –
Canada – Bibliography. I. Title.

N8660.L35A25 706′.5′0924 C79-094522-3

Painting reproduced on slipcase: *Promenade, Dieppe* by James W. Morrice

Contents

Memoirs of an Art Dealer

1 Arthur Lismer *Poppies, Bedford Park Avenue* 1924

1
Remembrances of Youth

Some years ago, in conversation with several men of letters and friends, it was suggested that I tell the story of my life as an art dealer in Canada, perhaps recording on tape or putting down on paper something of my knowledge and experience of the Canadian art scene as it existed from the early thirties to the present time.

My original intent had been to do a book on the Canadian artist James Wilson Morrice, relating particularly the story of my experiences during our long-time and ultimately successful search for his paintings. But I found myself instead writing about my life, the events, some incredible in retrospect, of my career, and the artists, dealers, and collectors I have known over the years.

Recently I have been reading the autobiography of the Irish poet-philosopher, William Butler Yeats. In it he acknowledges debts to his father, who was a man of letters as well as a painter. Yeats spends much time talking about his childhood and early life in Sligo and London, where his father later moved from Ireland in the hope of selling more pictures to support his family. I thought about proceeding with my own work along similar lines, as some special debts are owed my own father that I would like to record.

I was born in Montreal in 1911, and lived in that now-maligned English-speaking town of Westmount, perched on the side of Mount Royal, just west of the great river-port city. At that time and indeed for more than a century before, Scottish and English Canadians controlled the business and financial district of Montreal as well as the small but prosperous art dealing community. The Art Association of Montreal (later, Montreal Museum of Fine Arts) had been founded, funded and of course controlled by the English-speaking elite until very recent times. In fact members of the English-speaking establishment acquired all the great paintings that now exist in that magnificent museum.

My father was born in Peterborough, Ontario, in 1885; his parents and grandparents having also been born in the same community. They were early settlers in Hastings County, and the Laing family has been traced to Robert Laing and his wife Ann Jesson, who came to Canada in 1830. Robert, according to tales, fought with Wellington's armies at Waterloo. On my maternal side the Gilberts trace their lineage back to the Battle of Crécy, 1346. My mother's mother was born in Canada and my mother's father was born in Paris, France, of English parentage. One of my grandfather's cousins was the celebrated Victorian sculptor and goldsmith, Sir Alfred Gilbert (1854-1934).

My father was immensely proud of his Scottish heritage and strongly believed in the future of Canada as well as the total permanence of the British Empire. He was the fourth of eight sons born to a strict Presbyterian mother who brought up her boys in fear of God and belief in hard work. He was an ambitious man and wanted to succeed in life and business with all his heart. He also dreamed of achieving this success in Canada. His was a positive personality but he was never overtly aggressive and could also be quiet and reflective. He had the usual high school education of his time with an additional year in business college. In Ontario privately owned business colleges played an important role in terms of practical education for many young people until quite recent times. My father wrote excellent letters in a full round hand and was quick and accurate at figures.

It was wartime and in 1916 we lived in a house near the square and parade grounds in Fredericton, New Brunswick. I was just over five years of age when my sister was born there. My father

was an officer in the Army Service Corps stationed there, all the while hoping to be posted overseas. When my sister was only two weeks old, she, my mother, and I, accompanied by my ever-helpful grandmother, left on the long train journey from Fredericton to Peterborough, where my mother's parents lived. My father was almost daily expecting to be sent to the Western Front and wanted his family safely back home in Peterborough.

In Peterborough my grandparents lived in a red brick house on King Street, which my grandfather had built in 1912, just before the war. It possessed a large front verandah with thick Indian Pipe vines growing on two sides. It was a cool restful spot in summer where I sometimes lay down on a comfortable swing and daydreamed to my heart's content until my grandmother or mother called me to supper. There was a spacious lawn in the front, which, during October of each year, yielded a delicious crop of the little button-type mushrooms.

Grandmother Alice Gilbert, a bright, cheerful, and gentle woman of great common sense and character, was to live a long and useful widowhood after my grandfather died in 1929 at the age of seventy. Her family name was Freeman. She was one of eight children born of musical parents in Dundas, Ontario. She was a singer and her brothers and sisters were all musicians and were a well-known musical group in their day with their father as conductor. I was devoted to her, and look back with nostalgia on the years spent in Peterborough.

In the summer of 1921 my father bought a farm near Port Credit, about two miles west of Erindale, then still a small hamlet on the Toronto-Hamilton highway, with a little white-spired church at the crest of the hill, and across the road was a one-room schoolhouse, which I attended for a short time that September. Now the little villages and hamlets in this part of Ontario have all but disappeared, obliterated by sprawling housing developments. During the brief period I went to school there I was driven by horse and buggy either by my father or a hired man. I walked home with other children as there were no school buses in those days and the highway was a dirt and gravel road with little traffic.

I spent only one summer on the farm, and I remember visits by some of my parents' Peterborough friends, townspeople

who liked the novelty of a real working farm. Mr. Buller, the father of two daughters who were among my mother's best friends, was a former mayor of Peterborough and owned one of the early Dodge touring cars. He used to take us on drives in the country from time to time, and even the short ones were adventurous in those days. Mr. Buller's Dodge was a nifty open touring car, but drafty and hazardous for back-seat passengers, who would encounter flying ash from Mr. Buller's pipe. Such roads as then existed in the country were rough dirt ones often deeply furrowed by wagon wheels and tire punctures were common hazards of the road. This man knew the back country well as for many years he had been employed as a part-time government inspector to search out illicit whiskey stills in remote parts of Hastings County. He told hair-raising stories of his adventures.

But before eighteen months had passed my father became tired of the endless chores of farming, and was beginning to long for more excitement and better rewards than the marginal living the farm provided, and he traded his two-hundred-acre farm for what he thought was a lucrative confectionery business in Brantford, Ontario. It was well-situated on the main street near the town market place. The marble-faced soda fountain on one side of the store with sitdown stools seemed endless in length, and nearby were a few small tables with white painted metal chairs for customers to relax on. The other side of the store featured dozens of trays containing old-fashioned candies, chocolates and baked goods. I still think of the huge hemp bags filled with mountains of Brazil and pecan nuts used at the fountain and for baking purposes. The place seemed enormous to me then and the establishment had its own bakeshop where bakers worked making bread and assorted pies and pastry.

Like some other of his early business ventures my father's ownership of the confectionery store did not last long as the lease ran out and the property was sold over his head. Anyway, he was glad to get out of it all.

By 1923, there was a depression in Ontario and my grandfather moved from Peterborough to Brantford, and then to the border city of Windsor, where he found work with the Toledo Scale Company, a Canadian branch of a United States firm. My grandparents then rented out their lovely Peterborough house,

with its large and attractive property, and bought a smaller house in Windsor.

Windsor itself, a working man's town, was a fast-growing place in the early twenties. Its economy was controlled in the offices of the giant automobile manufacturers across the river in Detroit, reached in those days only by ferry, and when Detroit prospered so did Windsor. The city must have been the most cosmopolitan of all cities in Ontario at that time. There had been a large surge of European immigration to Canada after the war and many came to Windsor seeking employment in automotive and other related industries.

At the public and secondary schools I attended in Windsor there was a large school population of Italian, Polish and European-Jewish children, plus a smattering from Scandinavia and Eastern Europe, and so the Windsor schools became a cultural melting-pot, the students being absorbed with remarkable ease into the British-Canadian education tradition. Some of my school friends, recently arrived from Europe, quietly anglicized their names and when ready to enter high school had already become completely English-speaking Ontario-oriented individuals. They did not want to be reminded of their European background.

Thinking back to those times, Canadians, especially the inhabitants of English-speaking Ontario, were completely devoted to the Crown. It was a patriotism directed towards King and Empire rather than to Canada itself. Earl Grey, Governor General of Canada from 1904 to 1911, wrote a short piece on the meaning of Empire Day, which took up a page in the public school reader's textbook in editions well into the 1920s. It was written by a deeply committed man. "I want you," referring to his captive student readers, "to remember that one day Canada will become, if her people are faithful to their high British traditions, the most powerful of all the self-governing nations . . . that are proud to owe allegiance to the King."

My father always wanted me to excel in everything I participated in. I think in a way I was his alter ego; some of his ambition and spontaneous energy was lived out vicariously through me. There was something in his makeup that caused him to take a special interest in my activities from my early school days onwards, and in fact throughout his entire life.

He constantly tried to improve his learning and knowledge by reading. He also read inspirational books and copied out in notebooks passages that appealed to him as constructive either to life or business. He could also quote relevant passages from Shakespeare, one of his favourites from Hamlet – "Neither a borrower nor a lender be . . . ," which expressed his personal philosophy on the pitfalls of borrowing or owing money.

He was a fervent conservative in his political beliefs and kept in touch with the events of the times. He kept his appointments on time to the minute and expected others to do the same. He was both mentally and physically courageous, a chivalrous and Victorian romantic, who adored my mother and sister, and was always concerned with the well-being of his family.

Finally my restless and ambitious father decided business opportunities were not good enough in Windsor to warrant his staying there and early in 1929, he decided to try his fortune in the city of Toronto while temporarily leaving his family behind in Windsor. Always an enthusiastic and superior salesman he had no difficulty in finding a selling job there on a commission basis.

I completed my matriculation in Windsor during the spring of 1930 and was looking forward to enrolling at the University of Toronto.

Around the end of June, I arrived in Toronto to meet my father who had been staying at the Central YMCA on College Street, along with several friends living there either just before being married, or temporarily away from their own families. One of the men living there was P.C. Finlay, of the Holden & Murdoch law firm, a young lawyer who became my father's legal adviser. P.C. Finlay was to become an extremely well-known and successful mining corporation lawyer, eventually becoming president of Hollinger Mines, and he acts for me even to this day. For a short while, I, too, stayed at the YMCA, but within a few days we found living quarters in a house at 89 Collier Street, just two blocks north of Bloor.

Later that summer my mother and sister moved from Windsor to Toronto, and we found a house of our own on Park Road. I searched for a job, under the Help Wanted section in the *Evening Telegram*, and someone by the name of James McPherson was looking for a young man to canvass house builders needing

financing. The advertiser was obviously a Canadian Scot and in my reply I mentioned I, too, was a Canadian of Scottish extraction and promptly got the job. By 1930, there was little building going on in Toronto but Mr. McPherson subscribed to a building service that listed any and all of the few houses under construction. Since I had no automobile, I took the streetcar to remote parts of the city and walked the rest of the way to those half-built houses. Usually the builder was working on the job himself and more and more depressed by the negative prospect of sales; I seldom found anyone interested in our offer to finance. Although this turned out to be the most frustrating, unproductive, and shortest-lived job I ever had in my life, my zest for selling, which I had inherited from my father, remained intact. That summer he gave me a week's instruction on the art of selling in the actual field, in this case an advertising service to small businesses. He wrote out a preamble and sent me to try it out "cold" on possible buyers. It was tough going for a while until I learned to develop my own style of selling, but I learned basic lessons from him that have been useful to me all of my life.

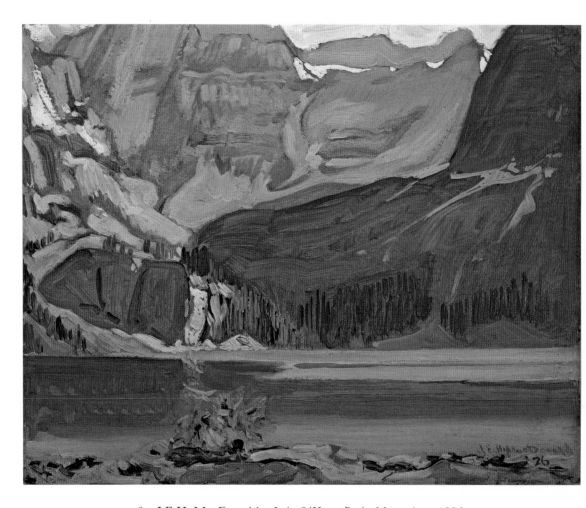

2 J.E.H. MacDonald *Lake O'Hara, Rocky Mountains* 1926

2
Early Days in Toronto

When I arrived in Toronto in the summer of 1930, at the age of eighteen, I was impressed with the natural beauty of the city and admired its handsome buildings; my affection for the place has ever since remained undiminished. Now that it has become a huge international metropolis, it is the fashion in some circles to regard the Toronto of the twenties and thirties derisively, as a dull and parochial town, a colonial backwater, or worse, but I find these opinions too fanciful and biased to be taken seriously. If one looks back in time, especially from today's viewpoint, certainly Toronto had its little faults, but they were normal ones common to any town or city in Ontario with a population that possessed a strong tradition of English-speaking Protestant puritanism, and so be it. I have always found Toronto an attractive and dynamic place in which to live and conduct my business and despite its critics I will always retain my pride and pleasure in being a part of that Toronto of old.

That summer was a hot and sticky one, but weather aside, it turned out to be an important landmark in my life. The house we moved into at 32 Park Road was then well-situated and proudly stands to this day. It was one of those classical semi-detached Victorian houses backing on the Rosedale Ravine, and pos-

17

sessed a fine view of trees and parkland to the north. The rent was $35 per month, and the house belonged to a venerable old school-trained lawyer by the name of Charles Kappele, who wore winged collars, a cutaway coat, and was very polite. The streets, with their great elm trees, the ravines, and especially Rosedale, with its splendid houses – to some of whose owners we would be selling pictures three or four years later – all impressed me immediately.

Park Road, Rosedale, the five-minute walk to Yonge and Bloor through old Yorkville town, this is the part of Toronto in which most of my life has been spent, both as a student and as an art dealer, and it has always absorbed me.

I enjoyed my daily walks from our house to attend classes at the University of Toronto. Just along Collier towards Yonge Street there was a blacksmith's shop. In the 1930s it was one of the last surviving ones in the city but still going strong; after all, there were still some horse-drawn milk, bread, and tea wagons in use on the streets. "John McLaren, Blacksmith," the sign said, as if to spell out his personal pride in his craft, but everyone knew him as "Jack," and he seemed to be constantly busy at his forge. Sometimes as you passed his blacksmith shop, clouds of pungent smoke would drift through the open doors, but it was well worth putting up with the smell of scorched hoofs just to watch his professional skill in applying a hot metal shoe to a horse's hoof and nailing it on, while deftly holding the foot in a fold of his thick leather apron.

On the street floor of the old four-storey Frogley Building, across from the original Yorkville town hall at the southwest corner of Yorkville and Yonge, was Harold Creasser's second-hand bookshop. He specialized in Canadiana and managed to eke out a living, but it must have been a small one. He was a nice man with a great love of books, and his prices were so low they cost almost nothing in his shop: just a few interested customers kept him going. Creasser let me browse through his stock at leisure and it was he who got me interested in the world of early Canadian books. I remember buying a set of Robertson's *Landmarks of Toronto* from Mr. Creasser for $10.

Across the street, on the east side of Yonge, was Mr. Sterry's little picture shop. Sterry had recently arrived from England, a tiny, wizened man with a shock of white hair and small steel-rimmed glasses that barely paused before falling off the end of his

nose; he was like a character out of a Dickens novel, and offered with great enthusiasm pictures of somewhat doubtful origin and authenticity. Sterry did not last very long in the picture business.

Nearby was the singing shoemaker's shop. Its Neapolitan proprietor, Joe, was an excellent cobbler and also a tenor who, at the slightest encouragement, or even without, would burst passionately into an Italian aria – real comic opera stuff. Next door, to the north, was a disreputable pool hall operated by two Serbian refugees. Later, in 1936, the artist Curtis Williamson, in dire financial straits at the time, occupied a dirty and dilapidated studio in the same building.

Also in this block there was an excellent barbershop, where a haircut cost twenty-five cents. Daily newspapers were three cents and sold then by the thousands by red-haired Sam at the corner of Yonge and Bloor. All these old haunts on the east side of Yonge are gone now and in their place sits the spectacular new Metropolitan Library building.

Further south, towards Bloor, was the friendly bookshop of Roy Britnell, and Carnahan's drug store. Mr. W.J.A. Carnahan was an elegant man, a well-known Torontonian in his day, who did most of the drug prescription carriage trade business in Rosedale.

Just around the corner on Bloor was Paul Hahn's (brother of the sculptor Emanuel) piano shop. He was a supersalesman, while offering his Steinways, and his hobby was collecting stuffed specimens of the extinct passenger pigeon, discovered in the homes of some of his old-time clients. He presented these rare bird relics to the Royal Ontario Museum. And then at the southeast corner of Yonge and Bloor was McIlraith's drug store, where my friend Harold Fishleigh worked long hours for years as a druggist. In the 1940s we were active together in Toronto municipal politics, he as an alderman and I as a school trustee in the old Ward Three of downtown Toronto. Harold later gave up being a druggist to grow wealthy as a real estate developer. Nearly all these places are gone now and the land from Britnell's south to Bloor is filled by the enormous Hudson's Bay building complex.

Across the street from McIlraith's was Frank Stollery's busy men's wear store. He was one of the early haberdashers of the district and developed to a fine art the display, advertising, and

selling technique of his goods. Frank remained active in business until an incredibly old age, while still walking with the bounce of the runner he was in his youth, and there was usually an enormous cigar tucked in the side of his mouth. A man of generous heart he was held in high esteem by Toronto citizens. While still in college in 1933, I worked in his store as a clerk for a two-week period during the Christmas rush.

I found the University of Toronto a new and challenging experience when I enrolled there in September 1930, in general arts. (In my second year I changed to a psychology and philosophy course.) But in those days the university was not the place to learn much about art, nor did I go there for that purpose. Actually there were no courses in the fine arts until years later though some good Canadian paintings hung in Hart House and in the women's residences.

Two professors, each a Dean of Women at colleges in the University of Toronto, were instrumental in acquiring Canadian paintings for the respective women's residences over which they presided. One was Marion Ferguson, who bought a magnificent sketch of *Petite Rivière* by J.E.H. MacDonald, and other pictures for the University College residence, and the second was the charming philosopher-scholar Jessie MacPherson, who bought from us a Tom Thomson sketch, and other works by members of the Group of Seven, for the Victoria College residence for women. Jessie MacPherson was so interested in Canadian art that she persuaded artists such as George and Kay Pepper, Arthur Lismer, Lawren Harris and A.Y. Jackson to lend their works for extended periods of time on exhibition in the residence common rooms. The pictures were a revelation to the students of the day, making many of them aware of Canadian art for the first time, and provoked great discussions.

And there were other people who were interested in art – my favourite professor at Victoria, John D. Robins, a memorable man, was one of them. He was head of the english department and had had his portrait painted in the mid-twenties by Lawren Harris. Harris was successful in expressing some of the good humour, intelligence, and character of the man that made Robins' lectures on english literature such a pleasure to attend. He was, in a modest way, an early collector of Canadian art. In addition to the por-

3 J.E.H. MacDonald *Petite Rivière* 1922

trait, he had a Lawren Harris sketch of the *North Shore, Lake Superior*, as well as a sketch, *Montreal River*, of 1918, by J.E.H. MacDonald, which I bought in 1977, from his niece. In retrospect, I realize I absorbed much more from this man than I ever thought possible at the time he was my teacher.

A member of the philosophy department, Assistant Professor Edmund MacDonald, gave seminars sitting on the edge of his desk, smoking cigarettes in his study on the quadrangle of University College. MacDonald was an amateur photographer and bird-watcher, very proud of some photographs he had taken of a hummingbird outside his study window. A handsome and pleasant man, he was interested in Canadian art and later photographed all the paintings in our 1937 Tom Thomson exhibition. Unfortunately, all the prints are lost. MacDonald had good potential as a philosopher-scholar, but never lived up to it; he had a propensity for drink. Every once in a while he would be seen in the basement tavern of the Park Plaza Hotel, rolling exuberantly on the floor and kicking up his heels, after a few too many beers. The university authorities were not amused by these extra-curricular activities.

Vincent Massey's friend, J. Burgon Bickersteth, presided over Hart House as warden. He was formerly an English schoolmaster, a bachelor, who had his own quarters in the building. He was a firm disciplinarian who would brook no nonsense if the house rules were broken. He was much interested in Canadian art, undoubtedly through the Massey influence, and was instrumental in building up the Canadian art collection in Hart House during his tenure of office. He also was another modest collector and possessed pictures by Arthur Lismer, A.Y. Jackson, David Milne, and others. He now, at the age of ninety-one, is living in England, and has presented his little collection of Canadian art to his beloved Hart House.

At the university, although aware there was "a depression on," (a vague phrase of the times, I remember), few paid attention to the fact, and any social and economic changes took place so gradually as to be hardly noticed. I myself had no inclination towards the political doctrine of socialism, but it was popular among certain intellectual and scholarly types attending Victoria, who became dedicated to the policies of the newly formed CCF Party. Among those I knew were E.B. Jolliffe and Northrop Frye. Jol-

4 J.E.H. MacDonald *Montreal River* c.1918

liffe was a likable and friendly man who was also a Rhodes Scholar. I enjoyed his company on many a walk across the campus. Later he became leader of his party and almost succeeded in winning the 1943 Ontario election, narrowly losing to George Drew.

There was a man, who, looking back, had a brief though significant influence on my life and my ultimate decision to go into the art business. His name was James Lawson, a Don at Burwash Hall, the men's residence at Victoria, a tutor at Emmanuel, and later, librarian of Victoria. He was about forty years old when I first knew him, a medium-sized man with a round face and reddish hair, bald on top. He had gone into the ministry but had never taken a pulpit, preferring, it seemed, an academic career.

James Lawson's great interest was Canadian art, and he had a very sharp eye for a good picture. He was one of the early collectors of Tom Thomson, A.Y. Jackson, J.E.H. MacDonald and, a little later, bought an important canvas by Emily Carr when hardly anyone had heard of her. He used to lend pictures to certain interested students to hang in their rooms, but not his more valuable ones. He told me how he had started buying from the artists at a time when practically no one else was interested, and the artists themselves were unknown.

By 1932 he had at least eight paintings by Tom Thomson, including two canvases, *Opulent October* and *Northern Night*. The latter we sold to Frederick G. Gardiner, the political architect of modern Metropolitan Toronto. There were also six late oil sketch panels, two of them rare wildflower subjects, and another, a vertical study of spring birches in luscious greens and pearly whites. One day Jim Lawson related to me snatches of the story of how he acquired them. He volunteered the information that they had been previously owned by a Mr. Cumming, who came into possession of the pictures by direct barter or trade of oil colours and other painting supplies with the artist himself.

Apparently, Alex G. Cumming was a "man about town," and quite a high flyer in his day. By 1910, he was manager of Toronto's leading artist supply and colour merchants, the Art Metropole on Temperance Street, in which position he got to know nearly all the artists of the time. Early in 1915, when Cumming heard, perhaps through his friend, Curtis Williamson, that one of the desirable and much sought after studios in the new Studio

24

Building was coming up for rent, he managed to get Lawren Harris, the principal owner of the building, to consent to his moving in. (Lawren Harris and Dr. James MacCallum had completed the Studio Building in 1914, on prime land in the Rosedale ravine, near Davenport Road and Yonge Street. It seems quite strange in retrospect that Lawren Harris would allow a non-artist to rent in the Studio Building at all, especially when there must have been other artists who would have been most eager to move in.) Cumming was also a lively and frolicsome fellow, who delighted in throwing parties and playing the latest popular dance tunes on his gramophone. It is not altogether surprising that the noise from these frequent parties began to upset some of his artist friends, who possessed more staid living habits than his own.

When Tom Thomson returned in the winters from his painting trips to Algonquin Park, it was always to his studio-shack in Toronto, a few steps away from the Studio Building. There he would paint up his masterpiece canvases. Being a neighbour, Alex Cumming must have thus seen a lot of Tom Thomson and probably got to know him quite well. One can only speculate, but it is more than likely that Thomson attended some of Cumming's parties, as he too enjoyed the companionship of attractive women, and also liked a drink or two. Cumming would have known Thomson, then, during his great painting years of 1915, 1916, 1917, the last for the artist, and judging from the pictures he selected for himself, Cumming seemed to have developed a strong sense of appreciation of Thomson's work. Either by outright gifts from the artist or purchases on his own, he managed to acquire from the artist some superb paintings.

Cumming lived in the Studio Building for more than three years, until late in 1918, when Harris decided to ask him to leave, not only in the interest of peace and harmony, but to hold vacant a place for A.Y. Jackson, who was scheduled to return to Toronto, following his army discharge, in late spring, 1919. By 1919-20, after his enforced departure from the Studio Building, Alex Cumming moved away to a Bloor Street East address, while still retaining his job as manager of the Art Metropole. By the mid-twenties he had retired from active business, and, by the early 1940s, was forgotten.

Lawson had a large J.E.H. MacDonald Rocky Mountain

canvas, *Morning, Lake O'Hara*, as well as some MacDonald sketches. We borrowed from him the two Tom Thomson canvases and three sketches for our exhibition of 1937, and later we bought from him the MacDonald canvas, the Thomson *Northern Night* canvas, and some sketches, including *Spring Birches* and a brilliant wildflowers subject.

In art buying, no one that I have ever known since could stretch a hundred dollars as far as James Lawson could. It had to be that way because he had so little money on hand to indulge his fiercely acquisitive buying instincts, and it is truly amazing that he was able to amass over a period of ten or twelve years all the things he did.

By 1933, I was seriously pondering my own future. I saw no point in continuing the study of philosophy and psychology. A career in teaching did not appeal to me, law or medicine were slight possibilities; finally I talked things over with Jim Lawson. I remember he listened carefully to what I had to say and suggested the direction of my father's newly established art business. I did not take his advice then, as I felt I had to work out my own options.

Finally, I decided to take a year off from university and it turned out to be one of the best decisions I ever made. I joined the William Neilson Company and sold cocoa and chocolate for them (and years later many pictures to its subsequent owner W. Garfield Weston). I enjoyed the work and they later offered me a permanent job. It seems to me almost every job I've had has involved some form of selling, whether advertising space for the varsity football program, or magazine subscriptions. I like its challenge and then as now have always gotten pleasure from "closing a deal."

This lapse of time away from Victoria cleared my mind and made it easier to make the decision to complete my degree and enter my father's art business, as Lawson had suggested.

3

My Father Founds a Gallery

Both my parents had an early interest in art, and my mother, a modest artist herself, was a painter of china and a wood carver. My father had already bought some paintings, and was now beginning to buy some European Old Master works. His interest in art at this point, however, was one of pleasure and purely academic. By 1931, he was doing extremely well as a salesman with a firm called Brock Securities, travelling with a chauffeur-driven car throughout southern Ontario selling oil stock certificates to prospects recruited by advertising in local newspapers.

In the depressed years of the early thirties, money was scarce and art was regarded by most as a luxury. The few dealers that existed in Toronto survived as the result of work turned out by their framing shops, while one or two others got by catering almost entirely to a taste that liked highly finished nineteenth-century English and European pictures. Canadian art was little shown, as there was no market for anything contemporary, certainly not the work of living Canadian artists.

In 1931, my father met Robert Mellors. Mellors had been manager of the picture department at Eaton's, but was dismissed in the firings, in those precarious times, of many company

employees. He then took an office in the old Bay-Bloor Building, and borrowed some pictures to sell, as well as pieces of Georgian silver, and attractive bric-a-brac objects, such as a gold watch that chimed, which I remember my father buying. He was a pleasant, innocuous, rather sleepy-eyed, pipe-smoking Englishman, who would have been about sixty years old at the time.

Before coming to Canada, Mellors had been trained as a salesman in a commercial gallery in the English Midlands, and he now enjoyed a certain status as an art expert in Toronto.

In 1932, my father hit on the idea of establishing a private art gallery, and asked Mellors to come in as a partner. Mellors was extremely receptive to the idea. It is incredible to think now that in the depth of the Depression, when the climate for selling art was so bad, my father was bold enough to consider starting such a precarious luxury business. But he was unshakable, and also had a certain faith in Mellors' ability to run an art business. In addition, Mellors had established a prestige position with some of his former clients at Eaton's, who could certainly be considered as potential customers.

There was one little snag – Robert Mellors had no money. He did, however, have in his possession a portrait of an old lady, called *Mrs. Hyde, Senior,* which he claimed was by the Scottish portraitist Sir Henry Raeburn. There still remained a market for old portraits in Toronto, a conservative Canadian society still strongly attached to traditional family backgrounds, and Mellors placed a value of $2,000 on his Raeburn portrait, quite a tidy sum in those days. He contributed this portrait as his share to the assets of the new gallery. The third partner contributed no money either, but he supplied material and labour at cost to convert the long, broad corridor of space, in an empty new store at 759 Yonge Street, into a splendid looking and practical gallery. This third man was E.E. Woodley, builder of fine houses, and amateur picture restorer.

Because of my father's desire, for whatever his own personal reasons were, to be a silent partner and remain anonymous as the dominant owner, the corporate life of our gallery began under the name of Mellors Fine Arts Limited. However, before many months had passed, he discovered that Mr. Mellors lacked the capability of running the business on his own, and in order to safe-

guard his investment, and also, I think, because of his growing interest in art, my father resolved to spend his full time at the gallery.

By 1940, the name was changed to Mellors-Laing and a little later it became Laing Galleries. Apart from the name changes, the firm remains today the same family business it was when founded in 1932, and I expect it presently is, by a span of many years, the oldest surviving family-owned private gallery in the country.

Our gallery was to be a showplace largely for European art; the strong Canadian content of the business was to come some two years later. It was a strikingly modern establishment much admired by artists and those who visited it. It occupied the street floor of part of a new building located about seventy-five steps north of Bloor Street on the east side of Yonge. Two sets of wings were built about five feet out from floor to ceiling, on both sides of the long room. This effectively broke up the straight lines of the interior, and provided extra hanging space for pictures. The ceiling was "dropped" as well, to provide troughs on either side for lights, which were directed downwards at an angle to provide even illumination on the walls. The walls themselves were painted a warm grey, the artist Archibald Barnes being consulted as to the exact amount of "rose madder" to add to the grey for the optimum tone. There was a special private showing room with a built-in easel and a light, its intensity controlled by a rheostat, dark plum-coloured velvet curtains draped the entire room, and there was a chesterfield on which our customers could sit in comfort. The whole conception worked extremely well, and helped us sell many pictures.

In those early days our sales technique was fairly standard. When we acquired a picture we thought might interest a certain customer, we would telephone him in the hope that he would come to the gallery, look at it, and possibly ask the price. If he showed interest, we would suggest he might like to see the picture at home. Sensing a continued interest the painting would be sent out on approval, carefully swathed in heavy velour, and fastened with large safety pins to make a safe and impressive looking bundle. Once the painting had been hung for a few days in the prospect's house, we would telephone him again for a decision. Usually it was negative – the picture was unsuitable, too expensive, or the prospect felt it was the wrong time to spend the money, a state

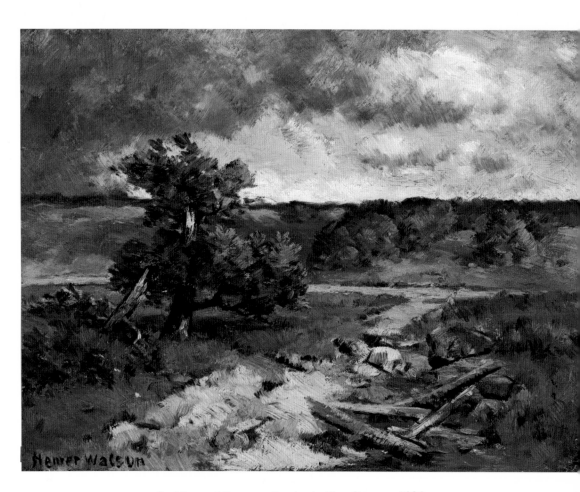

5 Homer Watson *Landscape Near Doon* c.1886

of mind that continued to plague us for many years. In those days any suggestion that a customer buy a picture to hold as an investment would have been thought ridiculous, and he would have been the first to emphasize that he was buying for pleasure and not to make money.

In the mid-thirties nearly all our customers were leading figures in the mining world. Engineers, prospectors, mining company lawyers, stock brokers, financiers, and of course the inevitable stock promoters. It seemed that all the real wealth of the time flowed from the gold, silver, copper and other metal mines of Ontario and Quebec. We sold pictures to the R.A. Bryces of Macassa gold wealth; J.B. Tyrrell, geologist and explorer; General Hogarth of the Steep Rock Iron Mines; Dr. George Cameron, medical doctor of Harry Oakes' fabulously rich Lake Shore Gold Mines and his wife, a lady from the American deep South. We sold to Norman Urquhart, mining financier, later president of Mining Corporation; J.B. Holden, legal counsel for the Hollinger Gold Mines; James Y. Murdoch, president of Noranda. The immensely successful mining engineer brothers F.M. and W.H. Connell were also clients, as were Jack Hammell, J.H.C. Waite and H.R. Bain, the mining stock broker. We even tried to interest the notorious Harry Oakes, then living in Niagara Falls, Ontario, but with no success. Then there were the banking families – people like R.S. Waldie, president of the Imperial Bank, and George R. Cottrelle of the Bank of Commerce, as well as H.R. Tudhope of the A.E. Ames financial house.

We also dealt with industrialist E.P. Taylor. In the mid-thirties he was totally immersed in the ticklish and involved task of putting together the pieces of what was to become his enormous brewing empire. He was possibly short of ready funds at the time because of large business commitments, but he badly needed some pictures to decorate his fine new home on Bayview. Rather than buying outright for cash, he took advantage of our picture rental scheme, which suited him to the ground. He chose five pictures by the English painter W. Lee Hankey. I recall Mr. Taylor, as I knew him then, sitting down at a desk in the gallery and checking the rental figures, and was impressed with how quick he was with his arithmetic. After six months, he decided to buy the pictures at the listed prices less what he had paid us in rent. The Taylors possess these pictures to this day, some forty-five years later.

I got to know Eddie Taylor well through the years but except for modest purchases from time to time, such as small panels by Clarence Gagnon, a street scene by Utrillo and a large horse-racing canvas by Alfred Munnings (not bought from us), in addition to the aforementioned Lee Hankeys, he never became much interested in art. He once told me that the high values of the French Impressionists "scared" him as a potential buyer, but he had no hang-ups about buying the swiftest and most expensive race horses. That is what stopped him in 1953 from buying from us one of Claude Monet's waterlily masterpieces for $12,500 – now practically priceless.

Ernest Poole, a man of strong opinions about his fellow man, was another of our keen early buyers. Born on Prince Edward Island he had moved to western Canada and set up a construction firm in Saskatoon and later Edmonton. When he first started to buy from us in the mid-thirties, his little business was struggling to survive and he was making constant trips to Toronto and Ottawa in search of government contracts.

Ernie Poole possessed an amazing acquisitive instinct. The first pictures he bought from us were sketches by Tom Thomson and J.E.H. MacDonald and in 1938, he bought a Thomson canvas, *The Fisherman*, for $600, paying for it on the instalment plan at $50 per month. Through the years until the early 1960s he was a consistent buyer, acquiring dozens of Canadian pictures including other works by members of the Group of Seven and later even abstract works by Jean Paul Riopelle. He built a deep sub-basement in his home in Edmonton where he could stow away in safety his treasures, fine Georgian and early Canadian silver and other works of art. The greater part of the Poole collection of paintings is now housed in the Edmonton Art Gallery.

It was during these years that we began to deal in early Canadian prints and watercolours. We were able to sell many of the items we found to William Coverdale, collector-president of the Canadian Steamship Lines. Captain Percy Godenrath, one of those proud men in Toronto who retained his First World War officer's rank as a title between the two wars, worked with us and taught me something about historical Canadian art, and to this day I enjoy dealing in Canadiana.

I first remember seeing paintings by Cornelius Krieghoff in 1933. We had just acquired five small ones from a family by the name of King, relatives of Mackenzie King. They lived in the Orillia area, north of Toronto, and it was said at the time that the pictures had been bought by an ancestor from the artist himself. The pictures had the fine detail and brilliant colour that one expects of Krieghoff. In four of them, the subjects were Indian hunters and squaws in native costume with Hudson's Bay blanket coats and multi-coloured *ceinture fléchées*, snowshoeing through deep snow. The fifth, an early one, was a dark interior, depicting habitants playing cards. This picture had deep cracks, apparently caused by the artist's experimental use of bitumen in his dark tones, which he expected would produce a more translucent surface. Fortunately, Krieghoff quickly dropped this disastrous technique. But there was no market for these pictures in Toronto at the time, and we finally sold them to Joseph Shima of Montreal for a grand total of $600.

Joseph Shima, a recent immigrant from Austria, was an energetic salesman and importer of sausage casings who had started a small art business on the side. He happily sold cheap Austrian Alpine snow scenes by the dozen in a shop on St. Catherine Street West. His wife Vilma shared in the running of the business, which later, having removed to Drummond Street, became the successful Continental Galleries. In the early 1930s there were only four established galleries in Montreal: Scott and Sons, the oldest and most important, founded in 1859; Sydney Carter, a small exclusive dealer, and photographer of Morrice, who handled some of his paintings too; William Watson, who showed the work of Maurice Cullen and Krieghoff; and the Johnson Gallery, which also had Krieghoffs and where the Amsterdam firm of Van Wisselingh showed French Impressionists before the war. Shortly afterwards, the Johnsons gave up the selling of pictures as a hopeless business and rented out the premises as a restaurant. Besides rent, their additional income was a commission of five cents they collected on every cup of coffee sold. Such an arrangement must have been a bookkeeper's nightmare.

I bought various fine Canadian paintings from Vilma Shima through the years, including works by Morrice she had on sale from the Heaton estate, Cullen, and many by Krieghoff. She became a prosperous art dealer, was a hard worker who travelled

extensively, and was liked and respected by her colleagues and clients. Some years after Joe's death in 1955, she married Paul Lafontaine, and the marriage was a happy if tempestuous one. Paul was an exuberant French Canadian, a lawyer and a high-ranking member of the Quebec Conservative Party elite in the John Diefenbaker days. Joe always needed money, and Vilma spent a great deal of her hard-earned fortune keeping him solvent.

Another dealer who brought pictures to us for sale in the thirties was Harry Wallis, Director of the French Gallery, London, who brought over pictures from England at least two years in a row to show in Montreal and Toronto. In those days, of course, he travelled to Canada by ship and during one trip had the good fortune to meet R.S. Waldie and his wife, also on board, who were already beginning to buy some pictures from us. During this trip Wallis sold to R.S. Waldie an attractive figure piece of a girl seated at a spinning wheel by J.J. Henner, and also a Dutch landscape by Th. de Bock. This was his only sale in Toronto. In 1934, R.S. Waldie bought from us the great Horatio Walker painting *The Royal Mail Crossing the St. Lawrence.* He paid $5,000 for it and our profit from that sale was certainly the turning point that established the gallery in security. Earlier that year, my father had travelled to the Isle of Orleans to see the famous artist who still remained the grand seigneur and patriarch of the island; meanwhile Mellors went to New York to see Walker's ebullient agent, F. Newlin Price. Apparently up to that time Walker had never seriously considered having a one-man exhibition and sale of his oil paintings in Canada and we thought it was about time he did. Mr. Price, candidly thinking of his own share of commission on any sales, agreed, and wrote from New York in a burst of enthusiasm that "Thar's gold in them thar hills." Gold in any form was something we had not seen at all up to then in our little fledgling art business.

Some of the works came from Walker's studio in Ste. Pétronille, and some from New York. Including sketches, there were about forty pieces. Horatio Walker himself came to Toronto for the opening and stayed on in the city for a few days. I found him a tired and cheerless man, resembling an old weather-beaten Cyrano de Bergerac figure whom the irascible Canadian art critic, Hector Charlesworth, once said he looked like. Obviously, in a state of worry and frustration he complained severely that his pictures

6 Horatio Walker *Royal Mail Crossing the St. Lawrence* c.1909

were not getting enough light in the galleries, but the truth was that at the age of nearly seventy-six his eyes were growing dim. Among the paintings shown were two important works from Walker's earlier years, the first, a wayside shrine composition entitled *Deo Gratias* and the second, the previously mentioned *Royal Mail Crossing the St. Lawrence*.

From about 1900 on, and until after the First World War, Walker had been getting huge sums of money for his large paintings; prices of $10,000, $15,000, and even more, were something quite normal for him. His dynamic dealer, N.E. Montross of New York, maintained complete control over all picture sales and dealings, including the responsibility of choosing pictures to lend to important national and international exhibitions, often under the Montross name as lender-owner. Also all correspondence to Walker was sent in care of Mr. Montross. I can think of the work of no contemporary artist, living either in North America or Europe, with the possible exception of the two surviving French Impressionists, Renoir and Monet, who received such prodigious prices for their work. But by the mid-1920s, however, Montross had quit his business and Walker was no longer creative; also gone was that sustained popularity which he had enjoyed for more than two decades with collectors and museums.

Although the prices of his pictures in our 1934 exhibition were substantially lower than those he had charged in the old days, they were extremely high in comparison to what other contemporary artists asked for their work. I had the distinct feeling that the reason he consented to a sales exhibition in Toronto at all, was that he had fallen on hard times and was much in need of money; perhaps, he felt, it was a chance to recoup part of his stock market losses. That important sale of *The Royal Mail*, to R.S. Waldie, could not have come at a better time for the selling parties involved. Newlin Price was especially pleased to get his share of the commission, as New York dealers were also starving then from lack of business.

The Royal Mail is as pure in its French Canadian subject matter as one of Clarence Gagnon's spring maple sugar bush scenes, or a Krieghoff sleigh and toboggan party painted fifty or sixty years earlier at the ice cone of Montmorency Falls, just across the river from Walker's own home.

After the artist's death in 1938, his work all but disappeared from the market and his name was almost forgotten. About nineteen years later, in 1957, I acquired nearly all the remaining sketches and canvases from his niece, Olive Pretty, who inherited her uncle Horatio's entire estate. Walker's wife Jean had suffered a serious mental illness and was confined to a hospital during the last twenty-four years of her life; ironically, she outlived her husband by three months. In her place the niece Olive presided over her uncle's household and probably dedicated the best years of her life to his comfort. The Pretty collection contained some good pictures, figure pieces, including a sensitive study of a young girl of the island, called *Pétronille*, which we later sold to the National Gallery. Around the same time we also acquired more than five hundred drawings of island subjects, including studies of domestic animals, habitant figures, usually in some active form of labour, such as ploughing, and some straightforward landscapes. Most of the drawings were done in the 1880s and 1890s. Crisp and well-executed, they remained authentic documents of the island people, depicting their semi-primitive working and living conditions on the Isle of Orleans, during the last twenty years of the century.

Then, in 1962, we bought Walker's erstwhile famous *Ave Maria* on the open market in New York, and sold it right away to the Art Gallery of Hamilton for $5,500. It had been part of the permanent collection of the Corcoran Gallery of Art in Washington, D.C. and was, at one time, considered a treasure by that institution. But later, as Walker's work fell into disfavour, the picture was consigned to the depths of the gallery basement, along with other works by unwanted artists, and finally "de-accessioned." "De-accession" is a word coined by an American museum academic to describe the process of getting rid of some picture or object one does not wish either to continue to store, or ever again place on public view. The old Walker would have been broken-hearted and felt betrayed had he lived to see the day when so many of his works, which formerly hung in important United States museums, would be carelessly thrown on the open market. He deserved much better treatment.

Clarence Gagnon, Walker's great friend, who stayed with him often on the island, used to spend all day long making his own colours. On Walker's death Gagnon undertook the job of number-

ing all the pictures and drawings left in the inventory, stamping each one "Estate of Horatio Walker," and signing his name on the back of each drawing to confirm its authenticity.

Another one of the artists we handled in those early years was Curtis Williamson. Williamson had been one of the original tenants of Lawren Harris's Studio Building and was so hard up by 1936 that he could no longer afford it, and moved to quarters on Yonge and Collier Street, where rent was even lower. Through dirty windows, looking west along Yorkville Avenue toward the Old Fire Hall, or through the same windows looking just across Yonge Street at the Town Hall, with its imposing clock tower, he painted murky wintry night scenes of streets and rooftops, which were very dark, and had a strange, melancholy but painterly quality about them.

As a young man Williamson had studied art in France and Holland. Back in Canada afterwards he did quite well as an artist and portrait painter for a time and was an active member and exhibitor of the Canadian Art Club from 1908 to 1915. His paintings were usually so dark, though, that they were not popular or saleable. Williamson had known J.W. Morrice in Paris and met Tom Thomson in 1914, when he first had quarters in the Studio Building and Thomson lived and worked in the little wood shack nearby. Williamson spoke of both these men with reverence and affection.

He must have found it difficult to re-adapt himself to Canadian ways after his many years in Europe, however. He never married, and lived out the last years of his life alone in that bedraggled, filthy studio. About the only outside social contact he had was with his niece, whom he used to visit on Sundays. The funds that supported his years of study in Europe had dried up and the dapper elegance of his youth gave way to an emaciated and shabby figure of a very old man.

Williamson wore a moustache with waxed ends and constantly smoked his curved pipe. The front of the fireplace in his studio was littered high with burnt-out matches; whenever he decided to go out he would proceed to the door, pause, and return to check for hint of possible fire. The rear part of the studio was dark, gloomy and crowded with old unfinished canvases, many of which he had not touched in years.

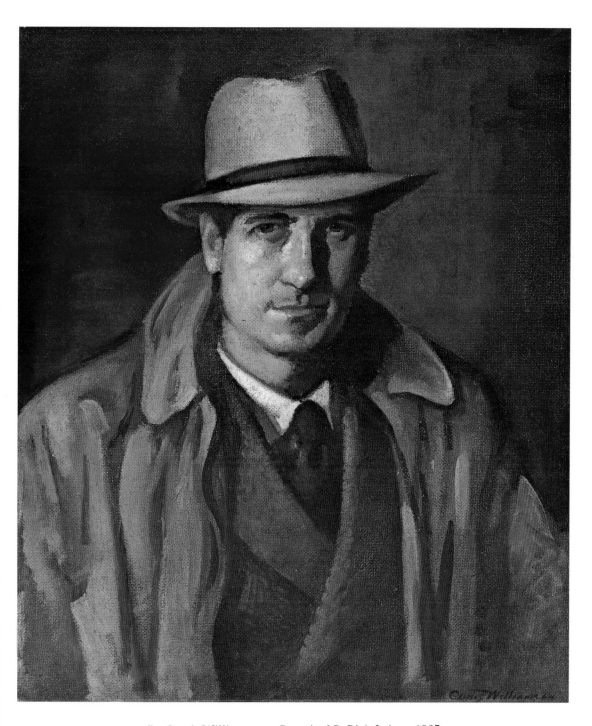

7 Curtis Williamson *Portrait of G. Blair Laing* 1937

He told me when I first met him he had recently completed a portrait of the well-known Perkins Bull, who was then busy compiling a series of volumes on the history of Peel County and who, like Williamson, came from that area. Perkins Bull, a lawyer, a controversial and vivid character, was notorious at the time; he constantly appeared in the newspapers as a shadowy figure, fleeing for his life from the Chicago underworld. Williamson seemed to be having trouble collecting payment on his commission and wrote him asking for his money. He was most articulate, and could compose sharp, expressive letters. On occasion, before posting one he would recite it to me, without looking at the paper at all.

But the portraits Williamson will be remembered for best are those of his artist friend Homer Watson and of Dr. James M. MacCallum. We arranged the sale of the former, a fine character study, to the National Gallery in 1942, and the money could not have come at a better time for the destitute Williamson. In 1936-37 he had painted a portrait of me, wearing a fedora and a light brown trench coat, for a fee of $100, which I paid on the instalment plan. It took many sittings and, as with all his pictures, he was never quite satisfied that it was finished. But I finally got him to call it a day and sign it; and today several galleries in the country would like to acquire it as an example of Williamson's work.

Around the same time he worked on flower and fruit studies and vegetable still-lifes, and the ones he completed we sold. Others were never finished; like Cézanne, Williamson painted so slowly that the flowers wilted and the fruit and vegetables perished long before he had completed the canvas to his satisfaction.

My personal memories of Williamson go back to the mid-thirties, when I would often see him outside our Yonge Street gallery, where he would pause and gaze at the pictures displayed in the windows, on his way to lunch at Bowles restaurant on Bloor Street West, and you could tell by the way he rocked his cane and cocked his head whether he approved of what he saw.

Another one of the original tenants of the Studio Building was Arthur Heming, who moved away in 1915 after a brief stay there. He took a studio on Asquith Avenue near Yonge Street and later, from 1934 until 1940, rented space in the Bay-Bloor Building adjoining the studio of Archibald Barnes, the portrait

painter. Heming was an aggressive little male popinjay who painted stagey northern wilderness landscapes with startled deer caught frozen in mid-air leaps, a Canadian Mountie in scarlet and gold encountering a surprised grizzly bear, or voyageurs paddling great freight canoes suspended on high waves running dangerous rapids, as well as other improbable subjects of the hinterland.

It is almost certain that Arthur Heming suffered an increasing colour blindness, and from 1933 on Barnes aided his colour selection. In the mid- and late thirties we showed a number of his pictures and sold some outright, and others for the reproduction rights to the Rolph, Clark, Stone printing firm for calendar purposes. In his own strange way at the time he worked out the prices of his pictures on a basis of sixty cents per square inch. Probably his compositions were visions dreamed up out of his head, or perhaps from northern images recalled from trips in the past. He was an autocratic and rather quarrelsome character, and hard to get along with, but one reason for this might have been the fact that he was suffering from lack of sales and money during those long, aching years of the Depression.

I think the first great aesthetic experience of my life was my introduction to the paintings of the Montreal artist, James Wilson Morrice, in the spring of 1934. It was one full decade since the artist's lonely death, on January 24, 1924, in Tunis, after losing his health and will to paint two or three years earlier. But for a few *cognoscenti*, his name was almost unknown in Canada. My father, who by chance had seen some of his paintings in Montreal and liked them, arranged to hold a large exhibition in 1934 in our new galleries, the first Morrice exhibition and sale ever held in a private gallery in Canada outside of Montreal. A small blue-covered catalogue was printed, listing the pictures and presenting a short biography of the artist. There were thirty canvases and panels and twenty-one watercolours, including some of his masterpieces, *The Ferry, Quebec*, and the original sketch study for it, and *Café el Pasaje, Havana*. I still retain in memory the first impact of those colourful, serenely beautiful works on our gallery walls, from the simplest watercolour to *The Ferry, Quebec*, both the original sketch and the canvas. What a marvellous thing this sketch is! Only the essentials are there. The little figures on the quay, waiting for the ferry to re-

8 James W. Morrice *Café el Pasaje, Havana* c.1915

turn across the St. Lawrence, lead one instantly into Morrice's special world.

Our connection with Wm. Scott and Sons, through the Morrice exhibition, and later an exchange of other of their artists, was the beginning of an important association we developed with other colleagues in our sister city of Montreal. There were, for example, the aforementioned Sydney Carter, the Johnson Gallery, William Watson, and the Stevens Gallery (Scott's short-lived successor).

Scott and Sons controlled the pictures still remaining in the Morrice estate, which together with works they already owned, formed a large and important collection. They had shown his pictures, perhaps only a few at any given time, since the late 1890s and were Morrice's exclusive dealers in Canada. A list of their customers read like a Who's Who of the Montreal elite. Besides Sir William van Horne's, they helped establish the Ross, Drummond, Shepherd, Hosmer and Greenshields collections. Their clients numbered in the scores; the wealthy English-speaking Montrealers, who, from 1895 to 1928, bought hundreds of paintings by artists of the fashionable Dutch Hague and French Barbizon schools.

The Morrice family itself had been for years an important part of this same establishment. David Morrice, eminent and wealthy father of James, was a native of Perthshire, Scotland, who arrived in Canada in 1855, and settled in Montreal in 1863. He became one of Canada's important businessmen as a successful textile manufacturer in the last quarter of the century. David Morrice was also a man who appreciated art, as his practical support of the Montreal Art Association showed, and as early as 1907, he presented an important canvas, *La Place Chateaubriand, St. Malo*, by his son, to the Mount Royal Club.

James Wilson Morrice was born in 1865, educated in Montreal, the University of Toronto, and Osgoode Hall. He possessed an early talent for painting and it wasn't difficult for him to convince his father that Paris was the place to go for the study of art. All through his life his father provided him with a generous income and left him a large sum on his death in 1914.

F.R. Heaton, who married William Scott's daughter, and followed Scott as head of the firm until his retirement in 1927, was a great admirer of Morrice and had a large personal collection of

his pictures. Many of those were early ones, reminiscent of the style of the French painter Henri Harpignies, Morrice's only acknowledged teaching master. Heaton's signature, and later his estate stamp, is often found on the back of the sketches and pictures he once owned. F.R. Heaton's son, John, was, by the mid-thirties, the owner of Scott and Sons, and came to Toronto for the opening of our Morrice exhibition and to help with sales.

He did not seem surprised at the lack of any, however, as there had been no sales in Montreal either. The exhibition was poorly attended, despite considerable advertising, and we even reproduced a photograph of *The Ferry, Quebec* picture in the then important publication *Saturday Night*, but with little effect. It is difficult to imagine now that the price of this masterpiece of Canadian art was $1,400, with no buyers or even a prospect in sight. With the deepening of the Depression people had no money available to buy pictures. There was one sale only – that, to Vincent Massey of three of the watercolours at a reduced price. Since the exhibition was almost a complete failure from a sales standpoint, the pictures were soon returned to Scott and Sons.

Nothing happened until 1939, when H.O. McCurry, Acting Director of the National Gallery of Canada, who had a sharp eye for both a good picture and a bargain, arranged for the gallery's purchase of *The Ferry, Quebec*, a Trinidad canvas, and two watercolours, all of which had been catalogued and shown at our exhibition. A year before, in April of 1938, in what was billed as Montreal's greatest art auction, and turned out to be its biggest flop, an event I well remember, Fraser Brothers sold under the hammer, in a public sale at the Windsor Hotel, the entire stock of Scott and Sons, including twenty-five Morrice oil paintings and watercolours. The prices were pitifully low, ranging from $60 to $1,250. Scott and Sons thereby effectively ceased to exist as art dealers. After the results of that disastrous auction the works of Morrice seemed to disappear from the market.

In 1935, I had met and become friendly with Newton MacTavish, author of *The Fine Arts in Canada*, the first comprehensive book on Canadian art, published in 1925. MacTavish was, I believe, Morrice's closest friend in Toronto, and they corresponded to some extent, although it was well-known that Morrice was not a great letter writer. Besides writing enthusiastically about Morrice,

9 James W. Morrice *The Ferry, Quebec* c.1909

MacTavish had had the foresight to buy some of his small pictures and encouraged his friends to do the same. One of his purchases was a view of the beach and ramparts at St. Malo, reproduced as the frontispiece to his book. He sold us this picture in 1939 for $50. Though not an old man at the time, MacTavish was not well, suffering from a killing form of palsy. He needed money and sold us other Canadian pictures from his collection, including two Tom Thomson sketches.

On MacTavish's advice, D.R. Wilkie, who was president of the Imperial Bank of Canada, had years earlier, in 1908, bought Morrice's *On the Cliff, Normandy*, probably direct from the Canadian Art Club's exhibition of that year. This painting remained in the Wilkie family until 1976. (The Canadian Art Club began as an ambitious organization of the leading painters of the day, but wisely invited other non-member artists to show as contributors. Many of these artists retained a high position in the community. Some of them like Homer Watson, Horatio Walker, and J.W. Morrice already had international reputations, having exhibited and sold their work outside of Canada, and in those days made a respectable living through the sale of their pictures.) D.R. Wilkie was invited to become honorary president of the club. Then lay members were elected, a list which included some of the most distinguished names of the Toronto establishment of the era. A photograph of a lost portrait of Wilkie by Curtis Williamson reveals something of the character of the man. He is wearing a high, starched white collar and holds a *pince-nez* in his right hand. The members believed his name would add to the prestige of the club; it did, and he bought pictures from their exhibitions as well.

Morrice was a generous contributor to all the Canadian Art Club exhibitions from 1908 to 1915, usually sending six or seven paintings. In 1909, he showed no less than eleven works, including *View of the Beach from the Ramparts, St. Malo*, by then already owned by MacTavish. These annual exhibitions were held on the second floor of the reference library at College and St. George Streets, the premises of what was rather grandly called the Art

10 James W. Morrice *Girl Knitting, Brittany* c.1900

46

Museum of Toronto. There were no good exhibition facilities in Toronto until 1918, when the Grange was enlarged, the first new wing consisting of three rooms. It was further enlarged and opened again in January 1926 as the Art Gallery of Toronto.

A special memorial exhibition of sixteen of Morrice's paintings was featured in that opening. This was the first major recognition of the artist in English Canada. I once asked MacTavish if Morrice ever complained of the lack of appreciation for his work in his own country. He told me that for Morrice, an extremely well-informed and sophisticated man, the recognition he achieved in Europe was far more important to him. For example, three panels I bought from John Nicholson in 1956, have labels on the back recording them as having been exhibited in the Champ de Mars Salon in Paris in 1899 and 1902. In a magazine clipping on the back of one, an art critic of the day, writing in the English publication, *Truth*, mentions the "excellent young Canadian painter, Mr. Morrice," whose pictures were hanging next to those of Mr. Henri Matisse.

It took a trip to New York in 1935, to see the van Gogh exhibition at the Museum of Modern Art, to make me realize what an impact modern art could have on so many people. Crowds were lined up, waiting to get in. As soon as I walked through the doors I understood why. I was overwhelmed by those pictures, by the brilliance of the colours and their strength and power. In the years since, I have seen many van Goghs at the Jeu de Paume in Paris and the Kröller-Müller and State Museum in Holland, always with wonder, but never with quite the awe of that first exhibition.

On this same trip I discovered some beautifully produced reproductions of Impressionist and post-Impressionist paintings. They were the results of a new German colour printing method called collotype, which used up to twenty and more different colour impressions for a single print. These reproductions were a revelation to me, as they soon would be for our Toronto customers. We negotiated exclusive Canadian selling rights with the publishers, the Hanfstangl firm in Munich, and over the next several years sold hundreds of them. Today, good Impressionist prints are commonplace but at the time the Hanfstangl reproductions were new, unique, and much admired.

We sold these reproductions, framed, at $12.50 for the

smaller, and $24.50 for the larger size. We also sold them to the University of Toronto for the original fine arts course that John Alford, a former student of Bernard Berenson, and recently arrived from England, had established. The sale of these prints contributed a modest boost to our income until mid-1939. Then we got a letter from Munich that ended with the salute "Heil Hitler," rather than the usual "Yours truly." We were not amused by what we considered a strange and ominous gesture, and ended our formal reply with "God Save the King!" That was our final business communication with the famous Hanfstangl firm. War broke out soon after.

One early exhibition, in January 1935, was certainly the most magnificent non-Canadian exhibition of paintings we ever held – the French Impressionist and Post Impressionist show. The pictures were from the collection of the world famous Durand-Ruel firm, the acknowledged first and original dealers in this school of painting. Some fifty pictures were on view including superb examples by Manet, Degas, Renoir, Pissarro, Sisley, Monet, and others. It included a Manet masterpiece of Madame Manet and two magnificent Renoirs, *La Chevelure* and *Femme Couchant*, which we proudly advertised as having been exhibited at the recent Chicago Century of Progress Exhibition. However, Toronto remained coldly indifferent to our newspaper advertising and other blandishments to tempt buyers. We sold two pictures only, an Alfred Sisley *Loing River* landscape, and a Eugène Boudin *Coastal Scene*, for a total of $3,000 to R.A. Bryce, the gold mining magnate who had just completed a new house in Rosedale. Herbert Elfers, the manager of Durand-Ruel's New York gallery came to Toronto especially for the show. He was a master salesman but his superior selling technique found little response here. In words and phrase I clearly remember he could describe a painting and make it seem more beautiful and desirable than in reality it was. Talking about a Renoir still-life, for example, he compared the colours to "translucent coral in the sea."

Later we had from Durand-Ruel paintings by the lesser Impressionists, Maufra, L'Oisseau, and Guillaume, but nobody wanted to buy them.

Such was the market for art in those Depression days.

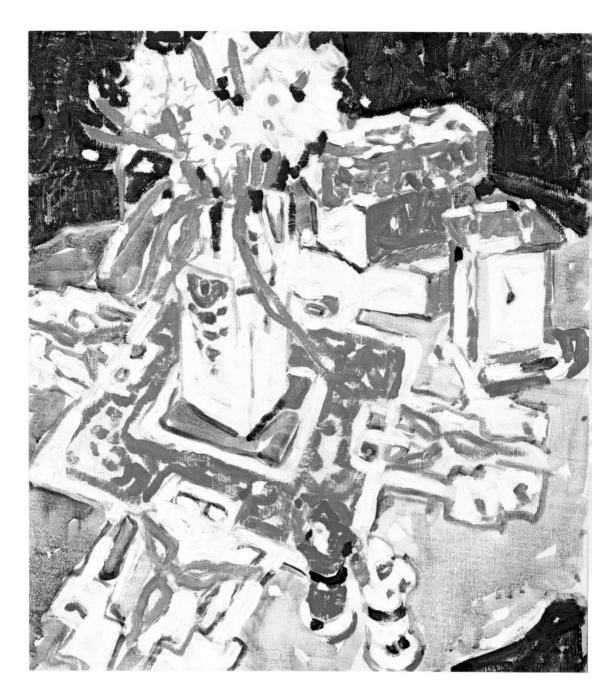

11 David Milne *Still Life, Lilies* c.1913

4

David Milne and the Massey Connection

The year 1934 turned out to be an eventful one in the life of our gallery. Among other things it was the year Vincent and Alice Massey invited us to hold an exhibition of paintings by an extraordinary Canadian artist they said they had recently discovered, David B. Milne. Actually, in a way, it was not the Masseys who discovered Milne, it was David Milne who had sought them out.

Milne for some time had cherished the dream of finding some rich and powerful patron, some twentieth-century Canadian version of a Medici merchant prince who had the wealth, taste, and desire to buy a significant collection of his paintings, and house them somewhere on permanent view. Milne always knew in his own heart he was a great painter, and at that time Vincent Massey, because of his money, position, and interest in Canadian art was his logical choice as a possible benefactor-patron. Milne wrote him a letter outlining his aspirations as an artist, and sent a large selection of his paintings to Batterwood House, the Massey residence near Port Hope.

Vincent and his wife Alice did everything together as a couple except when they bought pictures for each other as gifts, and on looking over the collection were delighted at the originality

and quality of the paintings and decided to buy some 250 works outright for cash, offering, on average, $10-$15 per painting. Milne, who was desperate for money, was glad to accept the offer. He may have sensed at the time it was a deal for posterity, and was confident that the Massey connection would be of great help to him. Ultimately, of course, Milne created a rendezvous with posterity in his own right through his art, but it would be many years after his death before this canonization would take place. The Massey purchase was probably the biggest deal, in terms of the number of paintings involved, ever made for an important Canadian artist, and nearly all were canvases from Milne's great painting years, 1928 to 1932.

I liked Milne's work from the first moment I saw it; it was fresh and original, but my father, for that very reason, was afraid that if an exhibition was held, it would be a failure. The paintings, he thought, were too modern for the public's taste, and he was right. However, the Masseys assured us they would send in their friends to buy, and some seventy unstretched canvases were selected from their recently acquired hoard and sent on to the gallery. They were placed on stretchers and framed in simple concave basswood frames, about three inches wide, and were soon all ready for the show.

This 1934 show was David Milne's first exhibition in a private commercial gallery in Canada, and it has since been hailed as an event of historical importance. My father dreamed up an eleven-word slogan, which was printed on the front cover of our catalogue. It read: "A fresh, buoyant, and mature interpretation of modern art in Canada" – a good statement about Milne any time, but especially apt looking back on Canadian art history from today's vantage point.

The prices of the paintings ranged from $20 to $150 each and although well advertised, the exhibition awakened no interest at all among our regular clients. The Masseys, however, were quite true to their word, and sent in their friends to buy. J.S. McLean, founder of Canada Packers, was one; he bought three, an acquisition which I believe was the very beginning of his Canadian collection. James S. Duncan (no relation to Douglas), then sales manager of the Massey-Harris firm, bought, as did Gerald Larkin, the Salada Tea Company owner, members of the Mulock and Caw-

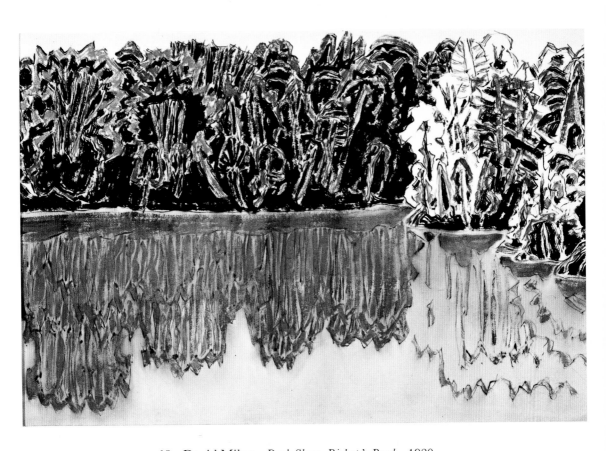

13 David Milne *Dark Shore, Bishop's Pond* 1920

the story went, to get away from his wife Patsy. In my eyes he did not look like an artist or act like one. He looked more like a chunky farmer, who wore steel-rimmed spectacles, enjoyed his pipe, and a quiet chat. He was a pleasant and likable man, both thoughtful and practical; he fully understood the role of good publicity and promotion in the selling of his work and also had his own well thought out theory of aesthetics on which he could be very articulate. For example, he had a theory that the use of spectacles interfered with an artist's vision.

It was Graham McInnes, then art critic of *Saturday Night*, who suggested I do a radio interview with him. Milne and I sat down and wrote out a script, questions and answers. I was the straight man. I remember how well, in his characteristically clear and lucid speech, he described finding a painting place and starting in to work. Here is an excerpt from our broadcast that Sunday afternoon in January 1938.

> B.L. Now, what about landscapes? How do you choose your landscape subjects, and how do you work on them?
>
> D.M. Many ways; sometimes I paint them from pencil sketches in the cabin, sometimes I paint them right where the landscape grows.
>
> B.L. Suppose I am the painter. How do I go about it?
>
> D.M. All right, you can be the painter. You gather your paint box and your easel and canvas, and start off in the morning. You aren't feeling any too good, you're thinking of your sins, or perhaps the sins of your neighbours. You pass slowly across the fields, seeing trees and fences and distant hills, but feeling nothing, interested in nothing, least of all in art.
>
> You move on across the fields, still searching; but, for a moment, art has brushed against you. You have, just for an instant, felt that electric thrill you have been seeking. On you go through field after field, rather more interested now, beginning to see things, a line, a colour, an arrangement. You come to another pond, deep in grassy banks, and as before a patch of flaming bush on the far side. This is your place. No wind will break this mirror today. You set up your easel and canvas and start to work – slowly, deliberately, even holding back.

You make marks on the canvas, noting the general arrangement of things. Up or down, this way or that. You see the broader worked-over spaces and blank spaces in your mind. Then you consider everything you intend to put in the picture, the shape of this tree or group of trees, of this contour or that. What you mark on the canvas is shorthand. You work forward and back, seeing each part not alone but in relation to the picture as a whole.

You open your paint box and start to use colour, you work more rapidly now, more freely without effort, without being conscious of it; and perhaps, if this is a good day, for half an hour you can do no wrong, things click into place and difficulties melt away. You are painting!

During the five years we held Milne exhibitions, I thought I got to know the man well, but I realize now, in retrospect, that I did not; I suspect few did.

He was born in 1882, the same year as A.Y. Jackson, in a log cabin near Paisley. His parents were impoverished farmers. As a boy, he was fascinated with art, and at the age of seventeen became a teacher in a one-room schoolhouse – not an uncommon temporary occupation for bright sons of poor parents in rural Ontario at the turn of the century – to earn a little money. At the age of twenty-two he managed to get away to New York, where he began to acquire some art training. Except for a short stint in the army, including four months as an official war artist, painting the aftermath of war on the Canadian battlefields of France, in 1918, and an unfortunate winter stay in Ottawa and Montreal in 1923, Milne spent all of his time working in the United States. There were the colourful cityscapes and interiors of the New York years, 1913, 1914, and 1915, and then the series of Adirondack oils and watercolours created during the later intervening years, ending when he abruptly decided to return to Canada for good in the spring of 1929, loaded with cases containing, so it has been said, hundreds of his works painted during those years. Milne finally moved to Palgrave in 1929, a village he called the "perfect place," where he settled down to three of the greatest painting years of his life and during which time, he wrote later, he never once left it.

In 1938 something surprising and dramatic happened in

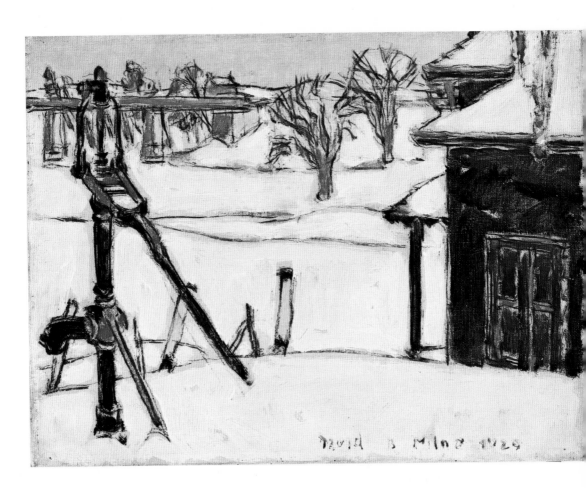

14 David Milne *The Pump, Weston* 1929

the life of David Milne. He fell in love. The object of his affection was a registered nurse, a young woman, twenty-eight years of age, by the name of Kathleen Pavey, whom he had met in Toronto and later at Six Mile Lake while she was vacationing with friends. Milne was then fifty-six, exactly twice her age. The young lady was no doubt charmed by Milne's personal magnetism, perhaps intrigued by the artist's strange solitary existence, and also impressed with his paintings. She told me later she had first seen his paintings at our 1934 exhibition and had also met Douglas Duncan and Alan Jarvis at the time.

When Milne moved to Toronto in 1939, he and Kathleen formed a strong attachment and she decided to throw in her lot in life to be with him. Kathleen insists that although twenty-eight years separated them in age she still felt they communicated as individuals of the same generation. Milne was never able to obtain a divorce from Patsy so there was no question of marriage to Kathleen, who bore Milne his only son, in 1941. They remained together until Milne's death in 1953.

After 1934, lacking Massey's active support, sales almost completely dried up; so too his work of the mid- and late thirties deteriorated in quality. Little 12 x 14-inch canvases, depicting lightning and thunderstorms, and studies of stars and constellations, like *The Big Dipper*, were nothing more than shorthand studies, and nobody was interested in buying them.

Our January 1938 exhibition, which was another financial failure, turned out to be our final one, although that had not been our intention. Sales, as I recall, amounted to only a few hundred dollars. This despite publicity through the radio broadcast, distribution of a small catalogue, with a reproduction of the little picture, *Water in a Jug*, on the front cover, and some newspaper advertising. When the out-of-pocket expenses were added up and deducted from the proceeds, as was done in our arrangement with the Masseys, there was little left for the artist. This was a deplorable situation, but we heard not one word from him expressing frustration or complaint. After all, near poverty was a state he had long been used to.

In early December 1938, we heard that Douglas Duncan was planning an exhibition of Milne's colour dry-points at the newly established Picture Loan Society. (This was organized by

Duncan and several associates in 1936, its function being primarily to rent out work of contemporary Canadian artists willing to allow their pictures to be shown on consignment.) I already knew the quality of these prints, as we had previously sold some to Milne admirers, and he had personally given me an artist's proof, *Queen's Hotel, Palgrave*, which I still possess. Even though the price of these dry-point prints was only $5 and $10 each, meaning the proceeds from any Picture Loan show were bound to be modest, Douglas Duncan had been successful in convincing the artist that he should become his agent and dealer, promising personal purchases and offering the incentive of a lower commission on sales.

At no time during the five years we were showing his paintings, did we have a verbal or written contract with either Milne or Massey, so Milne was perfectly free to do what he wished with his work. We returned all of his paintings save for two he had presented as gifts to my father and myself, and we soon lost touch with him completely, and he quietly slipped out of our lives. We never had a personal falling out with David Milne. We just drifted apart, aided by a nudge from Duncan. But the main reason we lost him was our inability at the time to sell his pictures. (As it turned out, Douglas Duncan was unable to promote sales any better than we, but Milne remained faithful to him and the Picture Loan Society until he died.)

Although I was unaware of the event until some years later, Duncan had earlier, in 1935, sought out the artist, having visited him at his Six Mile Lake cabin. Then, in 1936, I remember that Duncan's parents bought for their son his first paintings by Milne. Duncan was, at the time, living on an allowance from his father, the wealthy former president of the Provincial Paper Company, who lived in a mansion on Forest Hill Road. The three Duncans came into the gallery one Saturday afternoon, and were taken down to the basement by my father to look at the Milne canvases that were stored there. About half an hour later Douglas followed his father and mother back up the stairs, his face wreathed in smiles, and with one arm raised in triumph. He had succeeded in convincing them to buy for him two medium-sized canvases of the Six Mile Lake period. The price of those two pictures, as I recall, totalled $200. This was only the beginning of what would become his large collection of Milne paintings, from the New York and

15 David Milne *Queen's Hotel, Palgrave* c.1930

Adirondack periods, as well as many from the artist's later years. Duncan also accumulated a complete and unrivalled collection of Milne's delicate dry-point colour etchings. He was actually a compulsive collector of all kinds of pictures and ended up with well over one hundred assorted artists represented in his collection. Other than some truly great paintings by Milne, a large number of miscellaneous things by LeMoine Fitzgerald, purchased from the artist's widow, and a few other things of quality, the rest of his collection was an enormous conglomeration of non-art.

Duncan did become a dealer, after a fashion, but having been allowed enough money by his parents for financial security, had no need to depend on profits from sales of pictures, or picture rental fees, to live on. Then, after Milne's death in 1953, he assumed more or less complete charge of the pictures (in Milne's will the artist expressed the wish that his executrix, Kathleen, consult Douglas Duncan on matters pertaining to his pictures), and so Duncan became the sole arbiter in deciding which, if any, of the pictures should be destroyed because they were unfinished or poor in quality, and which should be allowed to reach the market place.

In his peculiarly personal and secretive way he took on this awesome responsibility. Some works, considered unfit or too slight for the market, were indeed tossed into the furnace, but a significant batch of watercolours, which Duncan apparently had rejected as inferior in quality, were rendered unsaleable by his defacing of the surface of the paper. As it turned out later, the Milne heirs found some of the pictures thus ruined to be good examples of the artist's work, but nothing then could be done to have them restored to their original state.

Gradually, as Milne's name became better known and finally famous, Duncan, late in life, became more and more sought after as a source for his pictures. It took a lot of patience to do business with Douglas Duncan; he would squat on his heels on the floor, puffing a cigarette, and with deliberate slowness, deign to show you a picture or two. There was always an excuse ready if, as it usually was, the painting you had most hoped to see was not available – "On exhibition," he would say, or "Not for sale just now." It was the ceremony of showing paintings Duncan enjoyed, not the actual sale itself. Sometimes he would not cash cheques for months on end, though on our purchases, he cashed them immediately.

To some people, Duncan's penchant for keeping un-cashed cheques and chaotic account books signified an admirable lack of commercial instinct. The truth was that he had no idea of business at all, and refused to trust anything to do with Milne to any sort of assistant, though he was forever complaining that he was overworked and couldn't handle all he had to do. After he died, in 1968, at the age of sixty-six, I often wondered how it was possible for anyone to sort out the Milne pictures in Duncan's estate let alone those he held on consignment from the Milne heirs. Predictably, Duncan left no will. The government and his heir, a sister, who had first choice of the pictures, finally sorted things out, in a way, and arranged an agreement whereby no succession duties were paid on the Duncan pictures on condition the works be valued and distributed to various galleries and institutions across the country.

When, in 1958, Vincent Massey, then Governor General of Canada, decided to sell his entire collection of Milne paintings, except those hanging in his own home, Batterwood, he got in touch with me. I suggested he put a price on the whole collection, and he arranged for Alan Jarvis, the great David Milne admirer and then Director of the National Gallery, to make an unofficial valuation for him.

An appointment to look at the pictures was arranged. I arrived at Rideau Hall in Ottawa, to be greeted by Massey's son Lionel, his *aide-de-camp*. (Vincent Massey himself did not appear at any time during the transaction; I expect he felt the Milne business too crass a matter for a Governor General to handle personally.) Lionel ushered me into an enormous ballroom, where spread upon the floor, unframed, and many without stretchers, were what seemed to me acres of Milnes. The paintings were from Milne's great painting years, from 1928 to 1932; several Adirondack pictures of 1928, work from Lake Timagami, Weston, and Palgrave, and also included were three lovely early Adirondack dry-brush watercolours. After looking over this unbelievable treasure trove, the major portion of Massey's original purchase from Milne in 1934, I asked Lionel what his father wanted for the collection. "Thirty-five thousand," he replied.

In the past Massey had always been a tough and canny buyer, who never hesitated to bargain and make counter offers. I

decided to try his own tactics and offered thirty-two thousand. Lionel looked distressed. Then after he had gone running back to another part of the hall to consult his father, we finally settled on thirty-three. I wrote out a cheque in Lionel's name (in accordance with his father's wishes), and proceeded to carry the paintings out to the car. The whole transaction, from the time I arrived at Government House until I left, had taken no more than two hours. There were 166 pictures in the collection, and no list of them existed at the time, nor did any kind of receipt pass hands to accompany the deal. The total cost averaged out to less than $200 per picture. The truth was that Massey had become tired of his David Milne collection and wanted to get rid of it. (In 1978, one of the paintings I had bought from Vincent Massey two decades earlier came up at a public sale. The price fetched for that one work exceeded what I had paid for the entire collection.)

In 1966, I bought from Vincent Massey an important J.E.H. MacDonald Algoma canvas and a large Quebec winter scene by Albert H. Robinson. At that time, I asked whether he would be interested in selling me his entire collection of Canadian art. However, this proposal was effectively scuttled by an individual, claiming, perhaps with some validity, that Massey had promised him one of the paintings I had already bought, and threatening legal action. When Massey asked for the return of the pictures, I refused, thereby cancelling any possibility of buying the Massey collection (or any further pictures from it). In his will Massey left the entire collection to the National Gallery of Canada.

Several weeks after our purchase of the Milne collection, in 1958, we held an exhibition in our galleries of about forty canvases selected from the recent acquisition. Douglas Duncan came in on the opening day to look at them and bought a large Palgrave Village street scene for $1,700 (now in the Art Gallery of Ontario), surely the most money he had ever spent on a single painting in his life. But he tarried a long time in the gallery and became so miserable and depressed on seeing all the magnificent Milnes that had eluded him, that my father took pity on the man and escorted him to Diana Sweets to calm him down with a milkshake.

When Vincent Massey's long term as Governor General expired in 1959, Lionel was out of a job, but his father secured for him a high administrative position at the Royal Ontario Museum. One day, towards the end of September 1963, Lionel called me to

16 David Milne *Sky Patterns, Palgrave* c.1931

say he had some pictures by David Milne he wished to sell. Would I come to his office and look at them? But a strange thing happened on my way to the museum. While crossing the street by the Park Plaza Hotel, at Bloor and Avenue Road, I spied the tall figure of Douglas Duncan ambling towards the museum. Apparently Lionel had called him too. But when Duncan saw me, an embarrassing moment for both of us, as we were both in pursuit of the same paintings, he did a quick double-take, wheeled in his tracks and disappeared, and so, by this surprising manoeuvre, or possibly thoughtful action towards me, ruled himself out as a possible purchaser. But it was a quirk in Duncan's nature that denied him any pleasure in competitive bidding. I went on to the Massey office and it took but a few minutes to conclude a deal. Lionel liked to work on a first-come, cash basis.

It is hard to realize now that Milne was virtually unknown to the public in the fifties, and his pictures had little value and were difficult to sell. In 1958, five years after Milne's death, we were still selling large watercolours for as little as $175, and up until 1964, the highest price we received for the finest and largest oils was $3,000, while the average price was less than one half of that. Any sales that were made went to a tiny band of his followers, as speculators in Canadian art were unknown in those days. Suddenly, in the mid-sixties prices began to soar. A lot of money was being made at the time by land developers and other entrepreneurs, who were intrigued by the possibilities of investing their money in Canadian art. Gone were the days when people bought for pleasure; a new group of collectors appeared, gobbling up the market. The advent of the large international auction houses in Toronto and Montreal in the late 1960s took the process a step further, bringing Canadian pictures to the highest commercial market place.

The grand total of Milne's estate added up to slightly more than $26,000, inclusive of $15,000, filed in an affidavit for probate in April 1954, as a valuation for all his pictures.

I don't know how many paintings actually remained in the estate, and I am sure that information will never come to light. However, had it contained five hundred works, perhaps a fair estimate, the amount would have worked out, in 1953, to approximately $30 per picture. Today, over twenty-five years after the artist's demise, these pictures would have a value in the millions of dollars.

5

Tom Thomson
and Dr. MacCallum

Toronto could never have become the centre for painting it did without the dedicated support of a few men like Dr. James M. MacCallum. It was Dr. MacCallum, along with Lawren Harris, who provided the personal enthusiasm and practical effort that made Toronto the Mecca of the unique movement that was to culminate in the founding of the Group of Seven. Just about that time (1912-13) Dr. MacCallum was busy buying the pictures of his two favourite artists, J.E.H. MacDonald and Tom Thomson, and helping A.Y. Jackson with his living expenses.

I met Dr. MacCallum for the first time in 1935 when he was seventy-five. I had heard about him through Thoreau, J.E.H. MacDonald's son, and through my new friend Curtis Williamson, who a year or so later painted my portrait and also talked about the Doctor, having painted two characteristically dark-toned but fascinating portraits of him years before, towards the end of the First World War, when Williamson still had a studio on the third floor of the Studio Building.

At the time, Dr. MacCallum had an office with a comfortable waiting-room on the sixth floor of the Medical Arts Building at St. George and Bloor Streets, where he still attended some of his older patients. He was the sort of doctor patients depended on,

sometimes abrupt but always decisive. Though short in stature his was a formidable presence. Mrs. Coulter, an Englishwoman, his secretary-nurse at the time, was completely intimidated by him. But she was not the only one to suffer from his pique. In 1937, C.B. Piper, a feature writer for the *Toronto Telegram*, asked me if I would arrange an interview for an article he was doing on Thomson. The two of us duly called on the Doctor, who was courteous and generally informative. But when asked about the circumstances surrounding the death of Tom Thomson, especially if he felt it was a murder or an accident, he became very emotional and snapped, "There was air in his lungs, not water"; he quickly rose from his chair, turned white, looked grim, and announced abruptly to the reporter that everything he had said was completely off the record. The Doctor was upset, I was embarrassed, and Piper was shaken.

Dr. MacCallum always refused to speak of Tom Thomson's personal life. I broached the subject on several occasions and every time he replied, "I'm busy now," and that ended it. It was as if talking about the man himself was too painful a subject to speak of or even think about.

His short temper showed in other ways too. Several months after our Tom Thomson exhibition, in March 1937, he loaned me six or seven sketches to sell. I mailed him a receipt, listing the pictures as "on consignment," but when I called on him a few days later he stormed at me, "Don't you think I know what 'on consignment' means?"; and then composed himself. I never did find out exactly what was behind this querulous challenge. Perhaps his intention was that I should have bought the pictures outright and paid for them immediately, as his price to me was only $150 for each sketch. Maybe the doctor was suspicious of business deals, but he had a very sharp mind and possessed a strong sense of propriety. I expect he merely wanted to let it be known that he was not about to be taken in by any young picture dealer's nonsense, but I was innocent and my motives pure and I am sure he knew that was the case too. Later he did let me have another group of sketches and one larger painting on canvas-covered board, *After the Sleet Storm*, to sell. To the best of my knowledge, I was the only person ever to whom he sold any of his personally-owned Thomsons.

Another sketch from the Doctor, *Maple Saplings, October*, we sold in 1938 to Mrs. Alan Plaunt, later a trustee of the National

Gallery, and another, *The Poacher*, we sold in the same year to Dr. G.H. Henderson of Halifax. I was able recently to buy back both of these.

All in all the Doctor was a fascinating non-conformist character and a visit to his office was always a rewarding experience. There, hanging on the walls of his waiting-room, were four lovely Tom Thomson canvases: *Snow, October*; *The Pool*; *Petawawa Gorges*; and *Birches*. The four are now in the National Gallery of Canada, as part of MacCallum's great bequest to the nation on his death in 1943. The Doctor never grew tired of talking about Tom Thomson's paintings. He particularly liked to discuss the mood of his work, how it related to weather and atmosphere, the moonlight scenes and star-filled skies, and the solitary moose or deer drinking at the edge of a lonely lake. The Doctor responded intuitively to the nature that Thomson made his subject matter, much more so than to the work of any of the other artists he came to know so well. In general he preferred the less brilliant paintings, and his personal collection had more sketches in the muted colours.

The Doctor could be highly critical too, as when he spoke of one of Thomson's larger canvases, a vertical composition with several deer, their forelegs folded under, resting on the ground in a woodland clearing. In mock disparagement, he told me he had said to the artist, "Those damn deer just don't look right in that picture," and he was right. (Years later we had this painting, which George Thomson titled *Springtime Decoration*, for sale from the Thomson family. Somehow the deer had mysteriously disappeared from that little clearing and the foreground was now empty. Studied closely, there is evidence of the elimination of the deer in a slightly different texture to the paint where they appeared in the original composition. In 1959, Lord Beaverbrook bought it from us for the new public gallery in Fredericton, his gift to the people of New Brunswick.)

Dr. MacCallum lived in a large brick and stone house on Warren Road south of St. Clair Avenue. Here on the walls hung dozens of Tom Thomson's little panels, nearly all in narrow black wooden frames. Others were kept unframed in cupboards and drawers. The house was a fine one, built about 1908, but the windows on the ground floor consisted of small, leaded panes, some clear, some coloured, so that the rooms were dark and it was

18 Tom Thomson *Maple Saplings, October* c.1915

difficult to see the paintings properly in the poor light. But it was here that I saw for the first time the sketch, *West Wind*, to me one of the most striking small landscapes ever painted by any artist, Canadian or otherwise. One day I asked him if he would consider leaving it to me in his will, as a legacy. He nodded and smiled, in his most benign manner, and I thought that the answer was Yes. I think he forgot all about it, though; his will directed that his entire collection, of over eighty sketches and canvases by Tom Thomson, as well as the many other Canadian pictures he possessed, was to go to the National Gallery. (It is interesting to note that there was only one Lawren Harris sketch in the MacCallum estate. The reason, I suspect, was that Harris, being a rich man himself, needed no buying support from the Doctor.) The first director, Eric Brown, had shown interest in Tom Thomson and had bought three important canvases from the artist in 1914, 1915, and 1916, and H.O. McCurry, the second director, continued his predecessor's interest. The Doctor's will did direct that each of his two sons have the choice of a canvas and a sketch. Arthur MacCallum chose the *West Wind* sketch and the canvas *Moonlight*. A.Y. Jackson, asked to make a choice on behalf of Dr. Fred MacCallum, who lived in England, took *Hardwoods, October* and a sketch.

A short time later, the *West Wind* sketch was offered by Arthur MacCallum to the Art Gallery of Toronto for $500. For some unfathomable reason the purchasing committee of the time passed it up, and it was acquired by J.S. McLean, chairman of the committee and the president of Canada Packers, who had recognized its quality immediately. Of course the gallery already possessed the large *West Wind* canvas, bought and presented by the Canadian Club in 1926. But in 1943, while the war was still on, funds were limited and the committee must have felt it wiser to save for future opportunities – an incredibly short-sighted decision. Many years later, however, in 1969, the *West Wind* sketch passed to the Art Gallery of Toronto as a bequest, along with other pictures from the McLean collection.

When we decided to assemble a comprehensive Tom Thomson exhibition in 1937, the diamond jubilee of his birth, I naturally turned first to Dr. MacCallum, as one of the two most important owners. We knew there would be little or nothing for sale but hoped some pictures would come on the market later. The

next step was to approach the other major owner, the Thomson family, the head of which was George Thomson, Tom's eldest brother, then living on Eighth Street East in Owen Sound. George being completely co-operative, there remained the task of locating the other canvases and sketches.

At that time this was easy. Apart from those in the National Gallery, MacCallum's collection, and the Tom Thomson estate, pictures of his were owned by only a handful of people, mostly fellow artists and their close friends. Everyone lent gladly, and among them were Walter Laidlaw, the Toronto lumber tycoon; Newton MacTavish, former trustee of the National Gallery and author of the first comprehensive book on Canadian art, published in 1925; Sir Frederick Banting, the amateur artist, great scientist, and painting companion of A.Y. Jackson; Taylor Statten, founder of Camp Ahmek in Algonquin Park, who also knew Tom Thomson and Frank Carmichael and J.W. Beatty, both painting friends of the artist. (J.W. Beatty once told me, with immense pride, that he was the one who had carried the large stones up the hill that were used to build the cairn at Canoe Lake, erected in memory of his friend, Tom.) Yvonne Housser, the recent widow of F.B. Housser, who wrote the first book on the Group of Seven in 1927, lent us the moody but magnificent sketch for *Chill November*. Another lender was Dr. Harold M. Tovell, a well-known physician and connoisseur who, using foresight, had negotiated the deal in which the Canadian Club bought the *West Wind* canvas and presented it to the Art Gallery of Toronto. My old Victoria College don, James S. Lawson, lent us five paintings, including two canvases.

I knew that twenty years earlier, in 1917, Dr. MacCallum had published an eloquent tribute to the memory of Tom Thomson in *The Canadian Magazine*, and he granted us permission to reprint a portion of it for the foreword to our catalogue. We also needed some publicity, as the public of 1937 had virtually never heard of Tom Thomson. There were no good colour prints of his paintings available, and only two little books about him, by Blodwen Davies, published in small editions. We decided that a talk about the artist over the radio might be effective, and so we bought fifteen minutes' radio time on CFRB for Sunday afternoon, March 14, 1937. I am told this was the first commercial radio broadcast ever made in Canada to publicize the work of a Canadian artist.

I tried to be informative, speaking of the life and work of the artist, the mystery of his death, and the development of his style to the final flowering of his genius in the last three years of his life. "In five short years of painting," as I said in opening, "for that was the limited span of his artistic life, Tom Thomson left a legacy to Canada the full significance of which we are only beginning to know, and which will grow for succeeding generations."

We offered to mail our catalogue free of charge to anyone who wrote in. The catalogue was twelve pages long and had two beautiful colour reproductions of Thomson sketches. (In 1977, I noticed one of them listed for sale in a rare bookshop for $12.50.) The broadcast must have had an effect, as several hundred people requested the catalogue.

The broadcast succeeded in attracting to the exhibition the usual curious types, most of whom had never heard of Tom Thomson but were intrigued by the story of his life and wanted to see what his pictures looked like. Numerous artists came to the opening, along with writers and poets, and a smattering of students and professors from the university. The most interest, by far, was generated among the lenders and their friends, many of whom came in several times to see the show. Since it was only two decades after the artist's death many of the lenders had known Tom Thomson personally, and as there had been no important Tom Thomson exhibition in the intervening years this was an occasion that owners and admirers of his work had been waiting for.

The artistic impact of the exhibition was dynamic and cumulative, and visitors were enthralled by the mood and the depth of his painting and revelled in the wide range of his work in this large and stunning show. All together there were ninety paintings on view but we had only three sketches and one watercolour for sale; the price of each oil sketch was $200 and $100 for the watercolour.

We later handled and sold for the Thomson family every one of the pictures remaining in the estate, consisting of some eighty sketches and fifteen canvases. (The total known number of his canvases, large and small, is hardly more than forty.) The profits we made from the later sale of these pictures went into the solid commercial foundation of our slowly growing business.

One day my father said to me, "You know, Blair, you

19 Tom Thomson *The Poacher* 1915

will see the day when one of these sketches will be worth at least $1,000." Charles Hendry, a former Dean of Social Studies at the University of Toronto, records in a privately published essay that my father sold him a sketch in 1941 for $300, payable at $10 per month with no interest. During the forties prices were stable, at $300 for a good one. By 1954, it was $500. On September 7, 1956, Robert McMichael bought a sketch, *Pine Island, Georgian Bay*, for $1,000. It was his first Tom Thomson acquisition, and he tells the story of how he and his wife Signe sat down and wrote out ten post-dated cheques for $100 a month to pay for it. I was present on that occasion and still retain the original invoice. The painting now hangs proudly in the Kleinburg collection. Prices of the sketches remained at $1,000 until 1960, and by 1963 were only $1,500.

Tom Thomson himself made several important sales of his larger canvases during his lifetime, but in general money was of little interest to him. In an article in the November 1917 issue of the University of Toronto publication, *The Rebel*, J.E.H. MacDonald estimated that in Tom Thomson's short painting life he had left over 300 pictures and sketches. There are probably more. Since 1937 we have handled some 125 of his works, including seventeen canvases and up until the mid-1950s we always had several sketches for sale, and sometimes even a canvas. Some of them were dramatic discoveries.

One sunny morning, early in March 1941, after a snow-storm, when the snow was piled high on either side of the highway and driving was difficult, I made a journey I thought was merely another pleasant visit to Owen Sound to see George Thomson.

Early in 1936, George Thomson had wanted a Toronto gallery in which to show his landscapes, and approached us; we talked it over, came to an agreement, and went on to hold annual exhibitions of his work for the next fifteen years. He gradually built up a group of his own admirers, who bought his pictures because they liked them, not knowing or not caring that he was Tom Thomson's brother. Prices for his paintings ranged from $35 to about $200, the total sales averaging at the most in any one exhibition from $2,000 to $3,000. Our profit was one third of the selling price and was a welcome addition to our meagre income in those days.

Born in 1868, one year after Confederation, George

Thomson was nine years older than Tom. An amateur painter for many years, in 1926 he made the exceedingly courageous decision to take up painting as a full-time career; moreover, he succeeded. Returning to the Georgian Bay district of his boyhood (he had been a secretary to a social club in Connecticut for many years) he was soon able to sell enough paintings to live on the proceeds alone.

In Owen Sound, George and his wife lived in a modest brick house on the side of a hill. George's studio, formerly the parlour, was a small room on the ground floor, facing north, and here he worked away assiduously, painting up his spring and autumn sketches into larger works. There was a sizeable garden, and like so many people of modest means in the towns and small cities of Ontario, especially then, the Thomsons grew their own vegetables and fruits for preserving. I have never met a kinder, more generous, and hard-working person than Mrs. George Thomson, and her husband was "a gentleman of the old school." To his great and lasting credit he never traded on his brother's name.

He corresponded in longhand, in the most beautiful copperplate handwriting, learned in his early business college days. He was also handy with tools, and made up all his own cases for shipping pictures. Over several years he sent us, in these small wooden cases, batches of Tom's magnificent 8½" x 10½" panels. He lived on into his ninety-seventh year (1965) and every year until near the end of his life sent us a handwritten Christmas card with one of his soft landscapes reproduced in colour.

It was only with some reticence that George Thomson would speak of his brother Tom's pictures, or of Tom himself for that matter. Did he realize their talents were not equal? I don't know for sure but in retrospect I don't believe he had any special feelings for Tom's paintings at all. His approach to his brother's work was casual and he paid no homage whatsoever to Tom as an artist. More important, perhaps, he was totally absorbed in his own work. Nevertheless, I did have the feeling he had been extremely fond of Tom, though because he had lived for so many years in the United States, George had seen little of him before his death.

I return now to that day in March 1941. After lunch, when the business connected with George's own forthcoming exhi-

bition was finished, I screwed up my courage to ask him if any of Tom's canvases still remained in the family. "Yes," he replied, rather unenthusiastically, adding that two of them seemed unfinished and the others were not very good. I asked if I could see them anyway, and he took me upstairs to the attic. I am sure he had not looked at these pictures for years. There they were, unframed, stacked against the wall in a corner, as one would cast aside things of little interest. As usual in Tom Thomson's case, all the paintings were unsigned. Collecting my wits after the initial thrill of discovery, I managed to convince George Thomson that the large canvases were finished enough to sell and would in no way reflect poorly on his brother's reputation as an artist. I also told him I liked the others as well, and much to my delight he let me have all six for sale at extremely modest prices.

The largest was the now well-known *Birch Grove, Autumn*, a late canvas presently in the Art Gallery of Hamilton. We sold it to the Hamilton Club in 1943 for $5,000. This painting is 40″ x 46″ and depicts the Algonquin hardwoods in the colours of high autumn. When it was hung at the Club this picture created serious and acrimonious arguments among the members, many objecting strenuously to its vivid colours and bold design. George Thomson, on his part, had been convinced that the foreground, with its large semi-rectangular rock forms, was unfinished; he did not think the picture should be placed on the market at all. Then there was a small brown and golden-coloured canvas, an early, rather dull, but well-painted work, with a tree branch curving gracefully over the edge of a brook. This was *Woodland Stream*. The third was a large canvas, called *Maple Saplings, October*. It is a rich and powerful painting, the sketch for which I had bought from Dr. MacCallum three years earlier. There were also three smaller canvases: *Early Snow*; another lovely small vertical, *Autumn*, which later changed hands twice before being presented to the McMichael collection in 1976; and *Sleet Storm in the Cedar Bush*, a muted but magnificent work of 1915. Tom Thomson liked the upright motif, and many of his canvases are almost square or vertical.

I had a new Nash automobile at the time, with a rear seat that folded back flat to make a platform wide enough for a bed. This accommodated the six canvases nicely. I drove home through a fresh blanket of snow, excited and happy about what

20 Tom Thomson *Blueberry Bushes, October* 1916

was the greatest find of my life, up to that time. However, it was going to take some time for me to realize the enormous significance of my discovery.

I believe it was through Blodwen Davies, a friend, and the author of the first book on Tom Thomson to deal with the circumstances of his mysterious and tragic death, that we originally heard of Thomson's friend, Winnifred Trainor. We rightly surmised that she had some Thomson paintings, and although we always hoped that she would one day decide to sell the pictures Tom had given her, that hope was never realized.

In conjunction with a fishing trip to the Huntsville region in the summer of 1937, my father called on her. She lived quite alone in a small frame house just off the Huntsville main street. My father noticed that there was not a single picture by Tom Thomson hanging in her house. To the enquiry as to whether she had any Tom Thomson pictures, she replied that she did, but that they were stored in the bank vault in town, and none were for sale. His curiosity awakened he enquired if he could see them. "Yes," she said, and together they went to the bank where she brought out of the vault a brown cardboard carton, about twelve inches deep and eighteen inches wide, tied with ordinary brown cord. The pictures were packed vertically in the box, side by side, lying like slices of bread. All except two were framed in plain brown-stained frames, one to two inches wide. Two of the oil sketches, as I recall, were unframed. After a cursory examination, my father asked again if she would care to sell them; again she declined firmly. Finally, he asked if perhaps she would like us to store them for her in our galleries in Toronto. Relying on an intuitive trust of my father she quickly accepted the offer. He wrote out a receipt and returned to Toronto with the pictures.

The carton of sketches was first kept in our Yonge Street galleries and then put into storage during two subsequent moves, to Bloor Street East, and finally to our present location on Bloor Street West. For over twenty-four years, until Winnifred Trainor died, in 1962, we kept that little carton, containing the oil sketches, tempera paintings, and one watercolour. We received brief letters from her from time to time, and at least once a year she travelled by bus to visit us, on her way to New England, where a sister lived.

Throughout those twenty-four years she never once asked to look at her pictures. She had probably packed them away shortly after Tom Thomson's death, and never set eyes on them again. In the bank, when she originally turned them over to my father's care, she barely glanced at them. It was as if a part of her life was stored away in that little carton of pictures, suggesting a time she had no wish, or dreaded in her heart, to relive.

When I first met Winnifred Trainor in 1938, she was in her mid-fifties, a medium-tall, grey-looking woman with a roundish face and hazel-grey eyes. She may have been quite handsome, if not very pretty as a girl, and there are snapshots, probably taken by Tom Thomson in the summer of 1913, that show strong, even features and a simple, quiet bearing. She and Thomson must have been on a fishing expedition together, as she is proudly holding a string of fine trout in one hand and a fishing rod in the other. In the long white skirt of the time, with a high collar circling her neck, she looks happy and dressed more for a picnic than a fishing trip.

As the years went by Winnifred Trainor became more formidable in her bearing and more withdrawn in her ways, but she was always hospitable towards us. I visited her in Huntsville several times. We had a most friendly relationship and nearly every summer she would invite my wife and me to use her cottage at Canoe Lake – an invitation we never got around to accepting. She talked very little, and never about art, her own life, or the unexplained story of her relationship with Tom Thomson. There is also no evidence that she knew any of the other artists of the time. Her visits to our gallery were social occasions and she never bothered to look at or even comment on any of the pictures hanging on the walls.

The real tragedy of Winnifred Trainor's life was not the loss of her beloved Tom Thomson but the bitterness that saturated her life afterwards. She was quick to feel slights and hurts but kept them all bottled up in her heart. As the only so-called love of the artist's life she too became part of the growing legend; but she could not cope with a society that regarded her with indifference, as if she were a total nonentity. But, after all, she was not Thomson's wife.

In the Trainor collection there was not a single picture

painted after 1914. Why were there no paintings of 1915, 1916, or indeed of the early spring of 1917? There is, I think, a tempting and logical explanation: Winnifred Trainor saw little of Tom Thomson during the last years of his life, and he was no longer, if indeed he ever was, in love with her. If he had been visiting her regularly in Huntsville, certainly he would have given her some of his late sketches. He was known to be an extremely generous man, especially in gifts of his pictures. Winnifred Trainor herself, late in life, insisted darkly that there had never been a rift between them, but this sounds like the wishful retrospection of a woman who felt herself cheated – and maybe she was. One could speculate on the tragedy indefinitely; but one thing I know with certainty, and that is that both she and Dr. MacCallum were convinced that Tom Thomson came to his end by foul play.

Immediately after her death, we received a letter from her lawyer in Huntsville, who had found among her papers my father's handwritten receipt for the pictures, asking if they were still there. Around the same time, I received two or three garbled anonymous telephone calls from Connecticut enquiring if we had any Tom Thomson canvases for sale. I had a suspicion that the calls were an attempt to find out about the Trainor pictures. Her relatives could not wait to get their hands on them, as by then they knew they were becoming valuable.

On the lawyer's instructions we turned over the old cardboard box to the inheritors. We received no thanks and no acknowledgment that we had stored and insured the pictures, at no cost whatsoever, for all those years. One of the beneficiaries was especially hostile, highly disappointed, and suspicious because there were no canvases in the collection.

Because of war, it was almost impossible to sell anything. The situation was the same all over Canada. On April 8, 1943, we wrote to Lawren Harris in Vancouver, offering to send to the Art Gallery of Vancouver a group of five late Thomson sketches on approval for possible purchase, at $300 each. Harris, who by then was firmly settled in Vancouver, and a member of the purchasing committee, wrote back on April 19 that, "the gallery has a fund for the purchase but the treasurer has it tucked away until the war ends." And that was that.

In the same year, we bought the canvas, *Moonlight*, from

Arthur MacCallum and sold it a little later to Dr. G.H. Henderson of Halifax. Dr. Henderson, a distinguished physicist, then working on secret war-time projects for the Royal Canadian Navy, made frequent trips to Toronto during the Second World War. In the spare time left from his high priority war work he bought other fine pictures by Tom Thomson, J.E.H. MacDonald, Harris, Jackson, Beatty, and J.W. Morrice. He also had lovely, previously acquired Morrice paintings from Scott and Sons in Montreal. *Moonlight* remains in Nova Scotia, one of only two Thomson canvases in the Maritimes.

It was no surprise to me that the entire MacCallum collection went to the National Gallery, and his son Arthur said that "the family were not among the favoured few." The Doctor himself told me he had no intention of leaving any pictures to the Art Gallery of Toronto. He had an implacable dislike of this gallery as an institution, and was vehemently vocal about it. He considered it a personal slight to the genius of Tom Thomson that the gallery had neglected his work for so long. It was a pity, but probably in his eyes a deserved punishment, that Toronto should lose the work of the painter who inspired the movement that originated there.

21 Lawren Harris *Arctic Peaks, North Shore, Baffin Island* 1930

6

Lawren and Bess Harris

As a boy in the late 1920s, I was fascinated to see at some exhibitions of Canadian art, enormous canvases of the Rocky Mountains and especially of the north shore, Lake Superior, that wilderness of desolate and burnt-out forests, bare stumps, and rolling treeless hills. These paintings were bare and stark and conveyed an inner force, something primeval. They were paintings by Lawren Harris. The idea never crossed my mind at the time that one day I would be selling them. His work was entirely different from that of the other members of the Group of Seven, and was among the most powerful and compelling painting ever before done in Canada.

Unlike most other artists of his time, Harris, because of family connections to the Massey-Harris firm, was a wealthy man. In early 1916, he joined the army, and was commissioned a lieutenant in June, before being sent to Camp Borden to take over the unlikely job of musketry instructor. There is a photograph of him, standing at ease in an officer's uniform, that makes him look handsome, cocky, and proud. In those years, all young officers of the Canadian army were proud to be in the service of King and country – an emotion then called patriotism. Harris hated army life, though, partly because it left him little time to paint. He was heartsick about the war, having suffered the loss of his brother, who was killed on the Western Front. Also he was unwell and he

finally got a discharge on medical grounds.

In the spring of 1918, hoping to regain his health, he went with Dr. MacCallum on a trip to Georgian Bay and then northwest on the Algoma Central Railway to Lake Superior. The Algoma district was a new wilderness country for artists and Harris was so enthralled by it all that in September of the same year he arranged the first of the celebrated railway boxcar trips. He, J.E.H. MacDonald, and Frank H. Johnston and the Doctor, travelled to Algoma in a work car fitted out with a kitchen and sleeping bunks. That historic journey produced magnificent paintings by all three artists. (J.E.H. MacDonald wrote lyrical descriptions of the Algoma and Lake Superior country in letters to his wife.) Harris and MacDonald made the trip again in the autumn of 1919, with A.Y. Jackson, who by then had returned from France.

The sketches Harris produced from his Algoma trips remain among the finest things he ever did. His technique was by then mature and his palette ranged from the pure, bright colours of sunny autumn days to the more sombre but still translucent effects of dull and rainy weather.

Harris was, among other things, an excellent portrait painter, one who got through to the spirit and character of his subject. Although his portraits were few in number – he did only eight – he was probably as good as or a better portraitist than Frederick Varley. Harris's first portrait was completed in the spring of 1920, a study of a Mrs. Oscar Taylor, a handsome young Toronto matron, seated in a wooden chair with a curved back, beside a carved oak chest. Mrs. Taylor, a young widow, was an active Christian Scientist, as was Harris's strong-willed mother, and much interested in the contemporary art scene. His painting of that fierce-eyed socialist Methodist minister, Dr. Salem Bland, is a powerful and revealing work. So, in a different mood, is the portrait of my revered former professor of English at Victoria College, John D. Robins.

According to John Taylor, it was at his mother's north Toronto house on St. Clements Avenue, in 1920, that Lawren Harris met the charming and beautiful Bess Housser, a woman who would threaten Harris's marriage and change his life dramatically.

22 Lawren Harris *Autumn, Algoma* c.1919

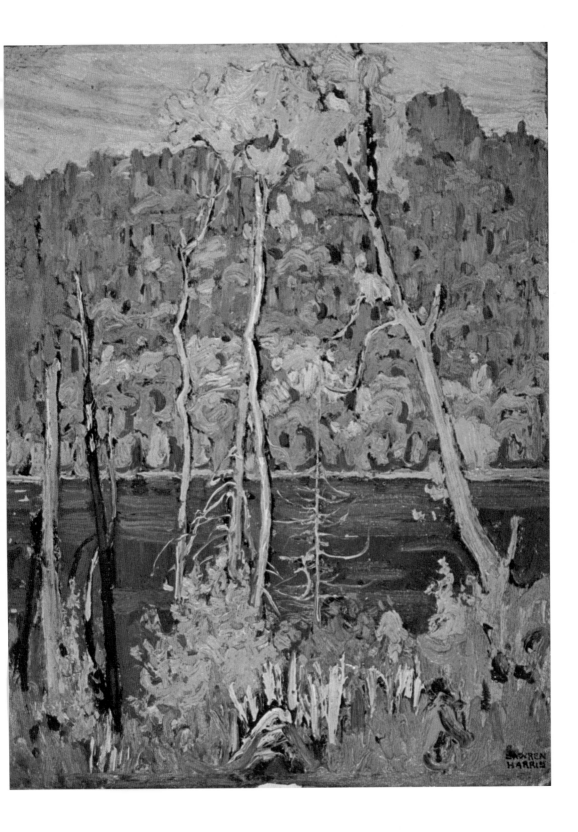

Bess was married at the time to F.B. Housser, writer, newspaperman, and later, in 1926, author of the first book on the Group of Seven. She herself painted, and the Houssers often entertained a coterie of Toronto artist friends. In those days Bess was a beauty, as she was handsome in later years, and elegant and vital in old age.

Late in 1920, Harris began a large portrait of Bess, at the Studio Building. After each sitting, he would attentively escort her through snow and slush to the nearest streetcar stop on Yonge Street. But what began as infatuation, and inevitably deepened into love, caused these two to become the objects of mischievous gossip, both from within and outside of their own little art circle. After all, the two lived in a city that was intensely conservative and still mid-Victorian in its social attitudes.

For almost fifteen years, this cruel and senseless vendetta against them continued and it reached the point where the city became unbearable for them to live in.

When I first met Harris it was in the late summer of 1934, when he must have been contemplating leaving Canada for good to be with Bess. He was at his easel in his studio on Severn Street, working on a large painting, which I now know as *Winter Comes From the Arctic to the Temperate Zone*. This was the beginning of his semi-abstract period, which, in retrospect, was a logical continuation of the paintings from sketches and drawings he made during his two-month trip to the Arctic in the late summer of 1930, on the government's Arctic supply ship *Boethic*. The paintings of icebergs, with their cold blues and stark whites, the semi-rounded mountain forms, and the green-blue water give a highly dramatic realism to the cold, bleak eastern Arctic, yet the general effect is significantly abstract. (It was typical of Harris to go on to new phases without referring to earlier painting periods. Only near the end of his life, in the 1960s, did he attempt to "look back," by working up some of his early Algoma sketches into large canvases; the result was stilted and unsuccessful.)

A distinctive looking man, medium-tall, lean and austere, he was then forty-nine or fifty years of age. He had abundant hair, almost white, and he combed it straight back, high on his head. He was quietly courteous but somewhat reserved, and I could see he was anxious to get on with his work. He impressed me

immediately as a man with tremendous drive and vitality, in pursuit of his life and his art.

I quickly came to the point of my visit. Our recently established gallery was interested in promoting the work of the best Canadian artists of the day; we wanted some of his sketches and canvases for sale and exhibit. I stressed my interest in his work. Harris, who it turned out already knew who I was, seemed slightly taken aback that anyone, apparently including an aspiring young art dealer, was interested in trying to sell his paintings. But, he was most receptive to my suggestions. "Sure," he said, "take your choice."

The sketches were stored, unframed, in a cupboard, and the canvases, some framed and some unframed, were leaning against the wall. Wasting no time, I picked out about twenty Algoma and Lake Superior panels, dating from 1918 to 1927. These were the very pictures I was most interested in and believed we had the best chance of selling. As I looked them over, I felt the excitement only a real work of art can give. Harris priced these sketches from $60 to $90 each. Of the six canvases from the Lake Superior and Arctic years that he let me have, the highest price was $600, for a large, 40″ x 50″ Lake Superior painting. Our commission was to be one third of the selling price. This was the first time that Lawren Harris had ever transacted business with a private art dealer and our association with him remained unbroken for the next thirty-five years. From 1934 until the mid-1940s the prices never varied.

Some time after my visit in the autumn of 1934, Lawren Harris and Bess Housser joined each other in Hanover, New Hampshire. A year later they obtained their respective divorces and were married shortly thereafter.

These were not easy days, however, especially for Bess. The gossip about them continued in Toronto, among certain so-called artist friends, and some of what was said filtered back to the Harrises. Bess particularly resented A.Y. Jackson, and considered him a malicious gossip. However, better times were ahead and Lawren and Bess Harris spent the next thirty-five years together, in an ecstatically happy and harmonious marriage.

In 1938, they moved to Santa Fe, New Mexico, and then two years later to Vancouver, where they bought a beautiful house with a garden, overlooking the Georgia Straits.

During the more than six full years Lawren Harris was in the United States he painted nothing but abstracts and experimental works, and these were relatively few in number compared to the great production of former years. Of course, he was growing older and as his paintings became more reflective and introspective they took longer to paint.

We had not heard from Harris directly since he had moved to the States, and then one day, out of the blue, we received a letter from him dated February 22, 1941, Vancouver, requesting a list of the pictures we had on hand, and enquiring about sales. Harris was now asking us to report to him direct, and to supply him with the names and addresses of all purchasers, saying he hoped we were asking the buyers to allow their pictures to be borrowed for possible future exhibitions. Why had Harris suddenly become so concerned about his old paintings? It was, I suspect, because of Bess, who was, by nature, an astute businesswoman. She had always liked his early work and furthermore was beginning to foresee their commercial potential.

Late in 1934, before Harris left Toronto, he instructed Thoreau MacDonald to get rid of all the sketches and paintings "kicking around" the Studio Building. To emphasize his point, he threw a whole bundle of sketches down the staircase into the basement. A little later Thoreau gathered nearly all of them together, but instead of destroying them he had his Russian cabinet-maker friend Valarian Adamovitch, who had a workshop in part of the old Tom Thomson shack, build a large cupboard under the staircase in the Studio Building and fit it with a lock and key. There he placed the pictures. Later, some of the large canvases went to the Art Gallery of Toronto for storage. Thoreau, by this adroit manoeuvre undoubtedly saved many of Harris's magnificent early paintings and sketches for posterity and, ironically, ensured an additional fortune for the Harrises' later years.

From about 1935 to 1941, A.Y. Jackson and Lawren Harris, Jr. also had access to Harris's pictures, and set prices on the same scale as Harris had earlier. We were then the only dealers in Canada to have any of his paintings for sale. I was so interested in his work, and thought it had such sales potential, that I suggested to my father early in 1939 that we try for an exclusive contract for

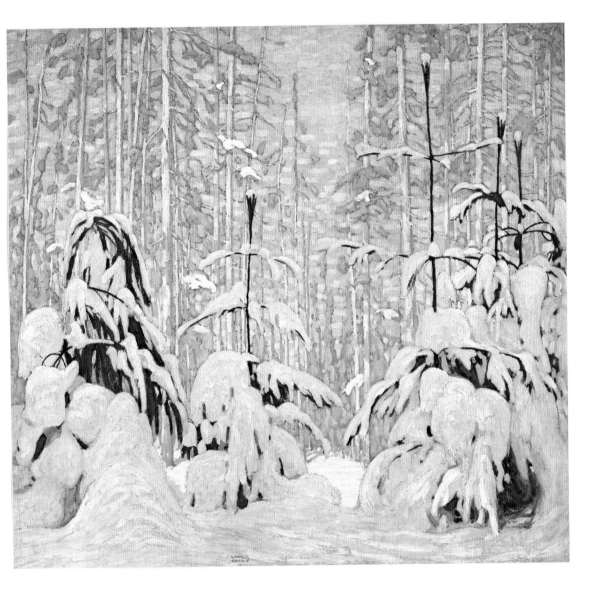

23 Lawren Harris *Winter Woods* 1915

all his output up to 1930. Harris, responding through his solicitor F. Erichsen-Brown (A.Y. Jackson's lawyer), was agreeable, and the preliminary documents were drawn up. The contract, however, was wrecked on the shoals of lawyers' disagreements. At any rate, by then the sullen threat of war was in the air and sales were extremely few and far between.

Incredibly, in the spring of 1942, A.Y. Jackson found a further cache of Harris pictures, hidden away in some dark corner of the Studio Building basement, and asked us to look after them. On May 12, 1942, in response to another enquiry from Harris, we wrote saying we had twenty large canvases and sketches on hand, and listed them. My letter added, "We also have a group of seventeen early pictures which Alex Jackson has asked us to take from the Studio Building. The latter group includes four canvases, the largest, a reddish-brown house with snow, twenty-two by twenty-four inches, and the remainder are sketches." We told him all the pictures had been cleaned and were in good condition. At that particular time, then, we had a total of thirty-seven Harris pictures for sale, but unfortunately, we had no visible customers for them.

Later on during the war, in March 1943, we offered the large canvas *North Shore, Lake Superior, VIII* to James S. Duncan, then president of Massey-Harris and a high-ranking civilian official in the government's war program. I remember taking the picture to Duncan's office and hanging it in the boardroom. All by itself over a mantelpiece it made a totally dramatic statement. James S. Duncan had been a friend and client of ours, at that time, for more than nine years, and was one of the early buyers of David Milne and J.E.H. MacDonald. A selling price of $600 had been placed on the painting, but by 1943, sales were literally non-existent, so without consulting Harris, we sold it to Duncan for $400. This was a lot of money at that time. We were left with no commission on the deal, so we wrote Harris asking if he would allow us one, mentioning who the buyer was. The answer was cold. We would have to absorb the commission ourselves or get the picture back.

The Harris family had been partners in the original Massey-Harris farm implement business and Lawren's personal fortune came in the form of an inheritance from the sale of the Harris assets in the company. We therefore had miscalculated his

reaction. Perhaps he thought that he of all people was not to be fooled over what James S. Duncan, the company president (whom Harris did not know personally), could or could not afford to pay for a picture. At any rate he was determined to get his full share of the price and whether or not there was anything left for us did not concern him in the least.

Vincent Massey was an enthusiastic buyer of paintings by A.Y. Jackson, and J.E.H. MacDonald, and had had his portrait painted by Varley, but he bought little if anything from Harris, and his collection of Canadian art, now in the National Gallery, has but one Harris painting. Theirs was a cool relationship – Harris the artist and theosophist and Massey the politician and realist had no real common ground. Although their family fortunes came from the same source – the great Massey-Harris Brantford and Toronto-based farm implement firm – that is where the similarity ended. There was never any personal rapport between these two men. They were interesting contrasts and each possessed the power, prestige, and position that only great wealth brought, especially during the forty-odd years spanning the two world wars and up to the mid-fifties. Massey, of course, also wielded huge political power stemming from an intimate association with Mackenzie King and the Liberal Party of Canada. Actually neither man flaunted his wealth – it was just a majestic part of their presence. Not as attractive in person as Lawren Harris, Vincent Massey was a spare, rather slouch-shouldered man with a large head and deep-set eyes. He spoke slowly and softly, measuring each phrase as if in fear of committing himself to a situation he did not really want to be a part of.

During the fifties I averaged about two trips a year to Vancouver, and almost always saw Harris. In between visits he continued to send us sketches and canvases on consignment, as, by then, sales were beginning to pick up. He packed them himself, with precise instructions as to the type and finish for the frames needed. His favourite framer was A.J. Boughton of Toronto, who also worked for us. At that time Harris preferred his sketches framed in white and gold and his canvases in silver leaf, with a three-inch, half-round moulding. We held many small uncatalogued exhibitions of his work and handled and sold approximately four hundred of his paintings over the years.

In our correspondence, he always wrote in a distinctive, bold, upright longhand. It therefore came as a complete surprise to me to receive a letter, typed by a secretary, dated March 14, 1962. In reply I commented that I missed his usual handwritten letters, tersely to the point as they were. Bess replied immediately on his behalf to explain that he was not writing in his own hand anymore unless it was absolutely necessary. "It is odd," she wrote, "because I watch him paint with extreme flexibility but the effort of writing bothers him." Of course Harris was seventy-seven years old by then, and not at all well. He spent his time in the painting room of his house, working on his last series of abstracts and a few large re-presentational canvases done from early sketches.

On May 26, 1962, I received another typed letter from him, abruptly asking for the return of all his paintings. These were almost all abstracts. We had held an exhibition of them the year before but the public had shown little interest and we had sold only two. I therefore wondered if something had gone wrong with our relationship and wrote back to ask why he was giving us such short notice. The truth was that I suspected other dealers were after his work, promising him the moon as well as higher prices. Bess quickly reassured me. "Lawren has nothing on his mind except friendliness towards you, and only wanted his pictures returned so he could make a selection from them for forthcoming exhibitions at the National Gallery of Canada and the Vancouver Art Gallery. In no way is he dissatisfied with his connections with you in the past. And," she added, "when he finds other works of interest he will let you know." Complete harmony was restored and we soon had more pictures from him.

On May 28, 1963, Bess wrote again saying that Lawren was concerned about the exorbitant amount of income tax he was paying, and was considering a suggestion to sell all of his paintings on hand to form a personal company. The idea was good; it did not seem right that these paintings, some of them his creations as a young man fifty years before, should be subject to such prohibitive taxation. Bess went on to say that what was needed was a professional evaluation to assess the current market price of all the paintings. They would then be sold all at one time to a personal holding company. "If you feel that you can make a valuation for this purpose please get in touch with me." I sensed the urgency of the situ-

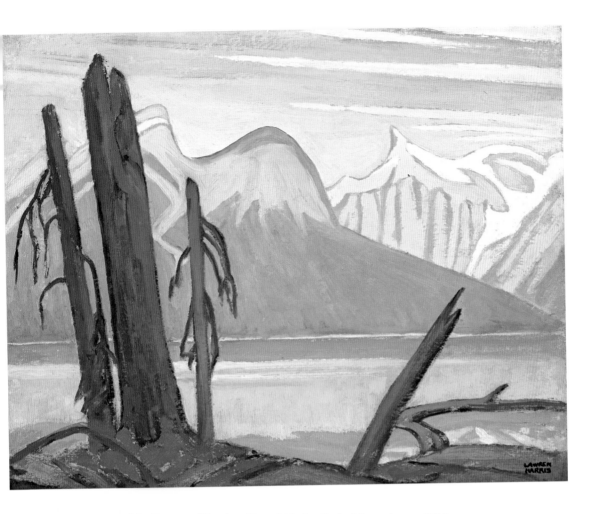

24 Lawren Harris *Emerald Lake, Rocky Mountains* c.1925

ation, and told them I would carry out their request as quickly as possible.

The task took me to three different cities; Ottawa, where there were paintings hanging in a Harris Retrospective Exhibition; Toronto, where several were stored in the Art Gallery; and Vancouver, where the pictures were stacked in special racks the Harrises had built in the basement of their house on Belmont Avenue. I asked no fee for this service but Harris insisted on an honorarium of $100 for "receipt purposes."

The total count of canvases and sketches placed in the Lawren Harris Holding Company was 202, of which 139 were abstract or experimental pictures, and the rest representational, dating from 1909 to 1930. The total market value on the collection, placed in the holding company in that summer of 1963, was a little less than $50,000.

Seven years later, in April 1970, I was asked to do the final valuation of all the Harris paintings for a trust company in Vancouver, which was handling the estates of Bess and Lawren, plus the holding company. My evaluation, which was a conservative one, amounted to nearly one and a half million dollars. This came as a shock to the trust company, as did my fee based on the value of the estates.

On July 16, 1963, Bess wrote to say they had enjoyed my visit and hoped I would like the early sketch of Lawren's they were sending as a present. She mentioned it had been painted in St. Jovite, in the Laurentians, on a trip with J.E.H. MacDonald. Harris himself wrote, on July 30, thanking me for the job I did. "I do appreciate your promptness. Now things can go ahead." It had been a big decision for the Harrises, and they were relieved that everything had proceeded so smoothly. In a second letter, written the same day, he said, "I am glad you like the early sketch I gave you, and I have a few sketches painted before 1920 which I have set aside for you and are not included in the company's assets. Would they interest you – what would you offer net to me? I have already been offered $400." I believe Harris always respected me for the battle I had put up for a share in the Emily Carr estate pictures (which I describe later). And this was another chance for him to show some good will he did not always spontaneously express. For the first time, in all the letters he had written me, he signed himself simply "Lawren." It was the last letter he ever sent me.

Bess wrote on August 23, conveying the grim news that Lawren had had a serious heart attack two weeks before. She said that the first week had been "a dreadfully anxious time but he is now slowly and surely on the mend." (He would never fully recover.) As for the pictures, she added, "You missed out on the sketches, they were gone before your letter arrived." She could not have known that Lawren had already offered them to me; someone must have bought the sketches from Bess while Lawren was ill; he always kept his word and would never have allowed them to be sold without first hearing from me.

There was a certain proud sense of importance expressed by Bess in her letter, despite desperate concern for her husband. On the new company letterhead, she announced its incorporation and said she had been appointed governing director. She was now making all the decisions, and suggested brightly that I write her in care of the company with any offers I had in mind. She would "soon get organized and get down to business as soon as the terrible tension and strain of anxiety gives way." The close of her letter was like a beseeching little prayer – "Please give us both your good wishes."

In October 1963, I bought ten large canvases and some sketches from the company's inventory, at a total cost of $12,000. A little while later Bess wrote that since there had been a stir over the Harris retrospective exhibition in Ottawa and Vancouver, requests had come in for seven large paintings, but that she was holding back until she heard from me. I bought them all. From that time on Lawren conducted no business on his own, Bess did everything and even took several trips east from 1964 to 1968.

On September 8, 1964, she wrote asking what price she ought to put on a large abstract called *Composition II*, that the Art Gallery of Vancouver wanted to buy. She was very concerned with her responsibility towards her husband's children in such matters, and the paintings in the Lawren Harris Holding Company were their inheritance. She went on, "You will be glad to hear that Lawren, after two trips to the hospital during the year, has again made an excellent recovery. We have had a fine summer. It has been a great joy."

At first Bess enjoyed handling the pictures; she was quick and naturally astute in trading and she had a keen insight into the

potential value of Lawren's work. When, in November 1963, I had wanted to discuss the sale of all of Lawren's pictures, with me acting as agent, Bess thought it was not the right time to decide. The pictures I acquired from her I bought by outright purchase. She became amazingly friendly and solicitous towards me, but she could also be very tough. I badly wanted a large canvas of a winter street scene with figures, which Harris would never sell, and which Bess also liked very much. This canvas, *Winter Afternoon*, which Harris documents as having been painted in 1918, on Avenue Road a block or so north of Bloor Street, and which Bess usually referred to as the *Avenue Road* picture, she finally sold to me to help pay for the colour plates and other printing expenses of her 1969 book on Lawren's work. (This book reproduced many of his abstracts; it was her belated but hopeless attempt to place them in a more important light in comparison with his other work.)

In 1966, I made a final attempt at an exclusive agency, and again Bess put me off, gently but firmly. She was very "friendly" to the suggestion, she said, but still wanted a little more time to think about it. She had by now become a very important person in the Canadian art selling world. Besides her book, which she took as a very serious commitment, she had complete and absolute control of all of the Lawren Harris paintings, his collection, her own, and all those owned by the holding company. She looked on the handling of the pictures and their dispersal as both a service to the art world and a labour of love, but it was becoming a more and more arduous and tiring responsibility for her.

At the end there were eighty-four of Lawren's paintings in Bess Harris's private collection, as well as some pencil drawings and one early watercolour. The selection clearly revealed her preferences in his styles and subject matters, as it included only thirteen of his abstracts. She was particularly fond of the old street scenes of Toronto and the early Algonquin and Algoma subjects, and when looking over a group of sketches for possible sale would usually set aside one or two that particularly appealed to her. On the back of those she chose to keep she wrote "Bess Harris Collection." All of these works ended up in the Lawren Harris Holding Company, as Bess left no will.

I remember one sunny morning in June 1968, when the front door of the gallery opened and in walked, alone and unan-

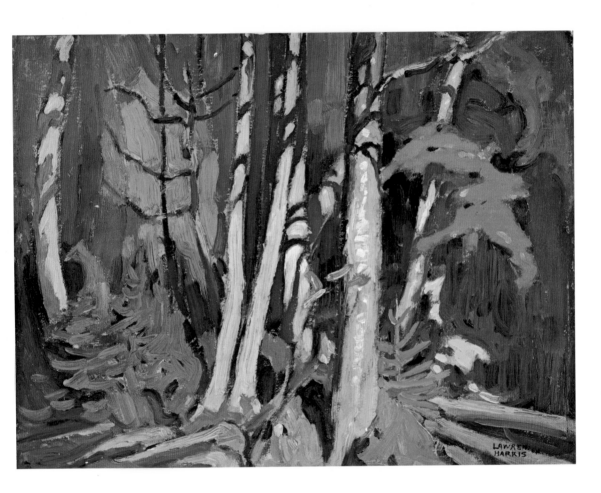

25 Lawren Harris *Black Birch and Maple, Algoma* c.1919

nounced, Bess Harris. She was chic in a bright pink suit, and for a lady of her age looked marvellous. She had come to Toronto to see her publishers about her book on Lawren's work, which was to feature a foreword, written by Northrop Frye. This trip, I believe, was her last to Toronto.

In Vancouver Bess usually took me to lunch at the Vancouver Ladies Club, but in the late autumn of 1968 I was a guest at the house. This was the last time I saw them. Lawren's only food was a glass of beer and some bread and cheese; the poor man was in a world of his own and said hardly one word throughout our simple meal. For a ride after lunch, their Chinese gardener drove Bess and me over the bridge to West Vancouver. She pointed out their house from across the inlet, talked about pictures, and mused over what Marshall McLuhan meant by his statement, "The medium is the message." When I kissed her goodbye at the door of the Hotel Vancouver there was a tear in her eye.

Throughout all the years I knew her there was always a residue of sadness about Bess Harris. Pretty little Bessie Larkin had married two important and creative men, and had lived a long, interesting life. Childless, she was a practical woman and a doer, not in any way an intellectual. But I wonder if she did not acutely suffer the memory of being ostracized by some of her early friends.

Lawren had arranged to leave everything to Bess in his will. However, fate intervened and she died on September 28, 1969. Lawren, who had no will to live without her, died on January 29, 1970.

7

The Thirties

The success of our Tom Thomson exhibition in March 1937, having demonstrated that there were commercial possibilities in the promotion and sale of Canadian art in Toronto, we looked around for the work of another artist to follow it up. We had already sold three J.E.H. MacDonald canvases, one, the quietly beautiful *Late October Evening, Algoma*, to J. Stanley McLean, two others to James S. Duncan, and we had also sold some sketches. These were consigned to us by his son, Thoreau, who managed and controlled the estate on behalf of his mother and himself.

I first met Thoreau MacDonald in 1933, a year after his father's death, and we have been friends ever since. Through him I met all of the artists then working in the Studio Building, including Lawren Harris and A.Y. Jackson. Thoreau spent a lot of time in a small work space he had established for himself in the rear of the Studio Building, facing south. He is a shy, sad-faced man who inherited many of his father's talents, was a fine illustrator, and a master of design and hand lettering and also did excellent studies of wild animals and birds of prey in the black and white medium.

Once we made up our minds to go ahead with a large retrospective exhibition of J.E.H. MacDonald's paintings in No-

vember 1937, Thoreau set to work to design the catalogue. The front cover alone is a fine work, hand-lettered, with a stunning small reproduction of *The Tangled Garden*. This catalogue is today a collector's item. Professor Barker Fairley wrote a short introduction, which today I find disappointing and irrelevant. This exhibition turned out to be one of the best of the twenty or so great shows we have had during the nearly fifty years of the gallery's existence.

There were ninety-five paintings and sketches in the show all together, including *The Tangled Garden*, other Thornhill canvases, and masterpieces of his great Algoma years. Thirty-six individuals and institutions, including the National Gallery of Canada, the Art Gallery of Toronto and some university colleges, lent; at that time there was no problem in borrowing all the paintings we asked for as their owners were proud to be included. I also did a radio broadcast on one of our usual Sunday afternoon periods over CFRB and again offered our special little catalogue, with its two fine colour reproductions tipped on, to all who wrote in, but there was not the great response we had had earlier from the Tom Thomson broadcast.

The pictures owned by the individuals, nearly all of whom had been personal friends of the artist, comprised, for the most part, all his existing works apart from those that still remained in the estate. *The Tangled Garden* was not for sale at the time, but the prices of the ninety-four pictures that were, ranged from $40 for each sketch and from $300 to $2,000 for the canvases, according to size. We made a few minor sales, generally sketches, just enough to confirm a small glimmer of hope for the future of the gallery.

A trickle of sales continued after the exhibition. *Tracks and Traffic* was sold to Walter C. Laidlaw, who later presented it to the Art Gallery of Toronto. Late in 1939, H.S. Southam bought *The Tangled Garden* for $5,000, as a family memorial presentation to the National Gallery. This enormous picture always intrigued me; on the walls of the gallery the full-faced sunflowers, nodding decorously among the late summer asters and zinnias, created a wonderful colour composition that suggested the feeling of a rich old tapestry.

Later, in 1941, R.S. McLaughlin, the chairman and founder of General Motors of Canada, bought *Forest Wilderness* and

26 J.E.H. MacDonald *Maple Boughs, Algoma* c.1918

Algoma Waterfall. McLaughlin's architect, John M. Lyle, who had just finished building an addition to his mansion in Oshawa, was his adviser. I remember the two of them coming into the gallery; Colonel Sam, by which title McLaughlin was familiarly known, was in his mid-seventies by then, a hard bargainer, and a crusty old man, who knew little about art.

About this time we began to sell a few of the sketches regularly to the Hon. Malcolm MacDonald, son of Ramsay, Dr. G.H. Henderson of Halifax, the physicist, Alan Plaunt in Ottawa, and a few others among the converted. Thoreau kept us supplied, bringing in at intervals his father's sketches, carefully shielded between sheets of old newspaper. Until 1963, the highest selling price for a good J.E.H. MacDonald sketch was still only $500. After 1964, Thoreau was wooed and pursued by speculators and voracious collectors. He always found it difficult to say No to anyone and the remainder of his collection soon dried up.

Lorne Pierce, the editor of the Ryerson Press, always had a strong personal connection with our gallery. He liked very much MacDonald's large *The Elements*, which depicts an island in Georgian Bay, under a stormy sky with water and great rocks in the foreground and two figures huddled near a campfire. Pierce was far from being wealthy and could not afford the cost of the picture at the time, so my father arranged with Thoreau that he pay a nominal sum for it, on condition that the painting be willed to the Art Gallery of Toronto. Actually, he presented it to the gallery before he died.

As well as being a painter, J.E.H. MacDonald was something of a home-spun philosopher and poet in the Henry Thoreau tradition, and he was also practical with his hands, an expert with a chisel, who carved his own frames. *The Elements* still remains in the carved wooden frame that MacDonald created for it.

MacDonald was late in life fulfilling his youthful promise as an artist and it took a long time for his natural gifts to mature; his experience, in effect, parallels the late development of Tom Thomson. MacDonald, just four years older than Thomson, in fact did not begin to assert his real form as a painter until 1911, when he was thirty-eight years of age. Next to Tom Thomson he was Dr. MacCallum's favourite artist, and the Doctor possessed a considerable number of his sketches. Like Lismer, MacDonald spent his

27 J.E.H. MacDonald *Thornhill Village* 1915

early years as a commercial artist and designer and the last few years as a teacher and finally principal of the Ontario College of Art.

From first-hand descriptions by people who knew him well, including his own son Thoreau, he was indeed a remarkable and talented man, as well as a painter of genius, who, on reaching his full painting powers, rose to dazzling heights. Had he produced nothing more than those richly coloured sketches and canvases of Algoma, he would still be ranked among our great artists. It is amazing that the man wound up his life by painting as much as he did. There was so little time left over from his teaching duties and painting commissions, and he suffered so much ill health during his middle and later years, that he was prevented for extended periods from even lifting a brush to canvas let alone going out sketching in his beloved Thornhill fields.

His lifetime's output of larger paintings, both on canvas and millboard (the latter as well-preserved as the former) was small – only about 108 exist, dating from 1909 to 1932. Yet, the power and originality of his Algoma paintings alone show him to be one of Canada's finest artists.

MacDonald's great production was in his sketches; before 1913 they were small – 5″ x 7″ to 6″ x 8″ – then he began using the 8″ x 10″ size and finally the 8½″ x 10½″, which Tom Thomson and Jackson also favoured. Most of his sketches were done on book-binding board bought from Brown Brothers, cardboard panels about one-sixteenth of an inch thick, and, in emergencies, he sometimes cut to sketch size cartons or cardboard boxes. Thoreau estimates that his father painted some six to eight hundred sketches from 1914 to 1932, and of these we must have had approximately 300 for sale over the years. Of the 108 large and small paintings in existence, other than sketches, fifty-one passed through our hands.

Few unrecorded MacDonalds turn up these days, but two that had been forgotten for many years recently came to our attention. One day in the summer of 1977, a tall, rather intense man with flashing dark eyes, came into the gallery. He had been referred to us by Thoreau, and had with him a MacDonald sketch about which he told us an interesting story.

His name, he said, was John Ross Taylor. During the

28 J.E.H. MacDonald *Flower Border, Ussher's Farm, York Mills* 1918

First World War his parents had been friends and patrons of Canadian artists. It was his mother, in fact, who had introduced Bess Housser to Lawren Harris. They owned a white frame house by the side of the road at Ussher's farm, in the valley of the Don River at York Mills. At teas and *soirées* they entertained various artists and members of the Arts and Letters Club, which had rented several acres of the fertile Ussher farmland on which to grow vegetables and small fruits. In 1917, Taylor's father died and the MacDonald family rented their house for eighteen months. Here the ailing artist began to slowly recover his health.

John Taylor then uncovered a striking sketch, *Flower Border, Ussher's Farm, York Mills*, dated 1918, from some brown wrapping paper and the little painting revealed the historical fact that by late summer of that year MacDonald had regained enough strength to sit down on a camp stool and paint a picture of his flower garden border, with blue delphiniums and orange lilies catching the morning sun. The picture was dedicated to Mrs. Taylor and presented to her as a gift. This sketch was a harbinger of even better things to come for the artist, as within a month he was well enough to accompany Lawren Harris, Dr. MacCallum and Frank Johnston on the first box-car trip to Algoma. That flower garden sketch had remained with the Taylor family for fifty-nine years, and we bought it on the spot.

In the same year a young school teacher, on an exchange visit from New Zealand, brought in a tiny sketch, 4¼" x 5¼", signed and dated September 1922, and inscribed on the back of the panel in the artist's hand, "The Mill Dam, Petite Rivière, N.S., for Mrs. Strath." This was an exquisite little panel demonstrating MacDonald's remarkable gift in painting a completely finished picture on so small a surface. It was a grandson of the original owner who was finally returning it to Canada after fifty-five years.

In the mid-thirties the few customers we had preferred English, Dutch, French, and other European pictures. Captain George Webster, for example, one of our mining tycoon clients, bought a portrait of a handsome young lady by the early nineteenth-century Scottish portrait artist, Sir John Watson Gordon, to satisfy a yen, I expect, to possess a Scottish ancestor to hang over his drawing-room mantelpiece. There was no feeling of Canadian nationalism in respect to the arts in those days, except perhaps

among a small band of the artists themselves, and Canada, apart from the economic hardships common to the whole western world, was politically stable. The bi-culturalism, bi-lingualism policies so stridently expounded by politicians and journalists in the late sixties and seventies as necessary to the preservation of our nation did not concern the people at all, either in Quebec or in other parts of Canada. Concomitantly, our few buyers of Canadian art did not buy pictures by Canadian artists simply because they were Canadian, but because they liked them. The change in attitude came many years later, when customers who proclaimed they would buy only Canadian art became commonplace. Late in his life A.Y. Jackson was to experience some of this acclaim I mention.

As a person and artist, A.Y. Jackson was a mixture of vaulting ambition and remarkable amiability. What he really thought of me doesn't matter though his behaviour towards me was always extremely friendly. Dealers as such were not his favourite people. He combined a personal modesty with an acute awareness of his own talents, and with a complete lack of greed evidenced spontaneous pride in showing and selling his own pictures. Among his colleagues in the Group of Seven, I think it was Jackson who cared most about being thought of as a "great artist."

He was a strong, short, stocky man, with a craggy face and a crooked nose that looked as if it had been battered in some youthful encounter and never quite regained its original shape. But his was a benign and sympathetic head, created to inspire a sculptor – actually a bronze does exist, by Jackson's good friend Frances Loring.

In 1933, when I first met A.Y. Jackson, he was in his early fifties and still a vigorous man. Painting was his life and of all those who worked in the Studio Building, he was the only one who actually had lived there all through the years. He made sketching trips in every season – a rugged physique and years of experience made camping in the wilderness a routine affair for him – and it was in many remote places, all over Canada, that he found the subjects for those wonderful little sketches of his earlier years.

Jackson worked so hard that on some sketching trips he would exhaust his supply of fresh birchboard panels, whereupon he would paint a second sketch on the other side. In recent years, scores of these double-painted panels have been successfully split

by slicing through the centre of the wood with a thin saw to make two paintings.

When Jackson returned from a trip he liked to bring all his sketches home and consider each as a possible subject for a larger picture. After he had moved to Manotick near Ottawa in 1955, he "painted up" several canvases for me from early sketches I had bought from him before he left Toronto. I remember one was a west coast Indian village sketch painted in 1926. These new pictures sold easily, but as works of art they were pale imitations of his early things and there was nothing of the spirit or quality of the A.Y. Jackson of old left in them.

The Canadian art historian, Dennis Reid, documents in detail the story of A.Y. Jackson's arrival in Toronto from the Province of Quebec in May 1913, and tells of his rapid introduction to Dr. MacCallum and the inner circles of the Toronto art group. Lawren Harris met Jackson a little later that summer at the home of Jackson's aunt, Geneva Jackson, in Berlin, now Kitchener, Ontario. Later in the same summer Jackson went to the Georgian Bay area near Penetanguishene, but painted little. European Impressionist masters such as Monet, Sisley, Boudin, and Jongkind, revelled in summer colours, like the greens of the Seine and Loire Valleys. But few Canadian artists, including Jackson, ever seemed to be at home with the strong greens of the Canadian summer. Tom Thomson was the exception; given the right mood he painted some brilliant spring and early summer landscapes, and striking wildflower studies. In later years, Jackson did paint many spring and summer studies, probably inveigled by friends at whose cottages he was staying, but these were bland and dull.

In the winter of 1914, he went to Algonquin Park to sketch, and in September returned to the park again, this time to paint with Tom Thomson. It was the beginning of a strong attachment between the two artists. As a result of his years of formal training in Europe, Jackson was able to demonstrate something of the French Impressionist technique to Thomson, and Thomson the woodsman, canoeist, and expert fisherman, passed on to Jackson practical tips on the art of living in the bush that were to stand him in good stead during his travels in the wilderness in later years.

The two spent six glorious weeks painting together in the park that autumn, joined later by Arthur Lismer and Fred Varley.

29 A.Y. Jackson *Georgian Bay Islands* 1919

Some of Jackson's sketches from that time are among the best and most colourful paintings he ever did. He was by then thirty-two, a mature artist, and these works were the beginning and anticipation of some of the great landscapes he was to create over the next two decades, the golden years of his painting career.

Earlier, in the spring of that historic year of 1914, Thomson also learned from that born teacher, Arthur Lismer, who was sketching in the park for the first time. During the spring and autumn of that year each of these artists was coming into his full sense of colour and freedom of technique. As for Thomson, from that point on, nothing could impede his rapid progress. He had become absolute master of his own technique. He had reached the stage where his creative impulses began to burst forth with the dramatic effect of one of those sudden summer thunderstorms that could surge across a northern lake full of power and fury, and he inexorably went on to produce those spontaneous little sketch panels that we look at today with such wonder and admiration.

All his life Jackson was fiercely proud of this association with Thomson and with other members of the Group of Seven, especially J.E.H. MacDonald and Lawren Harris. He was always interested in looking at any Tom Thomson sketch we had on hand at our galleries and, as he lived nearby, often dropped in. He liked to discuss the Thomson technique – for example, how he would use the wooden handle point or a dry brush to drag furrows in the wet paint to create a sculptural effect in a tree trunk. Jackson revered the memory of Tom Thomson and the impact of that 1914 autumn sketching trip always remained strongly in his memory.

Many years later, we acquired a group of Jackson's sketches painted during that historic trip. They had been stored away, unvarnished, in an old cabinet in his studio, and were as fresh and colourful as the day they were painted. Jackson himself never varnished his paintings, nor did he like a varnished surface; he claimed, with some validity, that with the passage of time varnish oxidized and turned brown, darkening the surface of the painting and becoming difficult to remove. (This was certainly true of some of the old resin and oil varnishes, but the new synthetic ones, while they darken with time, are easy to remove without the use of strong solvents and do protect the surface of the painting.)

30 A.Y. Jackson *Lake Shore, October, Algonquin Park* 1914

Both Jackson and Thomson worked on birchwood panels, 8½″ x 10½″. They also experimented with the early plywoods, but these cracked and sometimes ruined the surface of the painting. Thomson also used a hard, dark grey mottled millboard from time to time which has stood up extremely well through the years. These panels fitted nicely into slots in their wooden sketch boxes, with room for a small palette. Much of Jackson's best work was painted on these small boards, but from about 1937 onwards he worked almost exclusively on larger wooden panels, 10½″ x 13¾″. Although I don't think it was his regular practice, I was once intrigued to see him working in his studio on a Quebec winter canvas with the sketch, from which he was enlarging, divided into small squares tied with thread. I expect this was a device he used from time to time to help transpose the exact proportions to the larger work in progress.

In the twenties and early thirties Jackson's paintings had a clearness of image and subtlety of colour that was truly remarkable. His work, while not altogether realistic, was well-defined in an Impressionist manner. During this time, and for more than twenty years after, I continued to visit him at his studio, and he always let me have sketches and canvases for sale on consignment. I would choose a group of twelve or more from a bundle of perhaps twenty, all unframed and neatly kept in a pile in a drawer. There were never many canvases available at any one time, as Jackson was an enthusiastic exhibitor all over the country, with groups such as the Ontario Society of Artists, the Canadian Group of Painters, and the Royal Canadian Academy (though he resigned from this last body in 1933, because he thought the attitude of some of its members reactionary).

In the thirties, we sold Jackson's sketches at $35 each, our commission being one third. After paying for a simple wood frame, the artist would net about $20 from each sale. This satisfied him; he once told me that for a year in 1931-32 he had lived solely from the sale of his sketches, not having sold a single canvas during that time. But Jackson wasn't really poor. He was always selling some little thing, and had plenty of friends all over the country who put him up and bought from him. Like other members of the Group of Seven, Jackson was not much interested in money, even though later in life he was acutely aware of the prices his paintings were

fetching on the open market and could have asked much more for them. But he had an innate confidence in the ultimate value of his work and was also a superb natural salesman, very successful at public relations, always managing to get good press and magazine coverage, and using radio with skill to air his ideas on art. Yet even in the 1950s, he had no thought of demanding prevailing market prices; the price he personally set was sufficient, though he made it a rule never to make gifts of his pictures, except occasionally to friends with whom he was staying.

He lived simply. A strict self-disciplinarian, he gave up smoking during the daytime and never had a drink until early evening, and then it was usually beer he supplied for the little parties in his studio. He had no automobile and did not drive, walking everywhere or taking the streetcar or, on longer trips, the bus. During the thirties, like Curtis Williamson, whose personal living conditions he deplored, Jackson used to eat at Bowles restaurant on Bloor Street West near Yonge, where in those days a bowl of soup cost ten cents and a cup of coffee, five.

An incurable romantic as far as women were concerned, Jackson, though no Casanova, did fancy himself as quite a ladies' man, especially among the women painters of his circle. Unhandsome as he was, I have been told by two of these ladies that he radiated considerable charm and magnetism towards members of the opposite sex.

When I first knew him in the early thirties he was apparently carrying on a long love-letter correspondence with the Montreal painter Anne Savage (letters I am sure Jackson never dreamed would one day be published in a biography of Anne Savage). In a letter to her in 1933, he begs her to marry him, at the same time indiscreetly observing that he has a lot of "dear girl friends," and mentions no less than six. He argues strongly, as if it might be a condition for marriage, that he must continue his friendship with these other ladies. Of course, they were all artists. Moreover, by now Jackson was over fifty years of age and like all bachelors at that stage of life, set in his ways. Probably he felt quite safe that she would not accept his offer.

For many years A.Y. Jackson was a vital force in the Canadian art scene, holding avuncular court over a coterie of painters in Toronto and Montreal. His influence was benign; these

followers did not necessarily paint as he did, but some looked up to him as something of a god. There were the George Peppers, Prudence Heward, Pegi Nicol, Anne Savage, and Sarah Robertson. Other friends were Paraskeva Clark, a talented and peppery Russian émigré who did some fine work in the thirties, and Gordon Webber. Jackson had an excellent relationship with the National Gallery during Eric Brown's office, 1910-39, and later when H.O. McCurry was director from 1939 to 1955, and with the Art Gallery of Toronto under Martin Baldwin, director from the mid-thirties to the early sixties.

Jackson was a gregarious man, who loved meeting people and going to parties; when in town he attended all the openings of the Art Gallery of Toronto, and was active in various artists' societies and always familiar with their internal politics. He happily accepted all dinner invitations; on occasion he came to our little apartment on Winchester Street when I was first married. I remember once showing him a photograph of one of my daughters at the age of two. The photograph itself was not important but what delighted him was the "plastic quality" (a favourite phrase) of her head. "Like a Renoir," he declared. He was enthusiastic about anything connected with painting, and anything that added to the zest of life – he enjoyed a little gamble on the stock exchange, for example, and once in a while took a flyer on a tip that his friend, the mining prospector George Tough, would give him on a penny gold mining stock.

He loved talking about his trips and telling stories about fellow artists; in fact he was quite a gossip. In early spring he always found the opportunity to go to Quebec, where he was born and where he painted many of his finest and most typical works. He loved the villages of the north shore, Les Eboulements, St-Tite-des-Caps, St-Sauveur, St-Fabien and Petite Rivière. The villagers were fond of him too, and called him Père Raquette. It was in Petite Rivière, in March 1929, that he painted *The Red Barn*, a picture which is certainly one of his greatest works. Even Jackson himself admitted it was his most "popular" painting.

He seldom returned to these old Quebec haunts after the war, complaining that the villages had changed too much. The horses and sleighs that he loved to paint were gone, and paved highways and automobiles had taken over. "Now you only see

31 A.Y. Jackson *Yellowknife, Northwest Territories* 1929

Coca-Cola and Orange Crush signs," he said to me once, "and other kinds of screeching billboards."

The Red Barn was originally bought from Jackson by I.W.C. Solloway, a Montreal and Toronto stockbroker who went bankrupt in the early thirties. I bought it in 1972 from the veteran Montreal dealer W.R. Watson, who had owned it for more than thirty years and resisted all previous offers to buy it, including by the Government of Canada, which wanted to present it as a gift to Queen Elizabeth II, during one of her official visits to Canada. Yet in the thirties such paintings were very difficult to sell, even at the extremely low prices prevailing. The public in general thought them crude – the old Quebec barns with sagging roofs, tired horses pulling a sleigh over grey snowy roads, were not considered the stuff for pictures.

The exhibition of his work I best remember was in November 1935, at Wm. Scott and Sons in Montreal; it impressed me enormously, but closed with practically no sales. Jackson organized this show himself and there were twenty-nine canvases and eleven sketches, at prices ranging from $40 for a sketch to $200 and $300 for a medium-sized canvas, and $600 for the largest. There were works from his Algoma period of the early twenties, from his two Arctic trips of 1927 and 1930, and superb Quebec canvases of the mid-twenties and early thirties. At the prices listed, one could have bought out the complete show for a grand total of $7,950. Some of the best pictures Jackson ever painted were included in that exhibition – *Algoma, November*; *Road to St-Tite-des-Caps*; *Evening, Les Eboulements*; and *Summer, Pangnirtung*, later owned by John A. MacAulay. H.S. Southam of Ottawa afterwards bought *Algoma, November*, and I remember seeing it in 1938, hanging in a place of honour in his private office in the *Citizen* Building. It is now in the National Gallery of Canada.

I can find no record of that 1935 Montreal exhibition except one typed page listing the title and price of each picture, which John Heaton, the owner of Scott and Sons, handed to me, and which I still possess. Such was the climate for contemporary Canadian art in Montreal, and in Toronto it was just as bad. Yet a decade or so later Jackson would be acclaimed as one of the country's greatest painters.

I never got the impression it was the dealer's profit that

118

32 Maurice Cullen *Spring Breakup, Cache River, P.Q.* c.1920

bothered Alex Jackson, rather it was the notion that someone other than the artist was getting any credit at all for the fact that his pictures sold. His autobiography does not mention the name of any Canadian dealer as a seller of his work, but he did two nice things for me just before he left Toronto.

In 1955, he told me that his aunt Geneva's estate possessed two Old Masters, then stored in the Art Gallery of Toronto. The gallery had developed pressing storage problems and wanted to be relieved of their custody. A Dutch museum man had looked at them, and said that one, *The Incredulity of Thomas*, was possibly by, or in the school of Hendrik Terbrugghen (1588-1629), but the other was of no interest. "Would you care to have a look at them?" Jackson asked me. As soon as I saw it, I knew that *The Incredulity* was an important work, probably a masterpiece, and, furthermore, I knew where I could sell it, though certainly not in Canada. At that time we had close connections with one of the world's leading dealers in Old Masters, the P. & D. Colnaghi Company of London, which I will talk about later.

The next time I was in England I took a photograph of the Terbrugghen (my intuition and training told me it was an original work) to show to the Colnaghi partners. They offered to buy it with us in joint account. A price of $2,000 was agreed upon, and Alex Jackson was delighted to get the picture off his hands. I expect the painting today would be considered an almost priceless work of art. Writing about this incident in his book, Jackson could not resist a dig at the Canadian gallery authorities for missing out on this painting. He also let it be known that in his opinion the sale needed no effort expended in research, or even any particular knowledge of art. It was a curious quirk in his makeup, this reticence to admit that even a little outside help was ever necessary for sales, either of his own work, or, in this case, of a painting entrusted to his care. I have often wondered why A.Y. Jackson, who had had so many years of training and study in Europe, did not recognize the picture as a masterpiece. On the other hand, he probably looked at it from his subjective viewpoint as an artist rather than through the objective discipline of an art historian or through the trained eye of an experienced dealer in Old Masters.

The picture was shipped to London, cleaned, and placed in a carved period wooden frame, and, within a few weeks after be-

33 J.W. Beatty *Baie St. Paul, Winter* c.1920

ing exhibited, was back in Holland. It now hangs in the Rijksmuseum, having been purchased for the sum of £1,800. Visiting Amsterdam in March 1977 I went to the Rijksmuseum with my Dutch friend and former partner, Peter Eilers. Flanked by two other Terbrugghens, the picture looked magnificent and very much at home. As we were standing in front of it, an art class of twelve Dutch children came along with their red-haired teacher. The children, with straw-coloured hair and shining white faces, were gazing solemnly at the swarthy, dark-haired figures in this singular composition. I like to think of the picture the way I saw it on that occasion and was glad it had found its way back to its home in Holland.

The second and really much more important event was also in 1955, just before Jackson was forced into his unhappy decision to leave the Studio Building for good, after nearly forty years, and ended up in a little house and studio he had built in Manotick, near Ottawa, where a niece lived. He invited me to his studio before he left, and offered to let me buy any or all of his pictures still on hand. I returned to the gallery with about sixty early sketches and several canvases, including *Evening, Riaumont,* a fine early canvas which we sold to the Art Gallery of Hamilton in October of the same year for $600. Jackson's price to me was $50 for each sketch and $200 to $300 for the canvases.

It seems to me that of all the Canadian painters of his time, A.Y. Jackson was the one who most desperately wanted public recognition, and the one who most displayed genuine bitterness over the lack of acknowledgement all of them had to face in their early days. When he wrote his 1958 autobiography he complained resentfully of those who disparaged the achievements of the Group of Seven as "flourishes of backwoods nationalism."

As early as 1911, he was writing to the newspapers to criticize Canadian indifference to the arts, and when the National Gallery became a buying factor, to the gallery to criticize its lack of support. He used to rail at the presence of so many nineteenth-century Dutch painters such as Bosboom, the Marises and Wiessenbruch, in Montreal collections, many of them bought during the early years of the twentieth-century when, he felt, Montrealers should have been buying Canadian paintings instead. His autobiography harps constantly on the days when "a little group of em-

battled artists found itself in opposition to everyone in the country," and denounces the critics of his day for "heaping honours upon rapidly forgotten mediocrities." The man had a right to be bitter, however. After all, he was subject to reactionary abuse, as he saw it, at the beginning of his career, and patronized as a relic of the past at the end of it.

Ironically, except for his own intimate circle and Tom Thomson, of course, Jackson himself found little in the work of his fellow Canadian artists to praise. He talked to me about the work of Maurice Cullen but criticized his constant use of what he called the "S"-curve motif in his spring breakup stream compositions. He admired the paintings of J.W. Morrice and knew his work from exhibitions in Montreal after the turn of the century, but I can find no reference anywhere that he knew the older artist personally although he spent several years in France at the time Morrice was living there.

He had nothing good to say about David Milne as a painter, for example, or for that matter about Milne the man, though he hardly knew him. And Jackson himself was a sad spectacle in his latter years in the 1960s but continued to paint even though he had already lost the precious colour sense of his prime.

Like Jackson, J.W. Beatty had no use for dealers. He once told me that rather than let a dealer get possession of his paintings when he died, he would destroy the entire collection before he went. I often went to see Beatty during the last six or seven years of his life, at the Studio Building painting room he retained until his death, in 1941, and despite his opinion of dealers he let me have many pictures for sale on consignment. His favourite student, Alice Innes, was usually there, working at her easel, and she faithfully and affectionately helped to look after him during his final years, when he suffered so much illness.

Like Arthur Lismer, Beatty was a conscientious and well thought of teacher, but he sold practically no paintings during his lifetime. He earned his living as a professor at the Ontario College of Art and conducted summer schools, including the famous one near Port Hope, which he greatly enjoyed. I still meet former students of Beatty who speak of his teaching abilities with excitement and gratitude. He had certain serious weaknesses, though, as an art

instructor, because he did not allow his students enough scope to develop their own style. His criticism was so forceful that his students usually ended up painting his way, especially with the colours of his personal palette.

Beatty, however, admired other artists' works and had excellent taste. During the mid-1920s he became involved in selecting paintings for a remarkable collection of Canadian art being formed by E. Whaley, the wealthy owner of the old downtown Toronto Whaley-Royce firm that sold musical instruments. Beatty took much pride in this challenging task, selecting works by Paul Peel, Cornelius Krieghoff, Homer Watson, J.E.H. MacDonald, Daniel Fowler, and others. There was also a Tom Thomson sketch in the collection, *Spring Birches, Canoe Lake*, showing a glimpse of an Algonquin lake through a screen of birch trees in early spring. Elsewhere I tell the story of how this same picture came on the market by way of public sale more than fifty years later. Beatty was just as proud of the Whaley collection as were the Whaleys themselves.

It has taken more than three and a half decades for Beatty's work to receive any just appreciation. Alive, Beatty was overshadowed by some of his more illustrious contemporaries, especially A.Y. Jackson, whose social graces and wider connections Beatty lacked. He was also a forceful character, even in his later years, direct in speech, obstinate and unyielding in his views on art and fellow artists. But if he liked you he was a good friend, and he had a real, almost tender feeling towards many of his students.

He was quite serious in his threat to destroy paintings before letting a dealer get hold of them, though if he would not do it himself I doubt that anyone else would have, even under the direction of a will. Beatty was well aware of his painting merits, and I am sure knew in his own heart that one day his pictures would be much sought after. The following account describes what actually happened to the pictures he left behind.

A few weeks after Beatty died, in 1941, artist Frederick S. Haines, then principal of the Ontario College of Art, approached us to enquire if we would be interested in all the pictures in the Beatty estate – some three hundred sketch panels and about fifty to sixty canvases, including some early European subjects. Mrs. Beatty, a prudent old lady who lived in a little house on Duggan

34 J.W. Beatty *Kearney, Near Algonquin Park* c. 1914

Avenue, was most anxious to sell the entire collection. Fred Haines and Mrs. Beatty, together, set a selling price of $4,000 for the collection, a considerable sum in those days, especially for pictures that had no visible market.

We were the only dealers in Canada who specialized in Canadian paintings in 1941, and so there were no other potential buyers on the horizon. Although the art business was at a virtual standstill, we bought the Beatty collection anyway and were content to more or less store the pictures away for some years. However, in October 1942, we lent most of the paintings shown in the catalogued Memorial Exhibition of his work held by the Art Gallery of Toronto, which gave the Beatty name some much-needed publicity. After the war we encouraged Lorne Pierce to publish an illustrated booklet on Beatty in his Canadian artists series, and offered to pay for some of the colour plates. The book, written by Dorothy Hoover, Fred Haines' gifted daughter, is an excellent study of Beatty's life and work.

It took upwards of thirty-five years to sell Beatty's pictures, and even today we still have some sketches left from the original estate collection. No doubt Beatty's spirit still disapproves of any profit we made.

8

Art Dealing in the Forties

By the end of a dreary January in 1941, the picture business was so poor and the war so much on everyone's mind that we decided to move from our rented Yonge Street galleries and start looking for a suitable building to buy. There was an impressive looking old red brick house around the corner at 60 Bloor Street East that showed potential for a gallery. We bought it in May 1941 for $8,000, at a time when the price of Toronto real estate must have surely been at its all time low, and we remained there until May 1950, nine momentous years, and difficult ones for anyone trying to operate an art business.

After the more than eight years on Yonge Street we had mixed feelings about moving, but in the end we were glad to be rid of our heavy expenses and prepare for a new regime. The third floor of the old house, actually the attic, was remodelled into an apartment for my parents, who by then had decided to move away from Park Road. It was necessary to put in a kitchen and bathroom, where none existed before, but my hard-working and resourceful father was able to get the plumbing supplies, not easy in those days of wartime shortages, and other material by bartering a picture or two. The finished result was an adequate but far from luxurious apartment.

The house, built around 1890, had a wide frontage on Bloor Street East and was, by 1941, one of the last surviving old residences near Yonge and Bloor Streets. It also had an old-fashioned charm which one often finds in Toronto-built Victorian houses. Surprisingly in some ways it turned out as good a place as the original Yonge Street Gallery for showing pictures. For example, we could use the individual rooms to hold several small simultaneous exhibitions and there were four different mantelpieces, over which we could hang pictures in a home-like atmosphere. In those days, especially, the living-room mantelpiece was the favoured place to show off a picture.

There was an easy one-turn stairway to the second floor, which we carpeted, and so the first two floors became the galleries. The basement, which a little later was to be used for secret war munitions production, became a workshop for framing and fitting pictures. The bay windows looking out onto Bloor Street, perhaps thirty feet across a small lawn, where a black wrought iron fence separated the edge of the grass from the sidewalk, were converted into a large clear glass show window, so that a picture suspended on hooks could clearly be seen from the street. The front door was decorated by a stained glass window featuring the coat of arms of the original owner, Thomas Gooch. Then floodlights were placed on the ceiling of all the rooms, for a good lighting effect, and as a final asset we had our own paved driveway, with plenty of parking space behind the building. All in all it turned out to be a much better situation than we ever thought possible.

This move proved to be a stabilizing and consolidating one; it cut down our expenses and put us in a strong position to weather the storms of a few more hard years ahead before we began our steady climb to success and independence.

We had magnificent pictures for sale in those days, Lawren Harrises by the score, Krieghoffs, dozens of J.E.H. MacDonalds, A.Y. Jacksons, Lismers, Tom Thomsons, and some French Impressionists as well. But nothing was selling, and my father, always restless for more action, thought up an unusual but practical sideline. In August 1942 we started up a machine shop in the basement. Somehow we managed to buy some metal working lathes, a drill press, and other pieces of machinery. I don't know where we found the superintendent, Mr. Ross, but he was a good one and an

35 J.E.H. MacDonald *Log Drive, Gatineau* 1914

expert toolmaker, who brought along two young men, Keith and Bob, and a young woman, Henrietta, whom he was rather sweet on, to work on the machines. Mr. Ross found the idea of organizing a new machine shop a welcome challenge, as he disliked working in large factories. As long as it was efficient, a machine shop in the basement of an art gallery did not strike him as odd or unusual, but to us it certainly was.

My responsibility was to go out canvassing large industries holding prime contracts and willing to sub-contract some small components. We were successful, and after a week or so our little machine shop was humming away, working in shifts, twenty-four hours a day. The machine shop grew and grew until the basement had no room for further expansion. Still stored away in a cupboard in that same basement were twelve of J.E.H. MacDonald's larger works including *Harvest Evening*; *Log Drive, Gatineau*; and *Laurentian Hillside, October*, which up to then we had found impossible to sell, even for $300 or $400 each. However, on April 18, 1947, through Thoreau MacDonald, Max Stern sniffed them out and carted them off to Montreal; it was a deal that Thoreau has regretted ever since. Important works by J.E.H. MacDonald are now so rare and valuable that one of the above three was recently valued for gift purposes to a public gallery at $100,000.

We ran the machine shop for seven months during 1942-43, turning out those small brass and bronze components the end use for which was secret. I became adept at using a micrometer to check allowable tolerances and learned something about machinery too. However, almost abruptly in the end, we decided that our future must be as art dealers, not machinists, and sold out the business in February 1943, for $8,000, to Dr. Howard Batten, president of the well-known Rapid Grip and Batten engraving company. All the machines then went downtown to Richmond Street West and into a much larger shop.

The gallery survived this period of stress and frustration due to my father's determination to succeed and the long hours he put in. It was also good business technique and planning that did it, certainly there was no change in the public attitude to art; we stayed open six evenings a week until nine at night. We used large display advertisements in the daily newspapers, the first gallery in Canada to do so, and included reproductions, with lists of artists

whose works were available, and we also had our own weekly radio program, called "Pictures for Your Home."

The paintings we showed were mostly by Canadian artists; Europe being effectively cut off as a source of supply. But there were a few, although only a few, buyers of Canadian art during this time. One was H.S. Southam, Ottawa, chairman of the board of trustees of the National Gallery for nearly twenty years. The walls of his house in those days were hung with a glorious collection of French Impressionist and Post Impressionist works, including a great landscape by van Gogh. But his eyes would glow in appreciation and wonder when he looked at a Tom Thomson sketch.

After the war, business began to slowly improve. Alan B. Plaunt and his wife Bobbie (later Mrs. Dyde) were early patrons of the Group of Seven and buyers of Tom Thomson sketches. In October 1947, they paid a total of $180 for two Lawren Harris sketches and another $90 for *Bylot Island Shore, 1930* by the same artist. In 1947, Harry McCurry, Director of the National Gallery, bought for the gallery Emily Carr's *Logged Over Hillside* for $450, and Tom Thomson's own sketch box for $25.

Then, too, towards the end of the war and just after, Malcolm MacDonald, High Commissioner to Canada, became fascinated with the work of J.E.H. MacDonald. When he came to Toronto he often visited us and took home J.E.H. MacDonald and other Group of Seven sketches. Malcolm MacDonald was a distinguished and elegant English gentleman who, among other things, was a birdwatcher and naturalist; he used to wander about Whiskey Creek near Ottawa, studying the bird life, and wrote a book about it. We were once able to return an Old Master painting to MacDonald that had been stolen from him in England. It was a van de Velde marine, stolen from MacDonald's flat, which Colnaghi's had bought unknowingly and sent to us for sale.

One of our most astute customers about this time was James Coyne, who was then deputy governor to Graham Towers of of the Bank of Canada. My father had a great respect for James Coyne; he somehow felt the man possessed occult powers of divination in business trends and domestic and international money matters. I don't recall my father mentioning any pearls of wisdom regarding finance passed on by Mr. Coyne, but he paid great attention to him and made some spectacular pictures available at

the lowest possible prices. For example, in April 1947, three landscapes by Emily Carr cost him $750 all together, and a sketch, *Spring*, by the same artist, was $125. The next month, in May, he picked up two of J.E.H. MacDonald's superb Algoma sketches and a *Gull River* sketch by him, for a total of $187.50, the price reflecting a generous discount given to him by my father.

Coyne, a handsome man, was proud and aloof. For him, buying Canadian pictures was a calculated expenditure, and with my father's help he made no mistakes. When he began to sell his pictures many years later, I expect they turned out to be his best investments, as his aesthetic judgment on Canadian art was, I think, much better than his fiscal and economic prognostications. However, I have found out in a lifetime in the art business that the dealer himself gets no credit for selling superior pictures at reasonable prices; it is always the customer who prides himself on his own good taste and perspicacity.

H.O. McCurry, who succeeded Eric Brown as head of the National Gallery in 1939, was another hard bargainer, but, of course, the gallery was always low on funds. In general, I find public institutions more difficult to do business with than private people, largely because of time-consuming committee meetings and general funding problems.

Apparently, by 1948, Southam and McCurry had a personal falling out, and Southam began to offer us some of his French and Dutch pictures for sale on consignment. In February 1950, on his instructions, we offered two of his Courbets and a Daumier to the National Gallery, at "a special price" of $15,750 for the three. He also worked out higher individual prices in case they wanted only one. Needless to say, the National Gallery bought none. We also had a marvellous study of a boy, *Young Fitzjames*, by Fantin-Latour from him, for sale at $2,000. It did not sell and a little later he gave it to the Art Gallery of Hamilton. Southam had bought some J.E.H. MacDonald and Tom Thomson sketches from us and already possessed an Algoma canvas, which he later willed to the Art Gallery of Hamilton. Although extremely generous in his gifts, Harry Southam was constantly reselling or trading. We both sold to and bought back from him the finest MacDonald and Thomson sketches, and his reasons for selling are as incomprehensible to me now as they were then. In the early 1950s he sold his entire collec-

132

tion of great French masters and began buying paintings by Henri Masson by the score, giving them to various galleries and universities around the country. Why he bought so many Masson paintings, except that he liked the man himself, and his pictures were inexpensive, is no clearer to me now than any of his other motives in buying or selling.

In 1947, Sidney Dawes paid us $650 for J.E.H. MacDonald's canvas *Lake O'Hara*, which he wanted for the Art Association of Montreal. In the same year, Gerald Stevens, of the Stevens Gallery in Montreal, whose father had once worked for Scott and Sons, bought three J.E.H. MacDonald and two Lawren Harris sketches for a total of $483. In 1950, Coyne bought another MacDonald sketch for $125, as by then prices were slowly rising.

After the war, we began to attract an out-of-town clientele. Sidney Dawes, scion of an old and wealthy Montreal family and a successful businessman in his own right, bought Canadian paintings both for himself and for the Montreal Art Association of which he was a trustee. Dawes was a vital and courageous man who possessed a natural flair for spotting good works of art. In June 1947, he bought three winter scenes by the Quebec artist Clarence Gagnon, for a total of $850, and during the same year four late Tom Thomson sketches of the finest quality, also destined, he said, as gifts to the museum, at $1,200 for the four.

Although I never met Clarence Gagnon himself, his widow became a good friend, and I bought several canvases and at least two hundred small oil panels and gouache paintings from her, over a span of fifteen years. She often talked about her husband, describing among other things his conscientious and careful concern about his painting technique. In fact, it was something of a fetish with him, spending almost as much time experimenting with technical problems as in actual painting.

Recently I was interested to read one of his letters, handwritten in most descriptive English, from his Paris studio back in November 1935, to a person in Regina, Saskatchewan, whom he had never met but whose acquaintance he hoped to make later during a prospective automobile trip to the Pacific coast. It was a chatty and informative four-page letter answering questions about art and artists posed by his correspondent. The first was: Did the artist have a Quebec winter scene canvas available for purchase?

133

Surprisingly the answer was Yes, because all through Gagnon's painting life his uniquely attractive winter subjects were in short supply. Then Gagnon proceeded to offer him his one and only finished canvas available at the time, the now famous Quebec winter scene, *Ice Harvest*, for the sum of $800, and included in the price was the cost of a frame and pre-paid shipping expenses to Regina. He also enclosed a photograph of the picture, wrote a graphic description of the colour scheme, and referred it to related paintings in the Art Gallery of Toronto and the National Gallery of Canada. It turned out that the offer was not accepted, perhaps the prospect could not afford the purchase price at the time, as economic conditions were very bad, especially in western Canada. I well remember seeing the same picture on exhibition at the Montreal Museum some time later and was struck with its brilliant colours and interesting subject matter, but when I enquired about the possibility of purchase, was told the picture had already been sold. Actually it had been bought by the wealthy Montreal collector Harry Norton.

Gagnon's inquisitive correspondent had also enclosed a photograph of a Blair Bruce painting while enquiring about the possibility of buying paintings both by Blair Bruce and J.W. Morrice in Europe. Gagnon volunteered that the subject of the Blair Bruce painting was a spot in the village of Giverny on the River Epte above Rouen and also described Claude Monet's famous garden with its waterlily pond and little Japanese bridge "astride" the same little river. Gagnon said he had never run across any of Blair Bruce's paintings but was always on the lookout for them. As for Morrice pictures, he added, "Those who own some here do not want to part with them; there are not many of them; he has painted at the most 200 pictures and half of them are going to ruin owing to the bad material he used. If I hear of any I shall let you know." He then proceeded to talk about the importance of the technical side of his own painting and described how careful he was in preparing his canvases, even to the grinding of his own colours. Both Cullen and Morrice, he said, told him he was a "fool" to waste so much time on technique and he prophesied that the work of both of these artists would disintegrate into nothing over a period of years.

But Gagnon's ominous predictions that Morrice's work would go to ruin because of inferior materials used has not hap-

36 Clarence Gagnon *Yellow House, Baie St. Paul* 1910

pened, and in fact the 150 or so of the canvases and panels that have passed through our hands have remained in remarkably good condition, and I expect they will stay that way for a long time to come. Indeed it appears that Morrice had achieved a mastery over his own technique that surely would have amazed Gagnon.

Recently I acquired a Gagnon canvas, *Yellow House, Baie St. Paul*, a signed and dated work of 1910. It had remained in the possession of the Wilkie family in Toronto for more than sixty years, bought from the Canadian Art Club Exhibition of 1912, by D.R. Wilkie, who was honorary president of the club. Clarence Gagnon, I am sure, would have been gratified to know that the picture has remained in as perfect a state as when painted all those years ago.

Clarence Gagnon died in 1942, and in 1944 I met his widow, Lucille. She was a pretty little thing, very astute in business dealings, intelligent and strong-willed, but she possessed a deep perception for the quality of her husband's work and had no trouble saying No to the entreaties of people with whom she had no wish to do business. But we had a long association which included many pleasant visits to her studio-home in Montreal. After the war, she returned to Paris to live for extended periods in her husband's old studio in the rue Falguière, where I visited her from time to time in the early fifties. We always had small panels by Clarence Gagnon for sale, handed to us by Lucille on consignment, at prices ranging from $60 to $180, depending on the size and the quality of the picture in her eyes.

France for some time after the war suffered severe economic hardships and almost everything was in short supply. The greatest favour one could do for Lucille was to send over supplies of used clothing, which she would generously distribute among her Parisian friends. In 1945 and 1946 cigarettes were rationed too. Once, on receiving four cartons of her favourite Canadian brand, she wrote, "The French cigarettes are terrible and my ration card allows me, as a woman, only two packages a month; they are handy for tips; anyway the poor French don't know any better. . . ."

Every year she returned to Montreal to see her family. When a move was decided upon from the family house on Metcalfe Avenue to a new house and studio she was building on de Lavigne Road in Westmount, Lucille asked me if I could remove two

136

long horizontal canvases, of Baie St. Paul in winter and summer, that had been pasted to the walls as murals. I was able to do so by loosening the canvases carefully, and slowly rolling them up. The paintings were then lined on new canvases and were quickly sold. Gagnon canvases were always extremely scarce; he had not done many and those that were left, Lucille happily kept for her own enjoyment.

Iwan F. Choultsé was one contemporary artist whose pictures sold at remarkably high prices in the 1930s. He was a Russian émigré living in Paris, said to have been court painter to the Czar. He painted spectacular snow scenes in which the light seems to come from behind the canvas and glow. The critics scorned these pictures as photographic and called them non-art – but today this style of painting is called "magic-realism" and is much admired by critics and museum people. When I was at university I saw a small exhibition of his work at Eaton's, and marvelled at the technical competence of the artist, but my professor of aesthetics warned me the pictures were bogus and would be forgotten in a few years. Today they are more expensive than ever.

Frank H. Johnston, who later changed his name to what he considered the more "arty" Franz, became intrigued with the paintings of Choultsé and carefully studied his technique. What he learned and absorbed from the Choultsé style was to help make Johnston extremely popular and he became a "best-seller" artist of the thirties. Johnston was one of the original members of the Group of Seven, but soon dropped out to pursue his own independent career. Believing in the good life for himself and his family, financial and tax problems plagued him to the end of his days, but he determined to become a painter of pictures that would catch the public's eye and sell – and he did.

If we happened to have a Choultsé in stock and Johnston heard about it, he would hurry to the gallery enthusing in anticipation of discovering further mysteries of the master's technique, all the while murmuring praises of his work. He began to apply the Choultsé style to the Canadian winter landscape and even autumn and spring subjects. Johnston travelled to the frozen edge of Great Bear Lake just below the Arctic Circle and painted trappers and sled dogs mushing through the wilderness (some were done later

from photographs). A long series of exhibitions and sales that he held at Eaton's and Simpsons during the thirties were remarkably successful; Johnston was an aggressive and jovial salesman and happiest in the role of selling his own pictures. A bit of a rake and a great ladies' man, he would appear resplendent at exhibitions, in an artist's tam, a bow tie with long side ribbons, and a well-trimmed imperial beard. By the mid-1940s Johnston was selling his pictures for more money by far than any other living Canadian painter. Feeling that a "poetical" title helped sell a picture, he gave his works the most gloriously sentimental names he could invent. I remember *The Soft Smile of Spring*, for example, and *Under a Mantle of Snow*.

Despite all his ostentatiousness Johnston was one of the hardest working and most enthusiastic painters I have ever known. If one had a customer for a certain type of painting he might stay up and work all night, if necessary, to have it ready for the next day and a sale. He was very much at home in the tempera medium and painted probably his finest works during the box-car trips with Harris and MacDonald to Algoma. In the last ten years of his painting life he used mixed media – parts painted in water-based tempera and parts in oil colours. He fixed the tempera with copal varnish to produce glazes and highlights, and it would be impossible to determine by sight, from the highly varnished surface, which part was in tempera and which in oils. Unfortunately, after a time, the varnish oxidized and turned brown, presenting serious cleaning problems in restoring the original surface effect.

In the late 1930s and early forties, a small dedicated group of alumni set about acquiring Canadian paintings to present to Queen's University. This volunteer committee consisted of Lorne Pierce, the scholarly editor of Ryerson Press, Dr. Dennis Jordan, that elegant gentleman, distinguished physician and sportsman, who wore natty bow ties, and D.I. McLeod, the well-known Toronto financier and amateur artist. These were men of exceptional vision who were buying Canadian art long before the general pub-

37 Frank Johnston *Woodland Tapestry, Algoma* 1919

lic was conscious even of the names of some of our great painters. Among other things they bought from us in 1941-42 were four superb Tom Thomson sketches and the great *Wild Ducks*, which J.E.H. MacDonald had painted in 1917. These paintings now form a distinguished portion of the permanent collection at Queen's, though unfortunately the Thomson sketches, being so rare and so valuable, are seldom, these days, placed on exhibition.

Lorne Pierce loved Canadian art and at his death in 1961, possessed a first-rate collection of Canadian pictures, many acquired from us over a period of twenty-five years. As a man he was a pleasure to know but as he grew older he became more and more hard of hearing and relied on the use of a hearing-aid to communicate. But such was his commitment to humanity, including a desire to help other deaf people, that he was instrumental in founding The Hearing Society, an institution with services that provided help and hope for other sufferers of this dreadful affliction. He was a man of wit, personal charm, and strong will. Deeply religious, he was also a heavy cigarette smoker for years, but once he made up his mind to quit, decided to give the mischievous devil his ear. His method was unusual but for him it worked. He left cigarettes in handy places all over the place and once told me he even placed a package with lighter or matches on the night stand beside his bed to further try temptation. But such was the strength of his resolve that he stopped smoking overnight.

Under Lorne Pierce's editorship, the Ryerson Press began in 1937 to publish small cloth or paper-bound books in the Canadian Artists series. Albert H. Robson was the author of six of these little books; he had had an early association with Tom Thomson and several members of the Group of Seven. Robson was art director of the progressive commercial art firm and printers of Rous and Mann, from 1915 to 1939. I knew him well from his regular visits to our galleries in search of Canadian paintings suitable for colour reproduction in his Canadian Artists series of Christmas cards. These cards were extremely popular in the thirties and forties, and their circulation stimulated interest in Canadian art. In 1932, the Ryerson Press published Robson's *Canadian Landscape Painters*, the very first book of Canadian art in which every illustration was in colour. It was no mean feat to publish such a book in that depressed year, but since the paintings had been previously re-

38 Emily Carr *Yellow Moss* c.1934

produced as Christmas cards and the cost of the plates thereby written off, a limited edition became marginally possible.

Although I did nothing about it at the time, Lorne Pierce was perhaps the one to plant the notion in my head of writing a book about the art world. A great admirer of Tom Thomson, he visited our exhibition several times in March 1937. (A little later we were able to find him a sketch for his personal collection.) He was aware of my own deep interest in Tom Thomson and urged me to write a book on his life and work. "Write your heart out and it is bound to be good," was what he said. But I was far more interested in dealing in paintings, in those days, than in writing.

Through Lorne Pierce, along with Charles S. Band, a client and collector friend, I first heard of the west coast painter Emily Carr. About 1936, hearing of Lorne Pierce's interest in Canadian authors and artists, she had sent him a considerable bundle of sketches of forest scenes and west coast Indian material, as well as a manuscript of stories she had written. Some years later, Pierce told me how deeply he regretted not having paid more attention to both the manuscript and the paintings. The latter were actually priced at $40 each, and he ruefully admitted he had shipped every one back to Victoria. On top of that, he mislaid the manuscript; it turned up at Ryerson's only after much insistent prodding by letter from Miss Carr. The manuscript contained the basic material for the Indian stories in her book, *Klee Wyck*.

It was Martin Baldwin, then curator of the Art Gallery of Toronto, who suggested early in 1943 that I should try to get some of Emily Carr's pictures to sell. "She is a good painter," he said confidently, "and I am sure, some people in Toronto will be interested in buying her work. Lawren Harris is the person to contact."

In 1942, Emily Carr, who had been exceedingly ill, was advised by some of her friends to set up a trust in which to place all her paintings. There were many of them, since nearly all her lifetime's work had remained unsold. Lawren Harris was one of the people who advised her, and he became a trustee, along with Ira Dilworth and William Newcombe. Lawren Harris had settled in Vancouver late in 1940, but had known Emily Carr since her first trip east to Toronto and Ottawa in 1927. She had a high regard for him, and particularly admired the work he did before he turned to abstractions. She also heeded his advice.

I first became aware of the Emily Carr trust, and its role in the dispersal of her paintings, when I wrote to Lawren Harris in March 1943. I mentioned that Martin Baldwin had suggested we ask for some sketches for sale, and added that we would like to have two or three good examples of her medium-sized canvases. Harris replied, enigmatically, as was often his habit, that there were no medium-sized canvases by Emily Carr for sale, except those in the semi-permanent collection of the Emily Carr trust. "These," he continued, "are sold through the trust itself and we hope to send a number of Emily Carr sketches East, and if and when this is done I will let you know." Knowing Lawren Harris as a man of his word, I expected further progress. Since we were showing and selling Harris's own pictures, and were in constant touch with him, whenever we wrote about his own affairs we asked when we could expect some pictures from the Emily Carr trust.

We never slackened our efforts, and he must have been acutely aware of our interest. Finally, in a letter dated December 21, 1943, came the worst possible news. "We had chosen six Emily Carr sketches to send you but Miss Carr objected; she is seriously ill at present and I fear we can do nothing about sending any of her work to you." That was all; he gave no reasons for Miss Carr's objections. Of course she didn't know us, but surely a good word from Harris acknowledging our long interest in Canadian art would have allayed her natural suspicions and assured her that we were no fly-by-night operators. Why, if the trustees had decided to send us the six sketches, had Miss Carr, a desperately ill woman indeed, objected? What could have happened during those few months between April and September to cause this mysterious setback to our Emily Carr plans? The answer soon yielded to a simple explanation.

Before I knew Max Stern was in the picture, the long, drawn-out affair was conducted entirely by letter between Harris and myself. The pictures were simply going to the Dominion Gallery, a firm I had never heard of at the time. Even though Stern's name was never mentioned in this correspondence, I sensed from the beginning there was a clever and tenacious opponent involved. The account of my attempts to get paintings by Emily Carr is really the story of my impersonal and indirect encounter with this European art dealer who, by the fortunes of war, unexpectedly found himself a resident of Canada.

Excluding the paintings still to be chosen for the permanent Emily Carr trust, to be housed at the Vancouver Art Gallery, he was able to get his hands on almost all of the Emily Carrs available, first as her exclusive agent, and later by handling the pictures from her estate. But he did not quite get them all! Our own attempts to acquire a portion of the estate pictures developed into a strange and bitter struggle and we found the dice loaded against us. Max Stern held all the trump cards, and in the end we were lucky to get any of her work at all. Stern's great advantage lay in the fact that he had actually met Miss Carr.

Max Stern's parents dealt in art and antiques in Dusseldorf before the war, and he was brought up in the business. The European method of dealing with artists was stressed, a philosophy based on the technique of a dealer holding complete control over an artist's production.

Shortly before the war the Sterns escaped to England, by way of Holland, I believe, with some but by no means all of their possessions. The pictures left behind were later confiscated by the Nazis. Max once told me that many years later he received about a quarter of their real value from the Government of West Germany.

Detained in England briefly, he was shipped to Canada in June 1940, as a German civilian prisoner of war. The Battle of Britain was raging, and the Canadian government's offer to guard and house civilian war prisoners must have given the British some little relief, but for a German Jew to find himself confined as an enemy alien and a security risk must have been ironic and given rise to some strange and bitter thoughts on his part. But there was a war on. Max Stern remained in a detention camp first in New Brunswick, and then at Farnham, near Montreal, all together for almost twenty-four months, from the summer of 1940 to mid-1942.

On his release, by recommendation of a well-known Montreal citizen who vouched for him, he went to work as a salesman in a recently opened picture gallery on St. Catherine Street West, the Dominion Gallery. It had been established by a Mrs. M. Millman and, according to Stern, business was so poor that her to-

39 Emily Carr *Dawson City, Yukon* 1920

144

tal sales in the six months of late 1942 and early 1943 amounted to a mere $650. When he arrived on the scene things began to change for the better.

There had been an Emily Carr exhibition and sale at the Art Association of Montreal in January 1943, with thirty-three of her finest pictures, both early and late in style, but the later reports were that none of the pictures sold, not an uncommon occurrence when the work of an almost unknown artist is shown in a public institution and no sales promotion takes place. But Max Stern had seen the pictures and liked what he saw. He was struggling hard to establish himself in Montreal, and detected a future in Emily Carr. But Mrs. Millman's little Dominion Gallery had no money for purchases, and neither had Stern. Besides, it was completely against his principles to buy from exhibitions of this kind. Acquire direct from the artist was his dictum. It was in the early autumn of 1943 that he decided to take a trip to Victoria to see if he could get some pictures from Emily Carr herself.

Stern was a suave, highly skilled, experienced dealer. His urgent but quiet manner of speech, in strongly German-accented English, probably had its effect, and, ill and weak as she was, Emily Carr must have been swayed by his show of interest. She certainly liked his offer of another exhibition in Montreal, as soon as possible, with all the pictures for sale.

On his way home from Victoria Stern dropped off in Vancouver to see Lawren Harris, the important trustee of the Emily Carr trust. On top of the Montreal scheme he promised Miss Carr, and then Harris, coast-to-coast exhibition coverage. (Lawren Harris accepted this promise and repeated it to me in a letter.) But it was a promise Stern could never fulfil. That didn't matter at all, though, because people went to Montreal to buy Emily Carr's pictures anyway. Stern's instinct for sales possibilities, especially the more colourful and realistic Indian village scenes, was dead on, war or no war, also the selling prices were very low.

In the spring of 1944, I went to Montreal to see the much anticipated exhibition. The Dominion Gallery was just a little

40 Emily Carr *Trees in the Sky* c.1934

41 Fred Varley *Romantic Coast, B.C.* c.1926

the Permanent Trust, and to help look after Emily Carr herself, who was then so ill.)

But Max Stern had already gained an insurmountable advantage in actually having met Emily Carr in that autumn of 1943, making the trip at precisely the right moment. A newcomer to the Canadian art scene with a fresh eye, he had read her potentials accurately and pressed his advantage, doing an excellent job of imparting his dealing philosophy to both Harris and Carr. He stressed to them both the vital importance of having only one agent for an artist's work and Emily Carr probably agreed to the new Dominion Gallery proposal to retain exclusive and complete control over the sale of her work. Stern made sure that Lawren Harris was aware of the plan, too, claiming Miss Carr's acquiescence. Harris was, as Stern knew, the power behind the trust and the one person in whom Carr placed her complete confidence.

However, in spite of all this, I continued to vigorously press Lawren Harris for some pictures. Finally, on July 15, 1945, he wrote to say there had been a change in the situation; the trustees had selected an additional fifty works for the permanent collection. Then came the sickening news. The next paragraph declared that the executor and the two trustees had agreed to place the remaining pictures in the hands of the Dominion Gallery, Montreal.

Emily Carr died in March of that year, leaving Stern with only Lawren Harris to convince of the desirability of an exclusive agency for the pictures from the estate. He succeeded. For one thing his success, partly through our own buying, in Emily Carr's 1944 Dominion Gallery exhibition, had improved Stern's standing with Harris. For another reason Harris reported that Stern had promised coast-to-coast coverage, which he never provided. Stern also had the advantage of handling all the pictures on consignment, at a net cost for each picture. This left him free to buy any he wished for his own account, when he came into funds, and then later to place whatever price on the pictures the market would bear. Max Stern just couldn't bear the thought of anyone else having any Emily Carr works for sale at this time.

42 Fred Varley *Barker Fairley's Daughter, Joan* c.1923

Lawren Harris then wrote me that "he personally regretted" that we would not share in the disposal of the pictures but that the decision was that only one gallery should be involved. The latter pronouncement was completely hollow to me. On July 17, 1945, I wrote Harris a bitter letter and sent a copy to Ira Dilworth, the other trustee. I reminded him that for more than thirteen years our gallery had been promoting the appreciation and sale of pictures by Canadian artists and for over two years now we had tried to get examples of Emily Carr's work through him, always with some encouragement, but so far with no success. We felt badly discriminated against, I said, a feeling I am sure that neither he nor his friend Ira Dilworth would want us to retain. Finally, I stated that we were prepared to purchase outright for cash from the trust a group of her pictures.

Straight like the flight of two arrows in letters by return mail, both Harris and Dilworth insisted that no discrimination had been intended. Harris, his letter said, had discussed my offer to purchase outright with Dilworth, and the latter had a group of oil on paper paintings stored in his office. "They belong to the Emily Carr trust and are an excellent group, as good or better than any the Dominion Gallery will handle and we will sell them to you for $75 each." Then he went on to say, "There is still another possibility of purchase of seven canvases belonging to the original Emily Carr trust and stored at the Toronto Art Gallery. You are free to buy one or all of them." The seven were magnificent canvases of the 1932-37 period; we bought them all, at prices ranging from $150 to $400. These paintings were so fine in quality that if they had been in Vancouver rather than stored in the basement of the Art Gallery of Toronto I expect that today they would all be in the permanent Emily Carr collection in Vancouver. That furious letter of mine produced some twenty-five paintings immediately, and over the next three months we acquired five or six more. It was a compromise that Lawren Harris and Ira Dilworth happily settled on in the end and we now had enough pictures for other exhibitions.

43 Fred Varley *Immigrants* c.1922

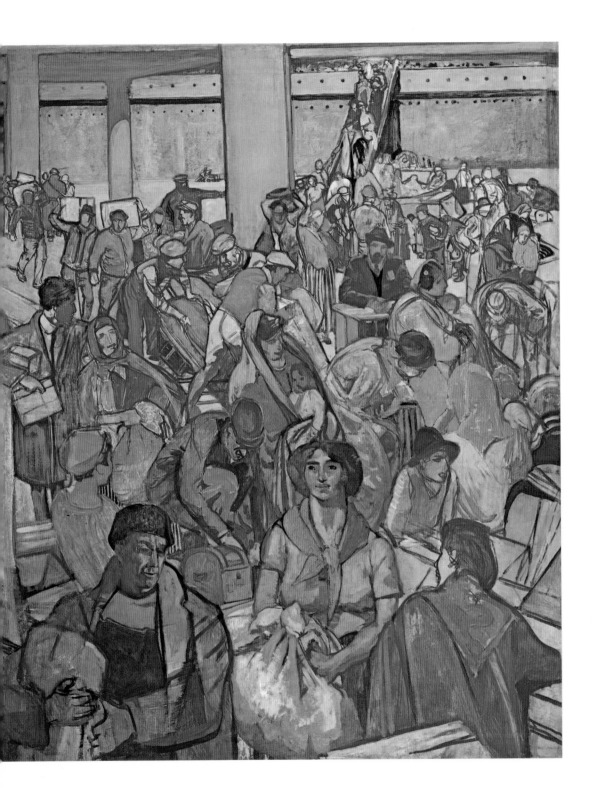

I first met Frederick Varley in 1948, when he was living in a rooming house on Bloor Street East near Sherbourne. He invited me to look at his painting and on this occasion I bought about thirty examples of his work, mostly watercolours, including the original sketch for *Summer in the Arctic* as well as a few oil panels. Varley's work had little value or sale at the time and the artist was desperately in need of money, if only to survive. I later bought an early *Figure Study* from the J. Merritt Malloney family, previously traded to Malloney in lieu of rent money. Later I acquired the large canvas of the Arctic subject and more recently one of his masterpieces, the large *Immigrants*, of 1922, that has been stored, apparently hidden away, for nearly forty years in the basement of the National Gallery of Canada.

We also had *Lady in a Doorway*, a study of Varley's friend, Kathleen Mckay, which we sold to the Montreal Museum. I had no great feeling for Fred Varley personally. Perhaps had I known him in his earlier years I might have learned to understand him better.

On one Saturday morning in May 1955, I was in Montreal and, hoping to renew an old acquaintance, called in at the Children's Art Centre of the Montreal Museum of Fine Arts. There, in a small classroom I found my friend, a tall, slender, slightly bent figure of a man, surrounded by kids, all having fun during a painting lesson. The teacher was, of course, Arthur Lismer and at the age of seventy working as hard as ever and still enjoying teaching his children's classes.

At the time Lismer's paintings were still practically unknown to the public, as it was only in the last fourteen years of his life (he died in 1969) that they began to gain a modicum of appreciation. Northrop Frye, who knew Lismer well, asserted that his place in Canadian art history was assured simply by his great talents as a teacher. Be that as it may, much of his fame now rests firmly on his paintings and many of them would never have come to light as soon as they did without that propitious May morning visit.

I had first met Lismer in 1937, just after his return from a twenty-month teaching sojourn in South Africa and the Antipodes. He let us have several pictures on consignment but they did not

44 Arthur Lismer *October, Muskoka* 1915

arouse even the slight interest the works of Lawren Harris, A.Y. Jackson, and J.E.H. MacDonald created. Prior to 1955, we might have sold at the most five or six of his paintings, a group having been turned over to us by H.S. Southam.

Harry Southam was a dominant figure in the Canadian art scene of his time. He was an Ottawa newspaper owner, also chairman of the board of trustees of the National Gallery, and collected nineteenth-century French and Dutch paintings and bought Canadian art as well. H.O. McCurry, a fellow Christian Scientist, looked up to him at the time with great deference. He was a man of fine bearing and strong personality who certainly loved paintings but could be unpredictably temperamental if things didn't go his own way. For example, he had a considerable collection of important Lismer canvases, but had a falling-out with the artist for some unknown and probably stupid reason, and so in 1950, he began to dispose of his Lismers to us. The arrival of these pictures at our galleries and their eventual sale re-awakened our interest in Arthur Lismer's work.

In 1950, the Art Gallery of Toronto had held a Lismer retrospective including fifty canvases, twenty-eight sketches, and some drawings and watercolours, but except for friends of the artist, and of course his students, the exhibition was largely ignored by the press, the critics, and the public. We lent two of the canvases Southam had sold us; they were for re-sale and our name was printed in the catalogue as owners, but no one so much as enquired prices. Prior to that the Art Gallery of Toronto had paid scant attention to Lismer's work, and by 1929 it had only one important work in its permanent collection. In his usual generous way Lismer had presented the gallery with some of his sketches, and later the gallery bought two or three additional canvases, but it never acquired any of the great works painted before 1920. And yet Lismer had been vice-principal of the Ontario College of Art from 1919 to 1927, with an office and studio just next door to the Gallery. The National Gallery of Canada, on the other hand, recognized his qualities and bought his work as early as 1914. Another case of the prophet without appreciation in his own country.

Yet during his early years before 1920, despite limited painting time, his youthful creative energy produced a remarkable volume of work, including masterpieces like *Sunshine on the Logging*

Road, Algonquin Park, 1914; *Sumach and Maple, Huntsville,* 1915; and *Snow and Back Fence, Thornhill,* 1919. While living in Nova Scotia he painted other fine works: *Spring on Sackville River,* 1916; *Logging, Sackville River,* 1917, and some great Halifax harbour pictures with camouflaged warships and tugs. Lismer went to Halifax early in 1916 to become principal of the Nova Scotia College of Art. The story is told that he escaped almost sure death in the explosion of December 6, 1917, by the merest fluke – he had the day off and stayed home in the house he had rented at the head of the Bedford Basin. Going through that disaster, if only on the fringes of it, must have been an awesome shock for such a gentle soul. Before 1930, Lismer did other Quebec, Algoma, Lake Superior, and Rocky Mountain subjects, nearly all of which we were later to have for sale.

Why was it then that his work continued to be almost un-known to the public? One reason was that after the mid-1930s his production fell off drastically and, unfortunately, so did the quality of his work. Also, further interfering with his output, was his ab-sence from Canada for long periods of time on teaching and other related assignments. The main problem was that he had so little time to himself and was forced to become a summertime painter only, painting pine trees, rocks, and inlets in the Georgian Bay, particularly McGregor Bay at holiday time, Atlantic coastal sub-jects, and, later in the fifties, the west coast of Vancouver Island.

But Lismer cannot be blamed for failing to paint more; he was a completely impecunious man, and early in his lifetime be-came resigned to the fact that he would never be able to earn his living by his brush. Of necessity from his early days he became so involved in teaching that at the end of his life he was known to sev-eral generations of children as an art teacher rather than a painter. Happily for him, he loved teaching and had a genius for it.

As a young man, closely associated with Harris, Jackson, Varley, and J.E.H. MacDonald, the last of whom he revered, he met Tom Thomson and painted with him in Algonquin Park in the spring and autumn of 1914. Lismer was already an accom-plished draftsman, and like Jackson had had considerable formal training in Europe; there is no doubt that Lismer, who was a born teacher, taught Thomson informally something of Impressionist technique and that Thomson, the truly original artist, soaked up

the lessons so attentively and turned the knowledge so subtly to his own style that no sign of outside influence can be found in his work. (I later got from Lismer some of his 1914 9″ x 12″ panels, including a painting of Tom Thomson's tent in the bush, painted in May of that same year.) After his return to Toronto from Halifax in 1919, he found time for brief trips with his painter friends, but from 1928 and up to the mid-thirties he produced only a limited number of large paintings compared to the vast production of A.Y. Jackson and Lawren Harris, both of whom were painting full time.

Though Lismer sold almost nothing to the public during the first thirty-five years of his painting life, he was a constant exhibitor at all formal society and group shows. Invariably his pictures came back unsold and unnoticed. Yet by the end of the Second World War, when we had pretty well given up all attempts to sell his pictures and returned those we had to him, we still remained on extremely good terms; he took this indifference by the public in his stride. He understood we were dealers, appreciated our efforts, but unlike, say, A.Y. Jackson, knew we were merchants who needed saleable pictures in order to remain in business. There was not a trace of bitterness in him; he was a man completely without avarice; teaching and painting were truly what mattered most to him, and he was generous beyond belief. On three different occasions he gave me my choice of a sketch as a gift, one a 1923 Algoma subject of a small waterfall and rapids, and two other Georgian Bay shoreline subjects. He attended the opening of an exhibition we held later, in 1960, of his black and white pen drawings and watercolours, which was almost a total failure from a sales standpoint, and he spent his time making drawings of children who happened to be there on the occasion, giving them later to the children as gifts. All in all he was one blithe spirit.

By 1940, Lismer had moved to Montreal and we did not see him for a long time. However, at our meeting in Montreal that May morning of 1955, he was, for his age, most alert and energetic, and displayed a quick wit. The owlish silver-rimmed spectacles hovering on the end of his nose, the rumpled clothes that never quite fit his ungainly figure, the wisps of long hair that he flopped over his high bald dome to simulate some growth there, the happy, puckish look in his grey-blue eyes, all combined with a sort of intel-

45 Arthur Lismer *McGregor Bay* 1933

ligent mischief into a figure that seemed especially appealing to children.

A pipe was in his mouth or by his side at all times; the lesson over that morning he invited me to his studio office and there we sat down while he filled it. This ceremony finished, I asked optimistically if he had any early paintings that he might wish to sell. He pondered for a moment, I remember, and said, "Yes, that's possible. Come to lunch and we'll talk about it." After lunch and some introductions to professor friends at the McGill Faculty Club, we returned to the museum and immediately went down to the basement, protected even in those days by an attendant, who unlocked a large sliding metal door to let us into the storage area. In an ill-lighted corner, piled against one another, unframed or lying unstretched in large rolls on the floor, were a great number of early canvases, dating, as I found out later, from 1913 to 1935. I surveyed them, in my usual rapid manner when I first look at pictures, and my very first impression told me that once again I had made another artistic discovery which was infinitely more significant than I had reckoned on.

"Dr. Lismer" (by which title I called him then), I said on our return to his office, "I would like to buy them all and would appreciate it if you would give us a little time to pay for them." "All of them?" he said, looking at me quizzically, taking a couple of puffs of his pipe, looking at me again to see if I was indeed serious, and said, "Yes, if you wish," adding that this was the first time he had sold any pictures outright to an art dealer. Like Lawren Harris, in a somewhat similar situation twenty years earlier, he seemed somewhat taken aback that anyone, let alone a by now experienced picture dealer, would want to buy all these early works from him. I suggested to him that we do a large retrospective show, well advertised with emphasis on sales, to give the public some idea of his early work and also a chance to buy.

Within a week, or ten days at the most, we received two large cases containing the pictures, all soon to be put in order by cleaning and in some cases relining and restretching. There were forty-four canvases all together, a major portion of his important works painted between 1913 and 1935. Many had been exhibited and retained the old exhibition labels. All had been removed from their frames, and most from their stretchers as well, rolled up to

46 Arthur Lismer *North Shore, Lake Superior, October* 1927

save storage space. Some of them had been quite forgotten, stored away as they had been for so many years.

I did not even enquire the prices he had in mind; I knew perfectly well that his was not a grasping hand for money, and a little later the list we received of suggested net prices named extremely modest figures, even for 1955. I later learned that he had told his wife and daughter Marjorie (whom I had known as a fellow student at Victoria College) that he had placed his normal selling prices on the pictures and was a little embarrassed at the thought that we might not be able to get rid of them. He was later surprised and delighted to find the public at last interested. Furthermore, like other older artists who keep on producing, he felt (mistakenly) that his recent work was better and therefore entitled to higher prices, and he said he didn't mind the "stockpile of my early work," as he put it, "disappearing."

For an artist, appreciation of his work, however late it may come in his lifetime, is a sweet and welcome event, and the public appreciation of Lismer in the last few years of his life was strong and generous. During our 1955 exhibition people came from all over the country to look and buy. The important canvas, *Cathedral Mountain*, was acquired by the Montreal Museum through Sidney Dawes, after it had lain unnoticed in the basement of that institution for all those years. Where another man might have felt upset or resentful by this happening, Arthur Lismer was amused by it all.

Lismer always knew exactly what was going on and wrote us cheerfully on June 19, 1956 about another of his important pictures we had sold: "We have the Mendel collection [now a public art gallery in Saskatoon] on view at the museum – and I found the large *Bon Echo* canvas with figures on the dock taking up a large space therein. They are getting around."

A little later, in 1956, I bought over one hundred early sketches from him, including examples of his Algonquin Park, Nova Scotia, Algoma, North Shore Lake Superior, and Georgian Bay periods. His net prices to us on those superb sketches ranged from $25 to $60 each. My father used to keep track of the Lismer inventory and on several occasions in the late fifties noted: "Blair came back from Montreal with the following Lismer paintings." Of course after 1955-56 all the pictures were later examples

162

painted from 1940 on. And they were just not as good; Lismer, again like Harris and Jackson, lived in the present, as far as his work was concerned late in life. I do not think any of the three could personally judge the difference in quality in their late years.

I used to visit Lismer at his apartment on Fort Street, just off Sherbrooke, where he kept many of his sketches in a cupboard in a small painting room overlooking the backyards and lanes of downtown Montreal. He told me he also had some in storage in the basement. When I enquired the date of certain pictures he would say, "I must consult the Oracle," that being Mrs. Lismer, who had a prodigious memory for places and dates. Though Lismer had his autocratic side, especially in dealing with members of his teaching staff, his wife Esther could be something of a small tyrant herself; she ruled the home roost, but they were a very close couple and he was devoted to her. During the early 1950s he took summer trips to Vancouver Island by train, because Mrs. Lismer would never fly, and it was always his pleasure to accompany her. They rented a small cottage at Wickaninnish, on the southwest coast, and Lismer painted coastal still-lifes, skunk cabbages, and forest landscapes. Lismer told me that when he stopped off in Vancouver on the way back to see his old friend Lawren Harris, Harris always made the same little joke: "And how did the painting go this year at 'wicked spinach,' Arthur?"

Before 1955, Lismer had been the unknown member of the original Group of Seven; he sold almost nothing for thirty-five years; yet reacted very positively to my approaches, and when later he saw the selling prices we placed on his pictures it was with surprise and wonder that we thought so much of his work as to dare to ask such sums, and that people might be prepared to pay them. And it never seemed to occur to him that he might have asked more for himself. I was glad that as the result of our buying in those years from 1955 on he was a little more secure and comfortable towards the end of his life. In addition, he was soon to be besieged by people knocking on his door seeking to buy, as well as dealers begging for pictures to sell.

47 James W. Morrice *A Café* c.1906

9

We Expand Internationally

Slowly, but ever so slowly, after the war years the art business began to improve. In 1947, my father decided, for succession purposes, to put the business in my name, though he was to continue to play an active role.

In 1949, we bought a Victorian house with large frontage at 194 Bloor Street West, where for years the genteel Mrs. Lillian Billings had conducted an exclusive boarding house. The lady having recently retired, we were soon able to have the old place demolished and start building a gallery. In May 1950 we moved into our Gordon Adamson-designed, modern three-storey building, the first such place built expressly as a commercial art gallery in Canada. The second floor was rentable space and the third, reached by a small elevator, comprised a penthouse apartment for my parents. It was so modern at the time that classes from the School of Architecture used to come and admire the building and study the interior lighting system. We were now ready to begin in earnest our new and ambitious role – we wanted to make our establishment the first truly international private gallery of consequence in Canada, in the sense that we would deal in various British and European schools of art and different media forms, including drawings and watercolours and, later on even sculpture, while all the time maintaining our strong position in the Canadian art field.

Successful art dealing is, in general, a highly personal and private business and picture dealers tend to be an egocentric lot, relying mainly on their own tastes and specialized knowledge. However, we all have our special friends and allies in the profession with whom we closely work. For me there were two men whose influence as dealers and friends helped develop the potential of any talents I possess. These two were Peter Eilers and D.C.T. Baskett, one a Dutchman and the other an Englishman.

Peter Eilers, the Dutchman and head of the old Van Wisselingh firm of picture dealers in Amsterdam, resumed his annual trips to Canada with a collection of French Impressionists and twentieth-century School of Paris masters. In Montreal he was showing with William Watson, and in Toronto at the Roberts framing gallery on Grenville Street. Guy Roberts had inherited the business from his father, and he, and especially his wife Jinnie, looked after the customers. At one time they had the best framing workshop in the country with their Scottish carver Alex Campbell, who made hand-carved gold leaf frames. Campbell later opened his own shop in the basement of the J. Merritt Malloney Studios on Grenville Street just west of Bay. Mr. Malloney used to have the occasional exhibition of Canadian pictures, but they did not sell and he made his living by renting out studios to artists, such as Franz Johnston, André Lapine and Fred Varley, but his main business was catering for parties and receptions. Two or three years after the war, Guy Roberts sold out his business for a pittance to realize his dream of opening a fishing lodge on Vancouver Island and get away from it all. I thereupon invited Peter Eilers to have his next exhibition with us. It took place in 1947, and that year began a long and productive association.

Peter Eilers was a big, rugged man of fine bearing and courtly manners. He wore impeccably tailored double-breasted dark suits, and had a sense of humour and a deep, inimitable laugh that boomed through a room. When he was thinking out a problem he would pace the floor with his hands clasped behind his back.

As well as his knowledge of French painting of the nineteenth and twentieth centuries, he was also an expert on the Dutch masters, Jongkind and van Gogh. Peter Eilers was a tenacious salesman, correct and patient in an old-worldly way. He seemed to

166

inspire a special kind of confidence in his clients, who invariably came to like him and looked forward to his annual visits. In those days it took time to sell a painting and it was essential to take it to the prospect's house, find a suitable place to hang it, and see that it was properly illuminated. Peter Eilers managed all these details deftly and would stay up all night in a client's house, if necessary, to make a sale. I remember him once staying up until four o'clock in the morning at Moffatt Dunlap's house on Forest Hill Road. Dunlap's father had been one of the original shareholders in the Hollinger Gold Mines and became very rich; the son developed a taste for French paintings and had already bought one of Alfred Sisley's shimmering Loing River landscapes from Eilers. This particular evening Eilers was showing him van Gogh's *Iris*, from the late Arles period. The price was $65,000. They reached an agreement in principle, and were going to close the deal the next morning, but Dunlap, in a state of self-doubt, telephoned his lawyer, a partner in an old conservative law firm, who advised against it. "Too much money for any painting," the solicitor said. *Iris* remained in Canada, however, and H.O. McCurry recognized its quality and promptly bought it for the National Gallery.

Peter Eilers used to travel throughout Europe in search of paintings, but it was in Paris that he found the best works for his Canadian exhibitions and also for his gallery in Amsterdam. The Van Wisselingh exhibition of French art in 1947, was the first French show we had held since the Durand-Ruel exhibition of 1936 and the Jacques Dubourg exhibition of 1938, and we carried on with annual Van Wisselingh exhibitions until the early 1970s. By that time good pictures by French masters were becoming so scarce and expensive that an exhibition every year was just out of the question.

Besides the van Goghs, I remember other Sisleys, Pissarros, Renoirs, Degas, Fantin-Latours, and Boudins. Then there were the twentieth-century artists, Dufy, Marquet, Matisse, and Picasso. Prices ranged from $2,000 or $3,000 to $50,000 and more. In the late 1940s there were only a small number of potential buyers – besides Moffatt Dunlap and members of the Osler and Matthew families, and Mrs. John David Eaton – perhaps a dozen at the most in all Toronto. We made no sales whatever to the Art Gallery of Toronto.

There must have been something about Canada that Peter Eilers liked, but it could not have been the ease with which he sold pictures here. He had first come as a young man in 1933, with his father and the well-known French dealer Etienne Bignou, a man of elegant mien who dressed like a count, wore spats, and carried a cane. The Van Wisselingh Company had opened in Amsterdam in the 1880s as makers of fine furniture and dealers in pictures, particularly the Hague School. Eilers senior branched out into the French school through an association with the Goupil firm in Paris, which then employed Theo van Gogh, Vincent's brother, as a salesman. The Eilers helped build the spectacular H.S. Southam and the Gordon C. Edwards collections in Ottawa, many of whose pictures now enrich the National Gallery of Canada. Peter Eilers carried on the firm after his father's death in 1936. By the mid-1970s there had been a great change in our pattern of doing business together; for certain works of art, business is now much better in Europe than in Canada and we have regular visits from Dutch, French and English dealers seeking to buy rather than sell here. Of course there were some good Dutch pictures sold in Toronto but many more in Montreal during the later years of the nineteenth century and well into the late 1920s. Early in 1977, I bought paintings by the Dutch artists Maris, Bosboom, Mauve, and Israels, which had originally been acquired by the Greenshields family of Montreal as early as the 1880s. There was no market in Toronto so I sent them to my colleagues in Amsterdam to sell.

I did not actually journey to England and the continent, those great reservoirs of works of art, until 1950, and one of my lasting debts to Peter Eilers is that through the years he took much time to introduce me to all parts of his own country as well as France, the country he loved best, next to his own.

We had always wanted an English affiliation and as early as the late 1930s had formed a tenuous connection by correspondence with the prominent English art firm, Thos. Agnew and Sons. They chose and sent us some Old Master paintings on consignment, but because they did not know the Canadian market (such as it was in those days), plus the general uncertainty of the times, our association never had a chance to develop. Also, around the same time we

used the services of a London art commission agent by the name of James Abbott, to try and buy some pictures for our account in the London sale rooms. But again the pictures he acquired were dull and unsuitable for our market. Then finally, before the war in 1939, my father travelled to London with a relatively small sum of money in his pocket to see what he could buy. At that time, the bank would extend us no credit at all and considered the buying of pictures a frivolous waste of money. However, my father was fortunate enough to contact a young dealer in Brook Street, London, who was willing to gamble on a trip to Canada, bringing a large collection of miscellaneous paintings assembled by borrowing from artists and other dealers. His name was Alex Fraser, and he came over to help with sales. He was eventually caught up in the war and remained in Canada, finally settling in Vancouver where he later opened a gallery.

It was not until late in 1950 that we got our first real boost from England in the form of active help from our new friend D.C.T. Baskett, partner in the P. & D. Colnaghi Company. Nothing now could hold us back, as we began our strong and active move to buy in the London art market, and soon under the joint efforts of our two firms there began a steady flow of fine and saleable paintings to our gallery in Toronto.

On looking back through the years, I think unquestionably the occasion that provided the most lasting impact on my business and private life was the result of my discovery of the London art world, with its subsequent revelations, encountered, quite by chance, during my trip overseas in the summer of 1950, when I met D.C.T. Baskett.

The weather was lovely in London, when I arrived on a June day, and I walked from the Savoy Hotel to Old Bond Street, gazing in the gallery windows. I stopped in front of one, which had in its window a landscape with a high, billowy sky. This was the premises of the P. & D. Colnaghi Gallery, and when I walked in, I was greeted by an open-faced, friendly man, with snow-white hair, who was wearing a dark suit, and who introduced himself as Tom Baskett.

D.C.T. Baskett was a remarkable man who contributed much to my education as an international dealer. He taught me facets of the London art world I never would have discovered with-

out the generous sharing of his extensive knowledge, gained by years of practical experience. Tom Baskett was one of the most talented art dealers I have ever known and together we would build up a partnership, which, before it ended, was to stimulate the development of the art market all across Canada.

Baskett's father was an artist, who apparently wandered away from his family very early in life. At the age of seventeen, Tom fought at Gallipoli, contracted malaria, and was invalided home. He joined Colnaghi's firm after the war. This establishment, probably the oldest firm of picture dealers in the western world, was much esteemed. It was Colnaghi's, which, in the early 1930s, negotiated with the Russian government, then in need of foreign exchange, for paintings from the Hermitage collection. Several complicated deals were made, in utmost secrecy, in Berlin. In collaboration with Bernard Berenson, Colnaghi's supplied many of the finest paintings that went into the Isabella Stewart Gardner Museum in Boston. In the early fifties, they were involved in buying a collection of Old Master prints and Rembrandt etchings from the Prince of Liechtenstein.

It was not easy for a young man to learn the art business in the early twenties, especially in England, when senior partners could be distant strangers and very autocratic. The two dominating partners in Colnaghi's then were G.M. Mayer and Otto Gutekunst; only the most important clients to appear at the firm's luxurious quarters in New Bond Street ever saw them.

Tom Baskett had a natural flair for spotting good pictures, and became expert at judging drawings and watercolours. It was greatly due to his hard work and ability that the firm survived the hard years of the thirties – Mayer went into personal bankruptcy and Gutekunst left England for Switzerland before the war, taking some of the finest pictures with him and hiding away others. Many were not found until the war was over. Colnaghi's had to move to more modest quarters, shared with the London branch of Knoedler's, at 14 Old Bond Street. In the late thirties Tom Baskett was made a full partner and became the dominant leader in re-establishing the firm's former eminence.

In 1950, Baskett had three partners. The venerable Gus Mayer, a stocky man, by then in his mid-seventies, so short that as a young man in his courting days he had taken boxing lessons in

order to hold his own with taller rivals, had made a financial comeback after the Depression and was going strong again. He used to take us to lunch at the Basque, a small French restaurant in nearby Dover Street. He loved the wines of the Rhine, and before leaving for lunch would take two or three bottles of his favourite "hock" from his wine cellar in the sub-basement of the gallery, put them in a small black bag, and carry them to the restaurant. On arrival, he would hand the case to the wine waiter, who would immediately place the bottles in the appropriate silver ice bucket to cool.

The second partner, Harold Wright, was head of the Old Master print department. He was a courtly kind of man, somewhat younger than Mayer, who used to turn his experiences in the art world into short mystery stories. Each year he had one printed up as a Christmas message. The third and youngest partner was James Byam Shaw, a scholar and Oxford man, who headed up the Old Master paintings and drawings department. He had written a book on Francesco Guardi, and his opinion was sought by museum people in Europe and North America.

So it was the individual qualities of each partner that made Colnaghi's of that time such an outstanding firm. But the clearest vision and the greatest ambition remained with Tom Baskett. He was always in process of self-education, constantly looking at good pictures in museums and art exhibitions. He would think nothing of making trips abroad for special showings, and I remember once in the mid-fifties I accompanied him to Holland to see the great Rembrandt exhibition to which the Soviet Union had lent, allowing for the first time some of their Rembrandts to leave the country. It has been said that Colnaghi's was "one of the most delightful places in Europe for those who like the best and find it none too good."

The London art world belonged to the many small private firms in the later forties and early fifties, before the big auction houses became so powerful. When any special picture happened to come up for sale, news travelled fast, especially through various dealer alliances. Tom Baskett always had his ear to the ground and had the knack of closing his deals quietly, efficiently, and usually on the spot. He had close connections with many single agents, called "runners" in the trade. These people combed the

countryside (with varying degrees of knowledge and success), checking all the small shops and visiting the local country auctions. Many a promising find came Tom's way through these agents; they knew they would get a fair price, and immediately in cash.

The painter whose landscape I had admired in Colnaghi's window was the Norfolk artist, Edward Seago. Baskett, his dealer, and adviser, subsequently offered to arrange a meeting, with a view to a possible exhibition in Toronto. As it happened I was in London only briefly, on my way to attend a conference in Paris and to visit several other European countries in my official capacity as chairman of the Toronto Board of Education. But I told Baskett I would be back.

The next day I was off to Paris. I will always retain in memory the thrill and pleasure of seeing Paris for the first time. The great avenues and open squares, the streets of Montmartre that made me feel I was walking right into one of Maurice Utrillo's famous street scenes, fascinating shops showing things, which, in 1950, we never saw at home, and all the while trying out my "Linguaphone French" that I had been practising so diligently for some months before the trip, and the effort turned out to be a rewarding one.

Over the years I have always had a strong liking for Paris, and it is an affection I retain to this day. The great city has always brought me good luck, and I am therefore highly biased in its favour. Also, the good will I hold for the French has been returned in kind, augmented by profitable business transactions with my Paris colleagues from whom I have bought so many Impressionist, Post Impressionist and School of Paris masterpieces, as well as works by J.W. Morrice. These activities for me make Paris a rewarding and exciting place to revisit.

Paris has a flavour different to that of any other city I know. Not large in area, one can walk with ease in a few minutes from the Place de la Concorde over one of the Seine bridges to the Left Bank and, today, still see the world of J.W. Morrice, unchanged as it existed during his lifetime. It is a city peopled from all countries of the world, but something happens in the end to all who live there – they become *Parisiens*, pure and simple.

Early in July I returned to London, and Tom Baskett took me by train up to Norfolk. Seago's was the first painter's

172

48 James W. Morrice *Le Pavillon de Flore, Paris* c.1906

studio I had visited outside Canada, and I was impressed. It was all so different, and little did I dream that I was about to embark on a business relationship with this talented artist and enjoy a friendship that was to last for the next twenty-four years.

Seago, dressed in a Harris tweed jacket with leather patches at the elbows, in the fashionable English country-squire manner, met us at the station in Norwich and drove us to The Dutch House, his seventeenth-century red brick home in the village of Ludham. This house was probably built by one of the Dutch engineers who came to England in the mid-1600s to drain the marshes, and so create the farmlands and waterways of the region, resulting in the expansive Norfolk Broads. The house itself was full of all sorts of treasures, sculptures, rare glass, exquisitely coloured paper weights, Delft china and many eighteenth- and nineteenth-century English and French pictures and drawings. Seago himself was a thoughtful host. We were led up to our rooms by a steep, narrow stairway up which you had to pull yourself by a thick ship's rope, anchored in the wood by two heavy bronze collars. The bedrooms were beautifully furnished with daily fresh flowers on the dressing-tables. Good watercolours hung on the walls and bits of interesting bric-a-brac were everywhere. Breakfast at The Dutch House was a simple affair served in our rooms, lunch was a hot meal provided by Miss Thompson, the cook, and dinner was again a plain and simple meal heated on a hot plate. Apart from this, the numerous details to make guests comfortable were the work of Peter Seymour, Seago's long-time companion and secretary.

In Seago's large and lofty studio there was a balcony that could be reached only by pulling on a rope that released a suspended ladder. I later found out that this was where he kept examples of his work he had personally discarded. He had two easels; one for painting on and the other for showing his finished work. He pulled out, one by one, his recently painted canvases or panels from a slotted storage cabinet and carefully slipped each one into the correct sized frame, fitted with glass, and placed it on the easel for us to study. He always showed his pictures behind glass because he felt it made the painting look richer in texture.

Seago was a medium-sized man, but rather strong and athletic looking in spite of the fact that he had had serious illnesses,

especially in his childhood, sometimes spending long months at a time in bed. He had the high forehead of a thinker and was a creator and innovator in almost everything he did. His was a clean-shaven face with keen blue-grey eyes. He greatly enjoyed his pipe and especially preferred the "sweet-smoking" corn cobs, which he found difficult to buy in England but with which later I was able to keep him supplied from Canada.

He had many hobbies: for example he could build magnificent kites, and fly them at dizzy heights on the windy Broads. He piloted airplanes, drove cars with a professional racer's skill, and he was also an able and daring sailor.

During the more than twenty-three years I knew him I must have visited Ted Seago in Ludham at least forty times, and always came away in a relaxed frame of mind with plenty of pictures to take back to Canada to sell. Days were spent looking at his work, visiting nearby places of interest, sometimes dining out in country inns, and carrying on little business talks during walks to the end of the exquisite garden.

There was always a row-boat moored to a small wooden dock on his own stretch of river-bank, and there was his splendid sailing yacht *Capricorn* anchored a mile or so away. Seago used to take *Capricorn* on painting trips from Yarmouth and Pin Mill down the east coast to London, sometimes in very rough weather. He crossed the Channel many times to France and Holland, sailing the Dutch waterways to paint the ancient towns of Gouda, Hoorn, Dordrecht, Amsterdam, and Rotterdam. His skill as a seaman and navigator was legendary and once saved his life and that of his crew in a harrowing experience in the English Channel. In October 1951, he had set sail for Holland at night, and about seven miles off the coast of England hit some heavy object below the waterline on the starboard side. It was only with the greatest skill and luck, and the help of his pumps, that he managed to get *Capricorn* back to the coast and beach her. She was finally salvaged and repaired and the next April Seago triumphantly sailed her across the Channel again and up the Seine to Paris, pausing on the way to paint river scenes as the Impressionists had done seventy to eighty years before. In May 1952 *Capricorn* was moored near the Pont de la Concorde, Paris, where G.M. Mayer, the senior partner of Colnaghi's, and I had a delightful lunch on board. (This was on the occasion of the Cognacq sale of French masters.)

Some of Seago's finest paintings were done at various places on the Seine, from Honfleur to Paris, as well as marvellous street scenes in Paris itself. He also painted in Portugal, Spain, Italy, Greece, North Africa, as well as in the far east. In December 1956, he was a guest of Prince Philip on the royal yacht *Britannia*, sailing as far south as Antarctica by way of Hong Kong, Burma and Bangkok. He painted remarkable works as a result of this trip. As well as paintings of those places mentioned there were others of icebergs, various British naval bases, and the sea itself. Many of the pictures, from sketches made on board the *Britannia* during this journey, are now in the Royal Family Collection. We also had about fifty paintings from this journey, which we exhibited and sold in Canada.

For the coronation of Queen Elizabeth in June 1953, he moored *Capricorn* on the Thames at Chelsea, and used it as a base for his work in London. He did some spectacular pictures of the guardsmen in scarlet, trooping down the mall on their horses, as well as other great regal processions.

Seago's friends in military circles were people like Field Marshal Sir Claude Auchinleck and Lord Alexander; and in the theatre, Noel Coward. Royalty visited him as well, and he was received by the Queen Mother, an old friend of his, on regular visits to Sandringham. Prince Charles, to whom he once gave a painting lesson, recorded in the press that he sat and watched enthralled as Seago painted a picture of Thames barges in an estuary, entirely from memory.

On my first visit in July 1950, we agreed to an exhibition in Toronto the following November. Characteristically, Seago put all his energies to work to make the show a success. Lord Alexander of Tunis, at that time Governor General of Canada, was an old friend and painting companion from the war years. Such was the depth and warmth of their friendship that Seago had merely to write him a note asking him to do the honour of opening the exhibit and it was done. On November 20, in our elegant new gallery, amidst three hundred invited guests, Alexander made an eloquent speech lauding the importance of the role of painting in general and the work of his friend Seago in particular. The occasion was a smashing success.

This was Seago's first exhibition in Canada and only his

second in North America, the first being in New York in 1937. He was completely unknown at the time but sales were good, Alexander himself buying one of the pictures. We held exhibitions in Toronto nearly every other year, the last and probably the finest being in May 1973. As Seago grew older his paintings seemed to get better, more colourful and livelier, and his subjects more and more varied. In his last exhibition with us he had several landscapes with full-blown poppies, their red faces dancing in breezy, sunny fields. He would never have attempted such a subject ten years earlier. "Too pretty," he once told me, but I suggested to him that if Claude Monet had used the subject successfully, "Why can't you?"

When Tom Baskett died in 1962, Colnaghi's carried on for several years as Seago's London agent, but the partners had lost interest in his work and were turning exclusively to Old Masters. In 1968, a private London dealer, the successful Edward Speelman, approached Seago with the suggestion that Marlborough Fine Art would be the best firm to represent him in England and intimated that they would also be able to arrange, through their various branches, exhibitions of his work in Europe as well. Harry Fischer, a Marlborough partner at the time, told me he had agreed to reward Speelman with a "rake off" on the Seago pictures Marlborough would sell, should he be successful in convincing the artist to make a decision in their favour.

At about the same time, in an unguarded moment at the opening of the Dame Barbara Hepworth retrospective sculpture exhibition, at the Tate Gallery, attended by a large number of leading sculptors and artists, dealers, and other invited guests, I must have mentioned within Fischer's hearing that Seago was considering the appointment of a new London dealer. It was no secret that my personal preference was Agnew's.

Shortly afterwards Seago wrote me a furious letter accusing me of meddling in his London business affairs. I wrote a letter of apology, protesting the highest regard for his welfare both personally and as an artist, and declaring that my words must have been maliciously distorted, which was exactly what had happened. He accepted my explanation, and we continued our close association to the end of his life.

In June 1973, I saw him in Ludham and gave him a report on sales of the recent show in Toronto. When I asked how he

was, he told me he did not feel well, that he seemed to be losing his sense of balance. Shortly afterwards he left to spend a few weeks in his villa in Sardinia. In early September he was operated on there for a brain tumour, and flown to London soon after. It was malignant, and, sad to relate, he lingered on for another four months until January 1974, when he died.

Seago had a great zest for life; besides his paintings and great and abiding love for his Norfolk homeland, he wrote and illustrated books, designed stage sets, enjoyed the theatre, ballet and circuses. (In his earlier days he frequently painted dancers and circus people.) He had an enquiring mind and talked on many subjects, though he was completely self-taught as an artist and also self-educated. Very strong-willed and forthright, he was also a good listener, and kind and generous to young people. He brought a young boy, Edward Tsui, from Hong Kong, whom he felt sorry for because of the lack of opportunities there, paid for his education as an engineer in England and gave him a home, until he returned to Hong Kong, and a good job. Seago admired the work of other artists, particularly Constable, Bonnington and Boudin, and continued to add both paintings and drawings to his private collection until the end of his life.

His annual London exhibitions were always great selling successes and buyers queued up on Old Bond Street waiting for the gallery to open. The public loved his work but the art critics were usually cold in their reviews, perhaps suspicious of his great popular appeal, and this lack of approval from the critics troubled him grievously. But today his reputation rests secure and with passing time he will be ranked higher and higher among twentieth-century English painters.

Edward Seago was a prodigious worker and apart from travelling, spent hours every day at his easel, or drawing and sketching out of doors. His lifetime's production must have been as great as any of the French Impressionists, or Eugene Boudin, the Honfleur painter whose work he so much admired. He was just one of those artist geniuses whose very nature compelled him to paint to express himself. Like most dedicated artists he never painted a picture because he felt it would sell. He believed only in striving for his best effort at all times. To give the reader some idea of the volume of Seago paintings shipped to us from across the Atlantic dur-

ing the years, a cablegram dated October 31, 1951 from Colnaghi's reads, "We have despatched to you today ninety-one pictures by Edward Seago." I estimate that we handled upwards of one thousand of his paintings throughout the twenty-four years we represented him in Canada.

In February 1974, some of Seago's friends arranged a memorial service at St. Martin's-in-the-Fields, that lovely early-eighteenth-century James Gibb church in Trafalgar Square. Perhaps 250 people attended, some who knew the artist personally, others who admired his work, and still others of the curious who came because they saw an announcement of the service in the *Times*. I remember being seated in the congregation and just before the eulogies began, two tall gentlemen in formal attire, carrying grey top hats, walked slowly down the aisle and seated themselves in the very first row. I thought to myself what an extraordinary performance – who are these distinguished looking men? After the service I posed the question to Peter Seymour. It turned out they were indeed personal representatives of the Queen and the royal family.

Seago was an original painter in the Impressionist tradition but different from all others who went before him and his contemporaries. From time to time he talked about his grave self-doubts as an artist and wondered just in what direction he was heading. But what important painter has not experienced similar apprehensions from time to time? Seago was neither a traditionalist nor a modernist and just followed his own special style. His just rewards and acclaim came during the latter part of his lifetime, not uncommon for any artist; his pictures were bought not only by the rich and renowned but by the man on the street as well; in fact his work delighted these people and they could afford to buy because his prices were for many years so modest.

Now, a few years after his death, the prices of his pictures have multiplied in value five- to ten-fold compared with the prices of twenty years ago and who knows when this escalation will cease. Also his work is now finding its way into public galleries, books are being written about him, and art critics are taking a second look at the work of this man from Ludham.

49 A.Y. Jackson *A Street in Murray Bay* c.1926

10
Showing Art
in Western Canada

Early in 1951, I suggested to Tom Baskett that we each contribute the sum of three thousand pounds to create a buying pool for pictures to be bought for Canada on the London market. This sum seems incredibly low by today's standards, but it was enough then to give us a significant start. We acquired pictures, shipped them to Toronto, and sold some of them immediately, at a good profit. With the profits going back into the business, our joint account started to grow. From 1951 onwards I was making four or five trips a year to Europe, and had established a very close liaison with all four partners of the Colnaghi firm.

Since the discovery of oil in Alberta in the late 1940s, and with the growing wealth in Calgary and Edmonton, I had wanted to explore prospects for picture sales in the western provinces. Tom Baskett, I knew, would make a knowledgeable and congenial companion; we could show the pictures he owned together, augmented by some Canadian works. Tom was enthusiastic and his partners agreeable, though to an adventure they must have thought at the time both marginal and time-consuming. However, by September 1952, we had put together a suitable collection; Baskett's friend, Sir Bruce Ingram, who was the owner and editor of the *Illustrated London News,* had an enormous collection of Old Masters and nineteenth-century French works and gladly lent us several pictures, including a magnificent Eugène Boudin harbour scene. At Bask-

ett's suggestion, Sir Bruce printed some colour reproductions of our pictures in his magazine, and continued to do so for many years. He reproduced paintings of ours by Edward Seago, Fantin-Latour, Krieghoff, Van Os, and Sir Thomas Lawrence, and others, in each case giving the Laing Galleries a credit line. Tom Baskett was a great believer in the efficacy of the printed word and colour prints as aids to selling. David Eccles, the politician, later Lord Eccles, lent us an important Camille Pissarro, *Dulwich College, 1873, London*, the college building in a golden autumn haze.

Before leaving Toronto I asked several people with connections in western Canada for letters of introduction. James S. Duncan gave me ten or twelve such letters, as did E.P. Taylor, and Colonel Phillips. John A. MacAulay was our Winnipeg contact; he was already a long-time customer and introduced us to all his Winnipeg friends. We assembled about sixty paintings for this western trip, the above-mentioned French ones plus some Old Masters, nineteenth-century English pictures, Edward Seagos, and also Canadian works by Krieghoff, Tom Thomson, Lawren Harris, and A.Y. Jackson. We left Toronto with eight cases of pictures.

Winnipeg was the first stop. We showed at the premises of the only dealer there, Richardson Brothers, an old firm pretty well on its last legs. It was a hot September day, the showroom was upstairs, and so dirty we had to spend the first day cleaning up the place and washing the windows.

The two weeks we spent in Winnipeg proved surprisingly productive in sales but by the end of our stay we were anxious to continue our journey further west. We moved on to Calgary, booked into the Palisser Hotel for a week, and set up our travelling gallery in a large sample-room. Again we telephoned everyone we could think of; Loraine Patrick, who owned a coal mine, liked the Pissarro *Dulwich College* very much but later by letter decided against it. We went on to Edmonton.

In another large room there, in the MacDonald Hotel, we set up our gallery once again. I had an introduction to one H.R. Milner, a lawyer and businessman, with an office on Jasper Avenue. I went to call on him and handed my letter to a secretary; she took it and went into his inner sanctum and a few moments later Mr. Milner appeared, in a smart top coat and wearing a light-coloured stetson. He told his secretary he would be back at

50 Paul Kane *Clallam Indian Travelling Lodges* c.1846

three o'clock, shook hands with me, announcing casually that he wanted to drop off at the shoe-shine parlour on his way to the hotel. Together we sat on the high shoe-shine bench, chatting, and afterwards walked over to our suite to see the pictures. This was my first encounter with one of the kindest, versatile, and most interesting men I have ever met in my life. Ray Milner was later to buy many fine Canadian paintings from us and we became great friends; on this visit he bought two pictures by Edward Seago. With his help we made several other sales, including a colourful Dufy *Still Life* to Mrs. Charles Munson, a former American golf champion, then living with her coal-mine-owner husband in an impressive house on the banks of the Saskatchewan River.

Ray Milner was also a great traveller and I used to run into him in Toronto, Montreal, New York, Dublin, and London as well as western Canada. In London, at Appleby's picture shop in Trafalgar Square, one day, I came across two superb small paintings by Paul Kane, typically unsigned, of west coast Indian encampments. I sold them to Ray over lunch at Claridge's and they went to his house at Qualicum Beach on Vancouver Island. His gardens ran down to the waters of the Straits, where you could walk through acres of giant pine and fir, or take a boat out one hundred yards to fish for Cohoe salmon. That meeting of mountain, sea, and forest was one of God's most splendid settings, and the Paul Kanes, being Pacific-coast subjects, seemed to belong there.

Horatio Ray Milner was a man who filled his life with good and quiet deeds. In the story that follows I tell how he put me in touch with his friend Mary Peel Hammond, whom he had known in Edmonton and who then made her home in southern California. Mary Peel was the adopted grand-daughter of the London, Ontario-born artist, Paul Peel (1860-1892), and wishing to sell a collection of her grandfather's paintings, consulted Ray Milner on how to proceed. Ray immediately recommended me as a potential purchaser. He pointed out to her, though, that while Paul Peel was still known to collectors, "The general public by now had pretty well forgotten him." However, one day in October 1963, I took off for California to meet the lady and have a look at the pictures.

51 Paul Peel *Mme. Peel at Easel with Daughter* c.1891

184

Paul Peel had an almost legendary status in the academic Paris art world of the 1880s. He was very young, still in his twenties, but already by 1889, was known there as the brilliant young Canadian painter when Paris was the burgeoning art centre of the world. Married to a beautiful lady, who bore him two children, Peel had achieved dazzling success during his young life, winning medals at Salon exhibitions, receiving international acclaim, and having his pictures bought by foreign governments. A gifted draftsman, he excelled in his interior compositions – often using his own children in exquisite nude studies – and his work was praised by critics and his renowned Beaux Arts School professors, Jean Leon Gérôme and Benjamin Constant. But then in 1892, after a short illness, in the midst of a lustrous career he suddenly died at the age of thirty-one. He had been a prodigious worker and few people I believe could have accomplished what he had in such a short life-span. In fact, he worked so hard that it might have been thought he had some premonition that his stay in this world would not be long. It was said that his old professors wept at his premature death because of the loss of such a gentle man with so much talent. Greatly saddened by her loss, his widow, the gracious Danish-born Isaure Verdier, an artist in her own right, shortly afterwards sailed for the United States, settling in Chicago with the two children, Robert and Marguerite. Of course all the Paul Peel pictures soon followed her.

When I visited Mary Peel in California, I must say it was a surprise to find so many of the artist's good works still available, especially since more than seventy years had elapsed from the time of his death. Large and small paintings included, I was able to acquire a total of sixteen canvases and bring them all to Canada. The collection included a third large version of *After the Bath* (a second replica had been sold by us to J. Powell Bell of Toronto back in 1936). There was a version of *Orchestra Chairs*, and other important works, among which was a large, unfinished composition, *Mme. Peel at Easel with Daughter*, the subject being Isaure, posing by an easel with their four-year-old standing close by. The picture was of magnificent quality and in today's taste probably more desirable than some of his finished salon works. This painting, one of his final works, was created at the height of his powers as an artist, and, as in other works of the same period, he had happily found his wife and one of his children the perfect models.

186

In Calgary I sought out Eric Harvie, wanting to suggest to him the serious idea of founding a gallery of fine art in Alberta. But though Harvie owned great tracts of land, with producing oil wells, and was extremely rich, he had little confidence in the value of paintings. He later told me he didn't believe that any painting was intrinsically worth more than a thousand dollars. However, on this occasion, he said his son might be interested. Donald Harvie did buy some good Canadian paintings from us and in the end his father adapted some of my ideas in his own style, gathering together an enormous number of objects of western Canadian interest as well as hordes of other things for the Glenbow Foundation he was finally to establish in Calgary.

After Edmonton we flew over the mountains and showed our pictures for a week at the Hotel Vancouver. Jerrold Morris came, the curator of the Vancouver Art Gallery; it was the first time I had met him. His gallery was the only good public gallery west of Toronto (there were almost no private galleries and even fewer framing or print shops in the West). The Vancouver Gallery possessed some Old Masters, but the main part of its collection was the Emily Carr bequest. It also had several J.E.H. MacDonald sketches, and a Tom Thomson, all of which Charles Stone had bought from us in the late 1930s, and had earmarked for the gallery. Stone was the proprietor of Michies, the famous old Toronto provision store on King Street West that catered to the carriage trade when the carriage trade shopped for groceries that far downtown. His brother was a member of the acquisition committee of the Vancouver Art Gallery.

Jerrold Morris had hoped to develop the Vancouver Gallery into the most important cultural centre on the west coast, but was frustrated, of course, by lack of money. However, he did arrange some important Old Master exhibitions and also, in 1954, put together the first comprehensive show of the Group of Seven ever held in Vancouver.

Selling fine paintings is different to selling anything else. Prospective clients have no gauge to work with for price, quality, and the condition of the work. Some unsophisticated and untutored prospects might not even know the work of the artist they were considering, or may not even have heard of the name. As dealers then it was necessary to develop their trust and confidence,

and representing well-established businesses in England and To-ronto did much to give us a certain credence.

On this first trip to the West our gross sales were only about $20,000 – but we made friends. Some people later called at our respective galleries in Toronto and London, and all of them began to look forward to our next visit. Our second trip, in 1953, was much more successful. We had more pictures to show, and we knew more people. Tom Baskett was now truly convinced that fu-ture prospects were good for selling fine pictures in Canada, and communicated his enthusiasm to his partners.

Winnipeg, we now knew, had the best prospects. Calgary for sales was hopeless, Edmonton, through Ray Milner and E.E. Poole, had better prospects. Vancouver was improving, but only slightly. We returned there seven times between 1952 and 1961; by our last trip it was still a difficult place in which to sell a picture. But there were interested people there: Walter Koerner, the Czech lumber king, who had emigrated to Canada in the late thirties and became immensely successful, was a cultivated man, who bought from us both in Vancouver and in Toronto; Ernest Buckerfield, who was in the grain and feed business, bought some Krieghoffs; Mrs. A.E. Chilcott bought fourteen Seagos through the years, from and after our exhibitions; the Gordon Southams were also custom-ers, but in general it was slow going and hard work.

In Winnipeg, of course, it was John MacAulay who started the art movement. It was largely due to his personal efforts as president of the Winnipeg Art Gallery in the early fifties that the new building was finally built, years later, replacing the old makeshift quarters.

I remember John MacAulay coming into our gallery in 1947 for the first time, when we were still on Bloor Street East, with Gilbert LaBine, the prospector and discoverer of the Eldorado Radium Mines on the shores of Great Bear Lake. LaBine had bought from us the Krieghoff masterpiece, *The Sugar Loaf, Montmo-rency Falls,* just before the war, in 1939. It had been found in Eng-land and sent to us by the London art firm, Roland, Browse, Del-banco. The picture shows the ice-cone with scores of figures in winter costumes, and horses and sleighs, frolicing on the snowy ice surface. MacAulay bought a picture by Franz Johnston on this oc-casion. (LaBine knew Johnston and had invited him and A.Y. Jackson to Great Bear Lake in 1937-38, where they both painted.)

188

52 Cornelius Krieghoff *The Sugar Loaf, Montmorency Falls* 1852

John MacAulay was born on a farm in Morden, Manitoba, taught school briefly, and then studied law. He joined the Aikins law firm in Winnipeg and soon became a partner. He was a wonderful conversationalist, which, combined with a genuine liking for humanity, made him friends wherever he went. He began collecting pictures before the war, but it was in the fifties and early sixties that his collection began to assume international importance. His friendly relationship with all the important dealers in North America and Europe, combined with his ability to make friends, meant that the help and encouragement he could give us was unique. Without him our trips could never have developed into the successes they did.

MacAulay was, in the late forties, in the process of putting together the finest collection of French paintings in western Canada. It was he who finally bought the Pissarro *Dulwich College,* for $7,500, trading in as part payment a Paris street scene by Utrillo. He also bought from us Henri Fantin-Latour's *Zinnias.* Anyone about to make an important art purchase in Winnipeg usually asked MacAulay's advice. His house on Wellington Crescent was a showplace of French art, and his Canadian room had some of the finest Canadian classical works in existence. At one time, his office in the Somerset Building had hanging on its walls four Morrice canvases, plus four lovely little panels. (I believe at one time he owned a total of eight Morrice canvases.) He also hung the offices of his partners with Canadian paintings. In the late fifties he began to buy contemporary European sculpture, and had sculpture gardens both in the front and the rear of his house.

The widow of Mayer's former partner in Colnaghi's, Otto Gutekunst, owned a large Rubens portrait of a man in armour, the *Marquis de Leganes.* She wanted to sell. With Mayer's blessing the picture was shipped to Toronto. I first tried the Art Gallery of Toronto, but Martin Baldwin and his committee were more interested in nineteenth-century French pictures and favoured a Degas. H.O. McCurry, director of the National Gallery at the time, was not particularly interested either, being in the process of buying some French pictures with blocked war-time currency in Holland. Full of ambition, I tried my luck with some of the big United States museums. The director of the Boston Museum of Fine Arts, W.G. Constable, knew and liked the picture but had no money available. I travelled to New York and Cleveland, Detroit and

Chicago, Toledo and Indianapolis, with no positive results.

Late in the summer of 1953, one of the Knoedler partners, William Davidson, came up from New York to see me. He knew the Rubens picture through photographs in the Knoedler library, and when he saw it he gasped. "Blair," he said, "I have a client for it." He wanted the picture shipped to New York; Colnaghi's cabled permission, but rather coolly. I discovered that the old Colnaghi partners did not radiate particularly warm feelings towards Knoedler's. It was something that happened many years earlier between them and had to do with Knoedler's taking an extra ten per cent commission off the top before splitting the proceeds on half-share sales, specifically on the van Eyck *Annunciation,* and the *St. George* by Raphael, which Colnaghi's had acquired by secret negotiation from the Soviets. The paintings were shipped to New York and sold by Knoedler's to Andrew Mellon in 1930. Colnaghi's took issue at Knoedler's taking an extra vendor's fee. As a matter of fact Knoedler's continued this lucrative practice and we were subjected to it once ourselves in the late 1950s.

The Rubens did go to New York briefly but came back to Canada at Colnaghi's urging. I tried the National Gallery again but nothing happened. The painting was a masterpiece, in beautiful condition, with an impressive history. There are letters extant in which Rubens himself records his commitment to paint the Marquis de Leganes. The price was a mere £25,000 but try as I did I could not sell it. On being returned to England it sold immediately to a Swiss museum, for much more money.

I remember two fine shipping scenes by the seventeenth-century Dutch artist, Jan van de Velde, owned by the British actor, David Niven. Colnaghi's had these pictures on consignment from Niven and was going to sell them on his behalf. Niven gave Baskett permission to ship the pictures to Toronto, writing, "If they fetch some really good sums, so a handsome profit is made, do you propose to cut me in on it?" He added that he was "anxious first to recoup the original outlay, but as I have now carted them back and forth from California, the outlay has grown somewhat. Anyway, do your best for me." A fine portrait by Augustus John that Niven owned was also included. We sold the John portrait but not the van de Velde shipping scenes. Canada was not buying the Old Masters and Canadian collectors in general are still not buying them. Too dark for the strong Canadian light, they say. Anyway it

is getting too late; most of the fine Old Masters, including David Niven's van de Velde, are in museums now, or in closely-held family foundations.

Interesting historical chronicles emerge from time to time in the dealer's art world. George Brown (1818-1880), for instance, is remembered as an aggressive journalist, politician, and the editor of the Toronto *Globe*, but apparently he liked art as well and must have been one of the very first collectors of Canadian pictures in Upper Canada. It is almost a certainty that he knew the artists and bought from them direct. In the autumn of 1955, Tom Baskett sent me some photographs of a collection of pictures painted in Canada in the 1870s. They included an important J.A. Fraser *Lake and Mountains*, painted in the Rockies, a Lucius O'Brien, of canoes on the misty Toronto lake front, two superb watercolours by William Armstrong, one of two canoes with Indians on a lake, a large fine oil of a lake portage by Frederick Verner, an Indian encampment scene by the same artist, and a Laurentian landscape by Henri Peré, an Alsatian artist who had emigrated to Canada in the early 1860s. The owners were two solicitor brothers, one living in London and the other in Liverpool. Their name was Brown, and they were direct descendants of George. About seven years after George Brown died, from wounds inflicted by an ex-employee, his widow, who, like George, was Scottish-born, returned to Scotland with her possessions, and her children soon followed.

Their pictures had remained in the family's ownership for more than seventy-five years. One of the brothers had written about them to the National Gallery of Canada, and Robert Hubbard, then the curator, wanted the pictures sent to Ottawa on approval. But my friend Baskett exerted some pressure on the Brown brothers, pointing out that this might be a long and tedious affair, and it would be wiser to sell the collection outright immediately. After seeing photographs I cabled individual prices, and using his power of persuasion again, Tom Baskett quietly convinced the Browns to allow him to ship the pictures to Toronto. When they arrived, I was delighted with their importance and quality and that's how the George Brown collection of Canadian art was repatriated. Actually, some are now in the National Gallery, and the

53 Lawren Harris *Rapids, Algoma* c.1919

Sigmund Samuel collection in Toronto, while the others are privately owned.

By 1961, it was becoming more and more difficult to find suitable paintings for our trips to the West and from 1958 on, we were augmenting our collection with sculpture by the modern masters, Henry Moore, Barbara Hepworth, Marino Marini, Giacomo Manzu, Pericle Fazzini, and others. Tom Baskett and I made our last trip together in 1961. One year later, in September, Tom was dead from lung cancer. I flew to London for the funeral.

It was one of those warm sunshiny and showery days of early autumn. One of Tom's friends picked me up at Colnaghi's at 14 Old Bond Street, and we drove through London to the suburbs, parked and walked by acres of green lawns. We entered a dark chapel; I remember standing with others and watching, transfixed, as an object on a slow-moving conveyor belt a few feet from the floor moved from an opening on one side of the room across to the other, and disappeared. A record played "Abide with Me." The scene stays in my memory, strange and unreal.

In less than twelve years, Tom Baskett and I had built up a collection of magnificent paintings and had been the first to take fine works of art to the four large cities of the Canadian West. We had broken new ground in showing and trying to sell good art and in the end had developed a thriving business. Yet, less than a year later, Colnaghi's wanted out.

In September 1963, Roderick Thesiger and Arthur Driver took me to lunch at Madame Prunier's in St. James's Street, London. These two were relatively new partners in the firm. They maintained that many of the pictures in the collection were for the Canadian market alone and not readily saleable in London – not a correct assumption. They wanted me to buy them out, for £7,500. Twelve years of hard work and astute buying ended with a stroke of the pen. On Colnaghi's part the decision was impetuous and wrong; we still possess paintings from the four hundred and more I bought that are now worth more than what I paid them in total for their entire half-share of the collection. All the partners of those years are now either dead or retired, and I believe the firm is owned by the London Rothschild Bank. Colnaghi's was, in its heyday, a renowned and vital institution.

11

The Cognacq Sale and Lord Beaverbrook

In the early 1940s, Colonel W.E. Phillips had become a friend and client. Although other Canadians were much better known, Phillips was no inconsiderable figure in this country. I personally thought of him as a kind of business genius.

Phillips distinguished himself as a soldier in the First World War, and later went into business in Oshawa, with a firm that imported and supplied glass for automobiles manufactured by General Motors. He was at one time married to a daughter of Col. R.S. McLaughlin. At the beginning of the Second World War, Phillips was instrumental in setting up a large company known as Research Enterprises, which worked on various secret wartime projects, and supplied components for radar and other wartime inventions. After the war he bought a farm in Oriole from F.M. Connell, where he raised thoroughbred cattle and did early experiments with film and colour photography in his private laboratory. One of his little luxuries was a private barber shop in his basement.

A man interested in art, and a collector who had bought from us, it was Eric Phillips who in 1952 offered to stake me when I decided to try and buy at the Gabriel Cognacq sale in Paris.

To my mind the beginning of the great art boom, which

195

apparently we have not seen the end of yet, began with the fabulous Cognacq auction sale of May 1952. Gabriel Cognacq was the owner of the Paris department store, Samaritaine, and had a collection, partly his own acquisitions and partly inherited from an uncle, that was one of the most remarkable groups of paintings owned by a private individual to come up for sale in the twentieth century. He had Cézannes, a great Degas pastel of ballet dancers, Monets, Sisleys, Pissarros, Renoirs, and van Goghs. Nineteen Old Masters were included, and five Corots. Cognacq had originally meant his collection to go to the Louvre, but in his will he "disinherited the Republic," as he put it, for what he deemed its personal "injustices" to him. What he meant was that he had been unjustly charged with enemy collaboration during the war and removed from the high office of President of the French National Museum Trust. Despite this final act of defiance, not many of his pictures did leave France in the end. They were almost entirely bought up by French collectors.

When I learned of the coming sale, in the spring of 1952, I was deeply interested, but knew I needed help from some experts. The Colnaghi connection was again useful. G.M. Mayer, then the senior partner, went to Paris two weeks before the sale to examine the pictures. On his return to London he wrote me a detailed description, giving his opinion on the quality and condition of the pictures, as well as estimates of the prices expected. In France, the authenticity of a work of art sold at auction is guaranteed by the auctioneer and experts are appointed to verify the pictures, note their condition, and estimate prices. Mayer also explained to me that unlike London, at the time, the buyer paid a commission on top of the prices reached under the hammer. The experience gained at the Cognacq sale was to be a valuable one for me in learning some of the intricacies of the international art world.

At the Cognacq auction, Mayer and I, along with hundreds of other dealers, collectors, and museum people, were allocated numbered tickets, and sat on frail gilded chairs in the front rows. The press reported three thousand people in the room that evening. M. Bellier, the auctioneer, dressed like a French cabinet minister, called out the bids, which his assistants intoned after him in loud voices, with flourishes of the arms and drama in their faces, pleading with their eyes for higher and higher prices.

The prices that evening were breathtakingly high; all exceeded the original estimates, some by two or three times. I managed to buy one picture, a Corot landscape, which was quickly sold on my return to Canada. But what was really important was that the Cognacq auction was an historical landmark in fine art dealing of the mid-twentieth century and I was fortunate enough to have been a small part of it.

Moving in the international, social, and business world of E.P. Taylor, Sir James Dunn, J.A. (Bud) McDougald and their friends, Phillips knew Lord Beaverbrook. In January 1955, Phillips telephoned me from Nassau, where he and Lord Beaverbrook were on a winter break. At this late stage in his life Beaverbrook had set his mind on building an art gallery in Fredericton, New Brunswick, near his boyhood home, and particularly wanted some good Canadian pictures for a start. Phillips asked if I would ship some paintings to Nassau for Beaverbrook's consideration. (These tycoons were always doing business, whether holidaying or not.) Import-export laws to ship in and out of the Bahamas made this project unfeasible, even if I were to have gone down myself, but another arrangement was made. Beaverbrook was going on to New York, and in New York he always stayed at the Waldorf Astoria Towers. So I packed twenty-five or thirty of our best paintings, including works by Krieghoff, Cullen, Tom Thomson, and some English, French, and European artists, into cardboard cartons, loaded them into the car, with some on the roof, and drove with my wife and elder daughter to New York.

I had carefully reserved the best suite I could find at $60 a day – so the pictures would look well and indicate to Beaverbrook, whom I had yet to meet, that we were not conducting business on a shoestring. The suite turned out to be enormous. Gene, my favourite bellboy at the Waldorf, helped me lug the pictures up. I announced my arrival to one of Beaverbrook's advisers, a red-haired French lady by the name of Madame Escara, who came immediately to look at the pictures.

Mme. Escara liked several of them and particularly a small study of a girl, *Miss Jane Allnut*, by Sir Thomas Lawrence, which she raved about, declaring in a husky voice, with her French accent, "I like your Law-Ranz." She knew nothing about Canadian pictures. She assured me she would ask his Lordship to view

197

the pictures as soon as possible but there was no sign of him the next day, or the next. I was trapped in the hotel and dared not leave the suite for fear of missing a visit from himself.

Finally, suffering from complete frustration, I went to Beaverbrook's suite myself and rang the bell. His valet appeared, to whom I told my troubles and then bribed outrageously in the manner of a Duveen. But this valet had a human touch, and having served Beaverbrook for many years understood my predicament immediately; within half an hour I had a call from his Lordship apologizing for the delay and inviting me to visit his suite and meet Joseph Kennedy. The latter was introduced to me as Ambassador Kennedy, a rather obsequious introduction I thought, since he had been relieved of his diplomatic post long ago, in 1940, and possessed such a grand title only in memory. But he and Beaverbrook seemed the greatest of pals and were drinking Kennedy's personally imported Scotch whiskey to the accompaniment of various jokes and guffaws by Beaverbrook about its fine, smooth quality; "So good, you have to be careful not to drink too much of it," was one pious pronouncement I remember. All this familiarity between these two surprised me, since Kennedy had been so hated in England for his negative public comments on Britain's chances of winning the war, while Beaverbrook had been an exuberant optimist and constant worker in the war effort and even in the early years never lost confidence that Britain would win in the end.

Beaverbrook finally turned up in our suite the next morning and bought several of the Canadian pictures, which I am sure were the first Canadian paintings he was aware of as a potential buyer. He, too, liked the Lawrence picture of Miss Allnut, asking me to reserve it for him and send on a photograph to London.

During his life Beaverbrook had never been a collector of pictures and had made no study of art; his interests were money, newspapers, and politics, and pursuing money, owning newspapers, and knowing the politicians in high circles gave him tremendous power. He was obviously enormously astute and at his age, then seventy-five, still willing to learn. I waited to hear from him for about two weeks then sold the Lawrence to my friend W. Garfield Weston, another London-based Canadian multi-millionaire magnate. Finally, several more weeks after the New York visit, I received a note from Beaverbrook saying he had liked the Sir

Thomas Lawrence painting but was advised against buying it. He added, "Now I have come to the conclusion that my own judgment shall prevail – not for better or for worse. But for worst." This Beaverbrook epigram meant, in his expressive mixed syntax, that he was going to make decisions entirely on his own from then on, on any other pictures we offered him in the future, and he did.

At that time, Beaverbrook had a stately home in Surrey, a villa in Cap d'Ail, a large flat in London, and Aitken's House in Nassau, besides many offices. He travelled with servants and secretaries, in the grand manner, and liked to hold court at luncheon and dinner parties, with good conversation, and attractive women. It took a while to get to know him, and come to terms with his many eccentricities. One day in the summer of 1957, when I was staying at the Savoy, in London, I received a call from a secretary inviting me to dine and stay the night at Cherkely, Beaverbrook's home in Surrey. A chauffeur picked me up at the railroad station and drove me to the house. The other guests were Lord Thomson of Fleet, then still Mr. Roy Thomson, and his daughter Irma. Dinner was informal, and Max and Roy did most of the talking, all about the newspaper business and its economics. I remember one point Beaverbrook insisted on was that if even one paper in a chain was losing money, that particular newspaper should be sold immediately.

At one point during dinner, I don't know for what reason, Beaverbrook melodramatically raised his arm and pointed through the dining room window to a cross and said, "Over there on that hill my wife is buried." During the evening we were entertained at his private cinema. I thoughtlessly lit a cigarette; this was a breach in manners, a bad *faux pas*, as he hated cigarette smoke, as most reformed smokers do, but all he said was that fire regulations prohibited smoking. Today, I too a reformed cigarette smoker, realize just how he felt. At that moment a butler came in and announced loudly, "Your Lordship, Sir Winston Churchill is on the telephone." I don't remember the movie!

The next morning, a sunny, warm one, we went for a walk through the beautiful countryside along his private road. Finally he spoke of pictures and his serious ambitions for a new gallery in Fredericton. He wanted "the best available art at the best possible prices" – all art collectors want that exquisite combination.

In time I was able to supply him with a Tom Thomson, David Milne, Krieghoff, Paul Kane, and a rare Morrice flower study, among many other Canadian paintings. He badly wanted an important canvas by Frank Carmichael. A local newspaper art critic called Carmichael's widow, Ada, who still lived in their old house on Cameron Avenue in Lansing, just north of Toronto, to ask if she had any paintings for sale. She said No. Beaverbrook went to see her anyway. Mrs. Carmichael, who was a friend of mine, told me later that she had received his Lordship with normal courtesy and simply repeated she had nothing to sell. Beaverbrook later told me this story as an example of the woman's admirable integrity. A year later I did get an important Carmichael canvas, which I sold to him. The painting I obtained from Mrs. Carmichael herself!

I had a good early A.Y. Jackson canvas on hand, and offered it to him in 1958. He wrote back in one of his typically cryptic letters that he "did not propose to buy a Jackson." Jackson's autobiography had just been published and apparently Beaverbrook considered certain of Jackson's remarks about incidents that occurred during the First World War, when Beaverbrook created Jackson an instant lieutenant, unsuitably flippant. There may not be a Jackson picture in his Fredericton gallery to this day.

I also offered him Harris's marvellous canvas, *A Mountain Lake*, exhibited at Wembly in 1924, and at the Jeu de Paume in Paris, for $3,000. He wrote, "We have a Lawren Harris. I am not one of his great admirers."

When we first started to do business together, Beaverbrook used to make offers; on a Morrice priced at $7,500, he cabled "I would be glad to buy the Morrice for four thousand." He paid the full price when he realized how we ran our business, and thereafter gained confidence in us.

Malcolm Muggeridge, the English journalist, finds it necessary to spend about fourteen pages in his 1973 autobiography, *The Infernal Grove*, smearing Lord Beaverbrook and his motives, though he apparently worked for him only a short time, as a gossip columnist in the 1930s and briefly again, years later, before, he admits, being fired. Muggeridge never mentions actually meeting Lord Beaverbrook, who seems to have outraged him simply by being Beaverbrook. Muggeridge also writes disparagingly of the "Beaverbrook cult," and of the insignificance of the historical set-

54 Franklin Carmichael *Wild Cherry Blossoms* c.1932

ting in which Beaverbrook went to such pains and expense to leave a legacy for himself. That anyone could lavish a fortune on such a place as Fredericton, simply because it was the country of his youth and he loved it, Muggeridge finds both mystifying and ridiculous. He reveals in passing his total ignorance of modern art; and he has no sense of what Beaverbrook accomplished in building the Fredericton Gallery and putting together its collection of art. Muggeridge I am sure will soon be forgotten but Beaverbrook's accomplishments will last for a long time.

While Beaverbrook was certainly no angel on this earth (and who is?), he was a unique and talented man, and I have never known anyone justly credited with more acts of human kindness, or who had more sympathy for those in trouble. Over the six or seven years I knew him I observed how many genuine friends he had and how vital and charming he could be. On my father's death, in 1959, he sent me a handwritten note of sympathy and signed it simply, "Your friend, Beaverbrook."

I admit that attention from a famous man is pleasant, and a little praise goes a long way with most of us. At the banquet marking the opening of the Fredericton Gallery, in September 1959, which was attended by as many notables as he could muster, including Maritime premiers, and other dignitaries from Canada and England, and also Captain Wardell, complete with black eye patch, Beaverbrook thanked me publicly as an "honest dealer." I could not help but feel warmly towards this sometimes irascible, eccentric, but often admirable man.

12
London and Paris in the Fifties and My Search for Morrice Paintings

One day in June 1954, W. Garfield Weston, that merchant prince among world grocers, happened to walk into our galleries during one of his regular visits to Toronto. We were always looking for new ways to promote Canadian art and among Weston's vast resources was his renowned food and specialty store, Fortnum and Mason in the heart of London, one floor of which would be ample to provide wall space for a display of paintings. A combined effort on a London exhibition of Canadian paintings seemed at the time to be good thinking and Weston, always a bright and decisive man, was immediately enthusiastic when I suggested the idea to him. No one could imagine what was to happen in the end and how the thing would snowball. What we were setting in motion was not merely a simple showing of Canadian art but something that was ballooning into an event with strong political and social overtones.

Our original proposal was for a straightforward exhibition with all the pictures for sale, in other words an ordinary commercial venture to try and sell some Canadian art in England. Accordingly, tentative dates were set for mid-January 1955, and we shipped off some fifty Canadian paintings. Somehow James Armstrong, then the active Agent General for the Province of Ontario,

who was originally appointed by George Drew, got wind of the coming exhibition and decided it was such a great idea that it should be promoted into a much larger affair with official government participation. Armstrong then took over completely and things were out of our hands; the show became an official event sponsored by the Government of Ontario with Lord Alexander, Canada's former Governor General, to preside at the opening ceremonies. The patrons were such august personages as the Dowager Lady Tweedsmuir, the Marchioness of Willingdon, Lady Patricia Ramsay, and Princess Alice, as well as three former Governors General, Field Marshal Alexander, the Earl of Athlone, and the Earl of Bessborough.

The paintings slated for the exhibition then began to grow in number as owners of Canadian art in England came forward to lend. There was even a Selection Committee, headed by Sir Gerald Kelly, a portrait painter, whose only connection with Canadian art was his claim to have been a friend of James Wilson Morrice fifty years earlier in Paris. Finally, the number was cut off at 142, nearly three times the number of our original shipment. The committee borrowed Krieghoffs, Morrices, A.Y. Jacksons, F.H. Varleys, Robert Pilots, Emily Carrs, Clarence Gagnons, Lawren Harrises, Frank Carmichaels, Maurice Cullens, and the works of many lesser artists. The Queen lent a painting by Goodridge Roberts, Sir Winston Churchill one by Robert Pilot. Brigadier A. Hamilton Gault, a Canadian of First World War fame, then living in England, lent a Morrice, *On the Beach, Brittany,* which we bought some years later from a relative of the Brigadier's. Alan Jarvis, then living in England, lent several of his David Milnes.

No Canadian art exhibition could possibly arouse such interest and attract such high patronage in London today. Looking back on this event after nearly a quarter of a century, the show seems to have been a kind of a watershed historically and socially in Canadian-British relations and confirmed the firm bonds that then still existed between Britain and Canada. These highly placed aristocrats, representing British prestige of old, were the very last ones with strong Canadian connections, including those who had personally represented the Crown as Governors General. They are all gone now. My father presciently remarked at the time in a letter, "Never, I am sure, never again will an exhibition of Canadian paintings be staged in England with such dignity."

55 James W. Morrice *A Procession, Algiers* c.1922

However, just before the exhibition opened, trouble appeared on the horizon in the form of unfavourable publicity in the *Toronto Telegram*, which criticized, among other things, the general quality of the exhibition. London, of course, paid no attention to this nonsense and crowds flocked to Fortnum's to see the pictures. Jane Armstrong, no relative of James, working in London as a journalist for the now defunct *Telegram*, had heard of the project, seen some of the pictures, and set out in a series of articles to disparage the exhibition as mediocre, and the headlines were very embarrassing as our name was naturally mentioned as the dealers responsible. I expect the press felt that the Laing Galleries were getting too big for their boots and should be cut down to size. Another result of this bad publicity was that all the pictures we had sent over, while still exhibited, were entirely withdrawn from sale.

From London, my father wrote, saying, "This woman is doing her best to discredit the show and she even telephoned Lord Alexander and Sir Gerald Kelly (who talked too much to the press) at their homes to suggest their names were being exploited in promoting a commercial enterprise." Not true, of course, since the Ontario Government had completely taken over and by then our name wasn't even mentioned as co-sponsors. The Toronto Art Gallery, the National Gallery of Canada, Vincent Massey, and the Canadian art establishment, were an unending source of, again in my father's words, "jealousies, and disappointment." However, at the last minute the National Gallery decided to lend four important pictures and they were flown over by air force plane.

To be present at the London exhibition was not my father's only reason for crossing the Atlantic that January. He also wanted to go to Paris to see what he could accomplish there. We now wanted to participate more and more in the international market and by now had built up a reasonable capital sum for buying purposes. My father was equally interested to explore in depth the potentials for buying French art in Paris as well as contact some of the French Canadian artists living there.

By the mid-fifties, the New York school, Jackson Pollock, Hans Hofmann, Mark Rothko, and others, dubbed "abstract expressionists" by the pundits, were becoming known to a small band

of art watchers in Canada. Developments in New York represented a new and intriguing field which I was eager to study. American art was not selling or even being shown in Canada at the time; Canadians wanted European or Canadian work. But there were Canadian painters involved in a new school. What could be a better idea than to contact them? They were to be found in Paris; it was the Quebeckers, Pellan, Riopelle, and Borduas who were doing the interesting work in a new style, rather than English Canadian painters. Montreal was scarcely hospitable to such innovations at the time, and Paris became their natural home.

My father spent two weeks in Paris, from January 24 to February 7, 1955. One day was spent with Alfred Pellan, looking at his paintings, and he ended up by buying a collection of his work dating from 1940 to 1950. Pellan was always to hold him in highest esteem as the first dealer to acquire his pictures by outright purchase. As a matter of fact Pellan was surprised that any dealer, let alone an English-speaking Torontonian, was interested in his work. Not that Pellan was naive, anything but, as my father found him perfectly familiar with the prices Pilot, Coburn, and Gagnon were bringing in Montreal; he thought his own paintings were worth much more and was reluctant to allow a dealer's discount. But the final results of the meeting were satisfactory as my father wrote at the end of the month, "I bought nine pictures from Pellan ranging in size from 12"x12" to 35"x45", for a grand total of $2,400."

During the short time he was in Paris, my father wrote me a remarkable series of fourteen letters, one per day, all together a fascinating chronicle of the time, recording artistic events in the city, his meetings with artists and others from famous dealers to the "*marchands amateurs*." Most of the latter, by the way, were responsible people with good connections, who worked on a commission basis. They were and still are an intrinsic part of the Paris art scene, and cannot be overlooked by serious searchers of fine pictures. My father wrote, "Pellan may be a top artist. They think so in Paris." As a guest of Pellan's he went to a private preview of his exhibition at the Museum of Modern Art. "They are impressive – dear knows when we will sell these pictures but they may be good pieces to own." How very right he was.

Jean Désy, the Canadian Ambassador to France at the

time, gave him most wonderful help and co-operation. (The introduction had been provided by Leonard Brockington, Rector of Queen's University, orator, broadcaster, and man of letters, who was a friend of my father's through Lorne Pierce and the other friends of the university who had been building up its collection of Canadian paintings.) Jean Désy was most interested in art himself and they developed a good relationship. Désy rounded up pictures from private sources for my father to examine at the ambassador's own residence, which he considered more suitable for the purpose than a hotel. "The Ambassador helped me in every way, setting up appointments with the masters and also supplying me with a guide and interpreter." Concerning the interpreter, my father wrote, "I realize what a disadvantage one is at over here when one cannot speak French," adding, "I hope my grandchildren will learn the language when they are young."

More than once, my father declared the international art dealers he found in Paris were among the best and the cleverest business people he had ever known. He called on all the important ones, including Durand-Ruel, Jacques Dubourg, Paul Brame, Bénézit and Pétrides. Prices struck him as extremely high, of course, but Jean Désy's good offices brought him private offers of paintings by Utrillo, Vlaminck, Rouault, Cézanne, Braque, and others. Paul Brame got a Rouault for him, through Rouault's daughter (that picture, an important one, we eventually sold to Mrs. John David Eaton). At the Museum of Modern Art the Director, Mme. Humbert, gave him the address of Mme. Albert Marquet, the painter's widow. Unfortunately Madame Marquet was away.

My father decided he wanted to buy some important pictures, "big names," he called them, for our gallery's general prestige. "In the hope we would eventually get our money back." He began with an important 1928 Utrillo, which he bought for $4,700, and a Vlaminck, which cost him about $3,000. "It is really tough going – these Frenchmen are smart!" he exclaimed. "Here people buy and sell pictures like we do stocks and bonds at home," and "I am gradually coming to the conclusion that if you want anything really first class you have to pay a fortune for it, and at that, from the standpoint of prestige and safety it is perhaps the wisest thing to do." He bought a Braque, for $5,900, "It was painted in 1931 –

an unusual Braque but a fine one. It is going to be reproduced in a new book by Maeght late this year," but was undecided about two paintings by De Stael. "They say here that De Stael is headed for a top place like Braque." Paul Brame sold him two great fauve Marquets, one, a view of the Pont Marie, painted in 1906, is now in the Art Gallery of Ontario. "It is good to hear," he remarked in his last letter, "that you are making sales at home. It will keep the pot boiling. Because of my exploits in Paris we will need a lot of money to pay for all these things."

To follow up the Pellan story, later that same year when the collection of his paintings arrived from Paris we held an exhibition, the first ever in Toronto. Surprisingly, we sold several, albeit at very modest prices. Later, in 1955, Pellan left Paris and built a modern house and studio at Ste. Rose, a few miles northwest of Montreal, where I visited him on several occasions and continued to buy his work. In November 1957, we held a second exhibition of twenty-five of his paintings, and apart from three that the National Gallery was interested in, and asked us to send to Ottawa on approval, which they did not buy, we made no sales whatsoever. We bought two for our own account and had acquired six drawings just prior to the show, so that all together we owned a good collection of his work.

Even in the days of his disappointments, though, Pellan was poignantly thoughtful of the feelings of others. After learning of the disastrous results of his exhibition, he wrote us:

> I received your letter, which because of the news, I suppose, was a difficult one to send. Be sure that I have no doubt that you did everything possible to assure the success of my exhibition. To think that you went through all those expenses and troubles for no result at all, makes me feel very sorry for you and ill at ease. What touches me most, and consoles me, is even though after these circumstances, you do not withdraw the confidence you had in me. Maybe some day, obeying a mysterious signal, people over there, goaded by your example, will start to understand and like enough of my paintings to wish to possess some. Let's wish we will all be present to benefit from the change. . . . I hope these last events will not keep you away from dropping in at Ste. Rose like you used to. We will always be happy to have your vis-

its on a friendly basis. Please transmit my regrets to your father. With my best regards to both of you.

The failure of that exhibition is hard to comprehend now, well-advertised as it was and the prices so pathetically low, from $150 to $640 for the larger canvases. Pellan has lived to see all that change, however: one of his paintings, *Roulant*, which we sold in 1965 for $250, was re-sold twelve years later at auction for the sum of $7,200.

Another Canadian artist my father met in Paris was Jean Paul Riopelle. Riopelle was a flamboyant character, which showed up in both his painting and the way he lived. He could also be elusive. On the morning of January 27, 1955, my father undertook to search him out "away on the outskirts" of the city. When he got there, he found that he had moved to the other end of Paris, only to find then that he was away for the weekend. Actually Riopelle had, at the time, deposited his wife and children in a flat and moved himself to a studio in Vanves, a rather sleazy working-class Paris suburb. My father left his card and address, with a request that the artist call. In the meantime, he had plenty to do as he had been invited by Jean Désy to a Canadian Embassy reception. Riopelle finally called my father later that day, and they arranged to meet. Riopelle picked my father up in his car at eleven-thirty the next morning and drove him to his studio. My father bought three large paintings from him for $1,515.

Later, my father, probably a little weary by now, wrote, "My time in Paris is just about over." But before he left for London he returned to Riopelle's studio and bought more of his colourful, harmonious canvases. We ended up with enough pictures for a show and were Riopelle's exclusive representatives in Toronto for many years thereafter. I can only estimate but I believe we purchased from him at least a hundred pictures over the next twelve years or so.

By 1957, Riopelle had left his wife, or she him, and he was living with Joan Mitchell, an American abstract expressionist painter, on the third floor of an old apartment building on the left bank of the Seine. Riopelle was now in the midst of his most productive years. A hard worker, he painted in great bursts of creative

energy. Jean Paul Riopelle also enjoyed the good life and was, besides, an extremely shrewd and intelligent man. By then he was selling as many pictures as he could possibly paint, and the stockpile in his studio dwindled to practically nothing, though he desperately tried to keep a few examples of the superb tightly-patterned works he had done in the early 1950s for his own personal collection. Throughout the fifties Riopelle was experimenting with style and format; he rediscovered the circular and oval forms, searching out old stretchers in these shapes, painted enormous 6′ x 8′ mural-sized works, and was equally good on tiny postcard-sized canvases.

Riopelle's energy spilled over into just about everything he did. He owned a boat and cruised her on the Mediterranean, liked fast cars, went on hunting expeditions for wild boar, and loved salmon fishing. At a moment's notice he would go off to the airport to catch the first plane to New York, without so much as a hand bag. He said he could buy anything he needed in New York and he was right; his dealer there, Pierre Matisse (Henri's son), gave him unlimited credit. Riopelle knew many of the artists and sculptors of the day, like Zao Wou-Ki and Giacometti, but in general he was a lone wolf. Yet at the same time he was always the generous host, ready to take you to dinner at one of the many good small restaurants he knew. He and Joan frequented the Dome and Coupole, and at both places his stocky frame and tousled black hair were well-known. I never missed a chance of seeing him on my trips to Paris, even if it meant an evening of wandering through Montparnasse bistros to find him.

Dealing with him was always interesting, if a little hectic. Except once or twice in the early days I don't recall ever receiving a letter from him; he seldom bothered to answer ours. One day in the spring of 1966, I telephoned him at his apartment. He arranged to pick me up next morning at the Hotel Meurice, but never turned up. I did not bother to follow it up, and haven't seen him since.

I don't know exactly what it was that appealed to me so much in the work of Paul Emile Borduas when I first saw it, and it has fascinated me ever since. I first remember seeing his paintings in New York in 1954, and being attracted by the shapes of the images and

the purity of the colours. Classically ordered, these forms seemed to float majestically on the surface of the canvas. From the time I came to know him, his paintings seemed to get stronger and stronger. His latest work never appealed to me as much as things done even a few months before, but in retrospect I find the later canvases – those strange, uneven rectangular forms in dark browns and blacks, somehow suspended on a great sea of white – far more powerful than I had ever thought at the time.

Unlike many abstract painters, Borduas usually titled his works in interesting and expressive ways. Titles like, *Sourante, Silence Magnetique, Figure aux Oiseaux* or *Formes Sous-Marin*. Perhaps for Paul the titles represented a slight nod towards the world of reality, but I never discussed it with him.

I first knocked at the door of Borduas' studio-living quarters at 19 rue Rousselet, on the left bank, in mid-January 1956, when he had been in Paris only about three months. I was met by a small bald man in slacks and black turtleneck sweater, about fifty years old, rather emaciated, with brilliant but deeply sunken eyes. A rather sad, neglected figure, I thought.

At that time I knew nothing of his manifesto, *Réfus Global*, published in 1948, a kind of intellectual revolt led by Borduas and a handful of his followers against the conservative controlling forces of the Quebec teaching and cultural scene. Nobody in the art circles of English-speaking Canada knew anything about what was going on in French Canadian *avant garde* art circles in the late forties and early fifties; moreover, no one here was interested or cared. During this meeting with Borduas there was nothing that suggested to me the mystic or activist; he appeared calm, business-like, and very practical.

Borduas had lost his job at the Ecole du Meuble in Montreal (where one of his students had been the young Riopelle, whom he never saw now), for what amounted to political reasons, and had gone to New York as a voluntary exile. Martha Jackson, a rich Buffalo woman, who had opened a gallery there and liked his work, became his American dealer. Through her he sold enough pictures to go to Paris in September 1955.

Paris just seemed the natural place for him to settle in, but he was growing older and was very lonely. The effect of the hostility he had met with in his native province made him sad and

212

the feeling remained with him always, and there was always a resi-
due of bitterness that spilled over into his talk. He made few
friends in Paris, though he held court with a small group of young
students from time to time, as a sort of visiting professor. A curious
aura of both pride and pathos surrounded this tiny figure of a man.
Yet in all he was a delightful person, possessed of great Gallic
charm, and we became good friends.

On that first occasion, with no idea of how the eloquent
but completely non-objective paintings he was showing me would
sell in Toronto, I chose six medium-sized canvases. I remember he
had a typewritten sheet showing a sliding scale of discounts from
the basic selling prices of his pictures. On one picture it was twenty
per cent, but on more than six it rose to sixty per cent. The six I
then chose totalled $1,250, and with fifty per cent off I paid him
the grand total of $625. During the next four years I always bought
paintings from Borduas on my regular trips to Paris. During the
calendar year of 1959, we purchased nearly forty paintings from
him, including large ones. On November 20, we acquired six at a
total price of $2,300, and purchased seven more in early Decem-
ber. In this final acquisition, Borduas took off the enormous dis-
count of sixty per cent from basic prices that were exactly the same
as they had been three years earlier.

I believe we bought more of his paintings during the last
three or four years of his life than all other buyers combined and I
like to think our purchases went a long way towards keeping him
going during those final two or three years of his life. He was sell-
ing a few pictures through the Arthur Tooth Gallery in London,
and a few in Paris, but practically none in Canada. By late 1959,
his earlier works were still selling better, the later ones, more and
more severe in form and less and less colourful, remained in ad-
vance of buyers' tastes. I remember his saying to me on one of my
last visits that he thought he could detect "a little speculation" go-
ing on in his earlier works.

Borduas was always extremely reliable and most meticu-
lous in carrying out business obligations – promises for delivery
dates of his pictures were always kept to the letter. By tacit agree-
ment he wrote to us in French and we to him in English, though by
the time he had arrived in Paris from New York his English had
improved greatly and he had no difficulty expressing himself in
that language.

We had just opened an exhibition and sale of Borduas' work in February 1960, when word came from Paris that he had died. The showing automatically became his first memorial exhibition. I was very sorry he was gone as I had become particularly fond of him.

Later that year I bought four important Borduas paintings from Martha Jackson in New York; she said that sales were so poor she wanted to get rid of her remaining stock and did so at bargain prices. A year later I bought more from Dudley Tooth of the Tooth Gallery in London, as Borduas was not selling in England either.

In the years that have passed, Riopelle, Pellan, and Borduas have become famous and I look back with satisfaction to the small part we may have played in their final success.

Public tastes in art were beginning in the fifties to slowly change. The post-war years were giving way to more affluence and an increased interest in purchasing art. We decided it was time to search out the work of James Wilson Morrice, few of whose works had reached the market in the intervening years since our disastrous 1934 exhibition, because we felt it was now possible to market them. It turned out to be a long-term project, indeed.

Since James Morrice had lived in Paris nearly all his adult life and was the only native-born Canadian artist to receive a deep and lasting approval from the critics, French collectors of his time, and French museum officials who actually purchased his paintings, France was the obvious place to start looking for his work. I had many interesting adventures during the years of my long search, some battles I won and some I lost. Sometimes the pictures had already been sold or the owners preferred to keep them in the hope that prices would continue to rise. I found Donald Buchanan's book, *James Wilson Morrice*, particularly helpful in tracking down pictures. It was published back in 1936, but in his *catalogue raisonné* he listed the names and addresses of the owners, which often turned out to be useful.

I had become friendly with members of the famous New York firm, M. Knoedler and Company. It was said of Charles R. Henchel, the extremely able president, that on buying trips to Europe he liked to purchase a picture every morning "before break-

56 James W. Morrice *Circus, Concarneau* c.1909

fast." In the early 1930s he was one of the highest paid individuals in the entire United States, probably as the result of profits on some of Knoedler's big sales of Old Masters to Andrew Mellon.

George Davey was the manager of Knoedler's Old Bond Street and rue des Capucines galleries in London and in Paris. He loved both cities, but especially Paris, and must have been one of the last great *boulevardiers* and reminded me of an English version of Maurice Chevalier, who, by the way, he knew as a picture collector. Who would be better than he to help me in my Paris project, I thought. Knoedler's was not at all interested in the work of Canadian artists so there was no question of competition with the firm and anyway George Davey was busy hunting for much bigger game at the time, though he was very helpful to me. Right away he put me in touch with M. Georges Manoury who lived in an eighteenth-century apartment on the rue Royale in the heart of old Paris. M. Manoury was glad to sell me Morrice's *Doorway, St. Mark's*, which he had bought at least fifty years earlier from the artist himself, for the Canadian equivalent of $200. It is now back in Canada at the Art Gallery of Hamilton for the second time, after having once been stolen from that institution.

Through another picture dealer colleague who knew of my interest in the work of Morrice, I heard about a painting in Paris which was for sale. It was a small canvas of a Venice moonlight scene, with several wispy female figures strolling along the edge of one of the lagoons. The painting was owned by Madame A. Berez, who had a little gallery and print shop on the left bank near the rue de Seine, just a step from Morrice's old studio on the Quai des Grands Augustins. It was a subtle painting showing the master's uncanny ability to handle moonlight and lamp-lit street scenes. Madame Berez was glad to sell it to me for the modest sum of $200.

I later came up with another thought and asked my Paris dealer friend, Paul Brame, to see if he could arrange for me to see the Rouché collection of Morrices. Jacques Rouché, a wealthy French aristocrat, had been for many years honorary president of the Paris Opera and was a personal friend and patron of Morrice. The address was on that street of elegant houses, the rue de Prony. But when I arrived I was stunned by the terribly rundown condition of the grounds and general exterior. The inside effect was also

bad, one of neglect and decay. Apparently the family had not lived in it for a long time. The hangings and drapes were faded and dusty, but one could see from the quality of the antique furniture, tapestries, and crystal chandeliers that it had once been a magnificently furnished house where the master entertained at dinner parties and receptions for the artistic and musical *haut monde* of pre-First-World-War Paris. Now everything was in a shocking state. Among the pictures, which hung askew on the walls, I saw several fine canvases by Morrice and some works by Morrice's friend, Albert Marquet, I should have loved to have bought. I then climbed the splendid staircase and there in a small storage room amidst a jumble of boxes and empty frames, was another painting, half dangling from its frame, which I recognized instantly as Morrice's great *Circus, Concarneau*. To my dismay, though, there was a large three-cornered tear in it, the edges hanging loosely, like a rent in a beggar's overcoat. I discovered that M. Rouché had recently died at an advanced age, and the estate was in the hands of the government authorities. Not one of the pictures in the house was for sale but some time later they passed by inheritance to M. Rouché's two daughters.

I heard nothing more until several years later, in March 1958, when I received a letter from one of them, a certain Madame Robert André. It was a curious, terse note, obviously typed by herself, listing five Morrice canvases, including the four I had seen in the rue de Prony house of her father. Madame André started her letter negatively stating that she did not think I would want to pay the prices her sister and she expected to get, while impressing upon me, as owners of paintings who wish to sell so often do, that she knew the true market values and was not to be taken in by any upstart Canadian picture dealer. Then came the real shock – the prices she asked were staggering, some three to four times more than the market value of the pictures at the time. Obviously she was flying trial balloons in full tri-colour. Madame André also wanted to be paid in American dollars. She suggested I call or write her son in New York, as he would be there on business for some time, but I decided to bide my time instead.

About a year later, in 1959, Lord Beaverbrook bought the canvas *Circus, Concarneau* for his new gallery in Fredericton, N.B., from Vilma Shima, then owner of the Continental Galleries

in Montreal. The picture had been skilfully restored by then and relined with a new canvas backing and the former damage was no longer apparent. Lord Beaverbrook, a shrewd man, usually took advice on the current market value of any painting he bought, so Mme. André must have significantly reduced her original asking price. I doubt that Beaverbrook would have bought the picture at all if he had known of its former torn and tattered state. Some time later I wrote Madame André that I was still interested in her remaining Morrices, provided she was willing to put a realistic value on them. On one, the lovely *Campo San Giovanni, Venice*, I thought she had done so, and agreed to buy it at her price. She still insisted on cash, in United States funds, which was no problem, so I made arrangements to pick up the money from colleagues in Amsterdam.

This arrogant and extraordinarily strong-willed woman lived in a luxurious house on the Left Bank, within the shadow of the Eiffel Tower. A maid-servant opened the door and invited me to come in and wait in the drawing-room. When Madame herself appeared a little later she was very charming indeed in her greeting, but when conversation turned to the matter of her father's pictures her cordiality all but disappeared. She had talked the matter over with her sister, she announced, and they wanted five thousand dollars more than the figure she had quoted me. I was stunned. I had come several thousand miles to buy the picture, at an agreed price, and now this imperious lady had changed her mind. On the other hand, I wanted this particular picture badly. We finally compromised, but the price was still only half of what she had wanted some years earlier, and the market was still rising on Morrices.

The transaction completed, Mme. André became her charming self again, and asked her pretty blonde daughter to drive me back to the Hotel Meurice. "Denise," she said, smiling gently, "take Monsieur Laing to the flea market on the way; sometimes one finds great bargains there." I still smile when I think about her imperial aplomb.

On my return to England, I learned that a Mrs. A. Hamilton Gault (widow of Brigadier Gault, a great Canadian patriot and soldier of the First World War, who lived his latter years in England), was now the owner of Morrice's *On the Beach, Brittany*. I

57 James W. Morrice *Campo San Giovanni Nuova, Venice* c.1901

went to call on her on my way back from a visit to the sculptress Dame Barbara Hepworth, who lived in St. Ives.

Mrs. Gault, a delightful lady, lived just outside Taunton, Somerset, in a fine old house on spacious grounds. She served us tea and toasted scones in the drawing-room. It was a delightful and friendly occasion, but she did not wish to sell her picture and that was that. She did say, however, should she change her mind in the future she would let me know. Some two years later one of my London colleagues received a telephone call from Mrs. Gault's niece, saying her aunt had given her the picture with permission to sell. She knew of our interest, and we were being allowed the first chance at it. And, she was careful to add, she had ascertained that the painting had great value, especially in Canada. I bought it happily at her price.

It was during a trip to Paris, in the spring of 1951, that I had renewed my connection with Jacques Dubourg, the prominent French dealer and collector I had known years before in Canada, and in the years to come he enabled me to expand my Morrice collection. He had brought a fine collection of Impressionist and twentieth-century French paintings to our galleries in Toronto in November of 1938. Business was so bad in those days that we sold only one picture, the *Jetty with Sailing Ships, Honfleur*, a beautiful small work by the Dutch artist J.B. Jongkind, to Miss Peggy Waldie, for $2,900. Peggy's uncle, R.S. Waldie, then president of the Imperial Bank of Canada, was a client of ours and encouraged his niece to buy the painting on assurance from Dubourg and ourselves that it was indeed good value, a condition of the times we were glad to accept. There were forty-eight paintings by masters of the French nineteenth- and twentieth-century schools in this 1938 exhibition, including Corots, Monets, Renoirs, Pissarros, Degas, and Cézannes, all of fine quality, at prices from $1,000 to $8,000 and up. No one was interested.

Despite his one and only sale in Toronto, Dubourg was slightly encouraged by selling a picture in Ottawa and another in Montreal, and not being a person to give up easily on a project once begun, he decided to return to Canada the following year and try his luck again. In 1939, just before the outbreak of war, thinking, in a fit of optimism, that such a catastrophe could simply not occur, he pre-shipped another valuable collection of French art to

58 James W. Morrice *The Bull Ring, Marseilles* c.1904

Montreal, expecting to follow personally on the next passenger boat. But suddenly war did break out and instead he found himself mobilized into the French army for the second time in his life. Captured in the 1940 German offensive, he remained a prisoner of war until released in 1942, as a result of the goodwill propaganda gesture extended by the Germans to captured French veterans of the First World War. By 1943, he re-opened his Paris gallery, this time on the Boulevard Haussmann.

The collection of pictures he had shipped to Canada remained there in storage in spite of pleas by letter and telegram from the Montreal dealer William Watson to release them for sale, but this permission Madame Dubourg steadfastly refused to grant, as Jacques was still a war prisoner and some of the pictures were on loan and not owned by her husband. After the war, the paintings were shipped back to Paris. It turned out that Jacques never did return to Canada with a collection of pictures to sell because following the war the demand for French Impressionists and School of Paris pictures began to grow steadily and he was quite satisfied to remain in Paris, always a rich source of supply, and from that time on until the day he closed his gallery in 1973, he never looked back on anything but success.

On Jacques Dubourg's return to civilian life in Paris, in 1920, he began to work for the well-known art firm, Georges Petit, a gallery that had exhibited and sold a considerable number of the works of J.W. Morrice. It was here at Georges Petit's that Jacques Dubourg first saw Morrice's work, and, impressed with its quality, proceeded to build up a choice collection of his own; he also had the foresight to buy the little panels belonging to Charles Paquement, a personal friend and patron of Morrice in the early days. Dubourg sought out Léa Cadoret, Morrice's friend and mistress, and bought from her nearly all the Morrice pictures that remained in her possession. Always a generous lender, as early as 1937 he sent four of his own paintings to the Morrice memorial exhibition at the National Gallery of Canada.

Over the years, I acquired at least ten canvases and large

59 James W. Morrice *Portrait of Léa in Tall Hat* c.1895

panels by Morrice from Dubourg, in addition to eight of the finest of the small panels. There were many ups and downs and sometimes long waits in getting the pictures. For example, Dubourg wrote me in March 1952, that he had a client who owned a canvas called *Vue de Paris*, which he was willing to sell. When I expressed my interest he re-approached his client, saying he had a buyer. However, the client demurred, refusing to sell, because it was the time of a serious monetary crisis in France and he was apprehensive regarding the future value of the French franc. In the same letter, though, Dubourg remarked he had a fine little *Study of a Girl*, which I could have for $130. I collected it from him in Paris the next time I was there. Some months later I did get the *Vue de Paris*, which was a scene from Morrice's studio overlooking the Seine with figures and bookstalls by the river bank – a marvellous picture. The original study for *The Bull Ring, Marseilles* came from him too. In June 1960, he sold me the *Portrait of Léa in Tall Hat*. This picture was one of the last of the paintings owned by Léa Cadoret, and indeed was a portrait of Léa herself. Morrice first met her in 1898, when she was a girl of seventeen, and they were the closest of companions until his death in 1924. Morrice painted several delightful studies and portraits of Léa, and posed her in landscape and seashore compositions. I nearly lost this picture, however, in a suitcase left in the dining car of a train while travelling from Geneva to Milan. The train stopped in the middle of Switzerland; we were asked to disembark, I don't know for what reason, but when we started again, the dining car, with my bag containing the picture, was part of another train also heading for Italy. I appealed to the station master for help and he immediately telephoned ahead and had the train stopped and my bag taken off just in the nick of time, at Brig, on the Swiss side of the Simplon tunnel. If that case had gone into Italy, the station master told me solemnly, it would have been gone forever.

I sold the *Portrait of Léa in Tall Hat* shortly after I bought it, and it came up for sale again in 1969. A Madame Lawrie Lerew, acting for the owners, wrote to Léa Cadoret for information, enclosing a photograph. Léa, who was living in Juan-les-Pins, wrote back saying that she remembered the picture well. It was painted in the Tuileries gardens, she said, and on that very day, her "friend" (Morrice) and she had had lunch with Gabriel

60 James W. Morrice *Promenade, Dieppe* c.1904

Thompson, the Welsh painter, and Henri Matisse. Pathetically, her letter added that she was now very old and desperately in need of money, having made large loans to certain people who never re-paid her, and naively asked if she could have a commission in the event of its sale. Actually Morrice had left her well off from an im-portant part of his estate and shortly before he died had bought her a house at Cagnes. I regret very much that I never made myself visit Léa at Juan-les-Pins.

One day in the autumn of 1960 in Toronto, J.J. Vaughan, a retired executive of the T. Eaton Company of Canada, and a collector of Canadian art, who was so fussy about his pic-tures that he provided white gloves for visitors who wished to han-dle them, called to say that his old friend A.B. Fisher was very ill, needed money, and wanted to sell some of his Canadian pictures, including the famous J.W. Morrice canvas, *Promenade, Dieppe*. He had, for adventure or for patriotic reasons, bought the picture in a travelling exhibition organized by the Royal Canadian Academy in aid of the Canadian Patriotic Fund back in 1914. Vaughan also cautioned me that a New York dealer was on his way to Toronto, having heard from a member of the Morrice family in Montreal that the picture was for sale.

I had known Fisher for many years as a member of the Arts and Letters Club and I also knew and admired his magnifi-cent Morrice. When I arrived at his house in south Rosedale, there he was, stretched out on a hospital cot in the living room, looking terribly old and terribly ill, but he was cheerful in his greeting and one could see his mind was sharp and decisive. He knew exactly what he wanted for the painting, and was as happy as a schoolboy, and even looked rejuvenated, when I wrote out a cheque in his fa-vour for $5,000. I was pleased too. The next day the disappointed New York dealer came into our gallery, not knowing I was the one who had bought the picture, bemoaning the fact that the beautiful Morrice he had come to buy was already sold. I later bought a Morrice watercolour and other fine Canadian pictures from the Fisher family.

In my buying, I have learned to make fast decisions, and my first instinctive reaction has always been my best guide. Ber-nard Lorenceau still reminds me about the bargain he gave me in 1952, on *Sailing Boats in a Regatta*, by Morrice, which I bought for $200 the instant I laid eyes on it, sitting unframed on an easel in

his little shop in the rue la Boétie in Paris. Another time my old friend J.A. McNeill Reid, the senior partner of the Reid and Lefevre firm in London at the time, once got me a Morrice within hours of contacting his client. His father had sold it to a collector in Glasgow many years before; when he told me of its existence, on a visit to London in 1954, it took him no time at all to telephone his client, arrange a price, and have the picture placed on the Glasgow to London overnight train. It turned out to be a fine one – a landscape with figures and boats on the banks of the Seine at St. Cloud, painted about 1908. It cost me $2,000.

Among the finest cigar-box-size Morrice panels I have ever seen came from John Nicholson, the New York and London based dealer. I ran into him at Charles and Sidney Hahn's picture restoring studio in Albemarle Street one day in the summer of 1956; he happened to mention he had just bought six small panels by a Canadian artist, J.W. Morrice. I pricked up my ears and asked if I could see them. A two-minute walk to Piccadilly, and a short cab ride took us to his flat in Kensington. The beautifully framed panels astounded me with their fine quality. I wanted them all, but Nicholson would only sell three – his wife, he said, was too fond of them to let him sell all six – I paid him £300 on the spot. A year later, visiting him at his gallery on East 57th Street in New York City, I learned that Nicholson was divorced. He had promised me first chance at the other three panels if he were ever to sell them; he kept his word and I paid him $1,500 for the other three with grateful thanks.

During my travels I often met and eventually got to know well the ubiquitous John Nicholson. He had his gallery in New York, but often travelled to London to do his buying. John Nicholson was a *bon vivant*, a garrulous, transplanted Englishman, who had a great love of pictures and possessed a talent for talking about them. He liked his whiskey and soda and sometimes the result of too many of these would affect his physical co-ordination the morning after. One day while in New York I went to see him to look for some possible purchases. He became so shaky on pulling out a large painting from the racks that he pushed the frame right through the centre of a valuable Constable canvas standing on the floor nearby. He maintained perfect poise as he calmly surveyed the damage, but he liked pictures so much, that he must have suffered some form of deep, inner anguish as a result of the accident.

227

Nicholson bought many marine and coastal scenes by Eugène Boudin. One time I was considering the purchase of one of these, an estuary with sailing boats, but hesitated, mentioning we already had several Boudins in stock. He replied, "In pictures you cannot have too many of a good thing," and he was right. John Nicholson possessed a good eye for almost any school of painting, and more important to a dealer, always knew what he could sell.

Charles Lock, another dealer-colleague in New York, knew of my interest in Morrice, and in 1955 found one, an upright landscape of the Tuileries gardens, with figures walking in the park amidst falling leaves and golden autumn colours. I sold it to Murray Vaughan of Montreal. Later I bought the small sketch for this picture from Jacques Dubourg, which is even more beautiful.

Robert Henri, the American painter and founder member of the Ashcan School, a powerful figure painter, was a friend of Morrice in his Paris days of the mid-1890s. In 1896, Morrice had painted a Whistlerian study of Henri. As late as 1960, part of the Henri estate was being dispersed by a New York art firm, and there among pictures by Henri and other artists was a lovely little Brittany street scene by Morrice, dated on the back of the panel, "1896, Paris," in Henri's own handwriting. The dealer said a compatriot of mine, an art critic and writer, was interested in it but had made no decision, so I bought the picture then and there.

When in 1966 John MacAulay, the Winnipeg collector, asked me if he should buy *En Plein Mer* by Morrice for $20,000, from a photograph offered by an American dealer, I hesitated to say, "Yes, buy it," but several weeks later, when I looked in at the New York gallery that had offered it, the picture was gone. The price was high for the time but cheap compared to today's prices.

Throughout the many years I have bought, sold, exhibited and studied the painting of J.W. Morrice, I always hoped that one day I would be able to visit some of the places in Normandy and Brittany, especially the fishing ports along the coast, where he did so much work during the first decade of this century and up to the beginning of the First World War.

Morrice used to buy from Bénard's in Paris little 4¼″ x 6½″ hard-covered sketchbooks, about the same size as the little wooden panels he used for oils. I possess several of these booklets, with all sorts of trivia written in them; train timetables to Dieppe, Chartres, and St. Malo, and the names of small hotels all over the

place. One sketchbook is dated July 11, 1906, and gives his Paris address as 41 rue St. George, a later one as 45 Quai des Grands Augustins, overlooking the Seine near the Place St. Michel.

On one or two recent occasions I mentioned the idea of going to Brittany to Peter Eilers, with whom I had made so many interesting trips. He suggested that we do it around the end of June 1977, starting out in Amsterdam. Peter, his wife Marcelle, and I set out on our journey on Friday morning, July 1, in his new red Ford. Both Peter and Marcelle knew the Normandy and Brittany country intimately, having travelled through these ancient provinces many times on the way to Belle Ile, that rugged island off the coast of Brittany, from Quiberon, where they holidayed every summer.

After staying the night in Honfleur, at the lovely old Hotel Lechat on the market square, we proceeded southwest on a beautiful morning along the coast through the famous summer resorts of Trouville and Deauville. Hundreds of boats with their sails billowing in the wind seemed to fill the bay of the Seine with their luminous white shapes. This was the territory of the French painter, Boudin.

Crossing the Cotentin Peninsula towards Cancale we were now moving into Morrice country. From a height of land driving in, one could see the main roadway on the bay shore with its outdoor cafés, shops, and small hotels. Cancale has been famous for centuries for its great oyster beds. It was low tide as we came down the hill into the old town, unchanged through the years, and the oyster fishermen were bringing in their harvest from the beds in the bay. Instead of the carts and horses of Morrice's time, they used tractors with small trailers piled high with the famous *"cancales."* I could imagine myself on the very spot where Morrice might have sat in an outdoor café, sipping a drink while making a drawing in his sketchbook, or painting one of his little panels. Nearby were the places Morrice did some of his most important work; the Brittany coastal towns of Rocheneuf, St. Servan, and Dinard, all contiguous to St. Malo.

When we arrived at St. Malo, pushing our way in heavy traffic through the small archway and down the narrow streets, it was almost dinner time, and the hotel which Peter had picked out from the Michelin guidebook had only one room left; a double room for Marcelle and himself. However, the proprietor was ex-

tremely helpful and pleasant, and got me a room in the rue des Marins in a hostelry, impressively named the Hotel du Louvre. I was embarrassed when he insisted that a woman porter carry one of my bags there. My room was number thirty-one, but up on the fifth floor, reached by a tiny elevator. It was Saturday night, and the sailors were out in force, whooping it up on the rue des Marins. They were in and out of bars all night long, singing French and English drinking songs with great abandon, followed by pauses and then the crash of breaking bottles. The street was so narrow that the noise had only one way to go, and that was up.

The next morning, a sunny warm one, Peter and I made a complete tour of the ramparts. What a sight! Surf on one side and rocky islets, some with ruined fortresses, and then a sheltered beach with bathers basking on the sand by their brightly-coloured umbrellas on the other. This was the exact spot where Morrice had painted *View of the Beach from the Ramparts, St. Malo* over seventy years earlier. In a drawing and a painting of his I possess there is an identical view of the ramparts and the same beach. The war-damaged ramparts have been restored, and now weathered, must look as medieval as before.

After St. Malo we went on to Dinan, another ancient town a little further inland, with Gothic churches and very old buildings. The French possess a deep sense of pride in their ancient history and have done a remarkable job of preserving and restoring their old monuments and buildings. In early July the Normandy and Brittany landscape was beautiful indeed; vast areas of dark green apple orchards, flax fields in soft straw colour and mustard fields in burning yellows. The terrain was always changing, through many small mountains and extensive valleys, and the houses were very attractive, with high slanted roofs, often painted white with dark, wood slats.

We cut across the Breton peninsula from Dinan to Locronan, to the town of Douarnez where, according to Léa Cadoret, Morrice visited with her and painted, and down the south Breton coast to Concarneau, another important fishing port with an inner harbour and walled town. I liked Concarneau, its granite walls and medieval fortress rising from the water's edge provided a backdrop, like a stage setting for the fishing boats anchored in the har-

61 James W. Morrice *View of the Beach from the Ramparts, St. Malo* c. 1899

bour. The scene recalled in dream-like fashion the Morrice images I knew so well from the pictures he painted there. But it was a surprise that such a place still existed, and all that was missing that day from the scene of old, was the tented circus with a background of sails, a subject the artist loved to paint on summer visits to Concarneau.

Our search for Morrice paintings still goes on. However, by the late seventies the number of them coming on the market from old European collections, especially French, all but dried up and very few of his pictures are now turning up for sale in Canada. Through the years we did meet with great success and were able to provide our clients with many excellent examples of the work of this great painter.

13

Krieghoff and
Kane Discoveries
and Other Revelations

One day in May 1964, I attended the preview of an auction sale in Toronto of general household effects and pictures. There, hanging on the wall, in a poorly-lit *cul-de-sac*, was a painting of a band of Indians making a portage around river rapids, some with canoes slung over their heads and others already paddling downstream. I gazed at it in wonder and admiration. Was this not an important work by the rare mid-nineteenth-century Canadian artist Paul Kane? I thought it surely was and wondered if anyone else suspected it was a work by the master. It was catalogued simply as a river scene with Indians and canoes. No name was suggested as the artist and the picture was unsigned. This pointed with more certainty to Kane, who seldom signed his larger pictures. The next evening came the sale and I bought the painting for $1,000. Obviously some people had liked it as a picture but no one was willing to bid me up to a Paul Kane price level, which would have been from $8,000 to $10,000 even in those days. I could hardly contain my sense of elation. I well knew that Kane had painted replicas of many of his pictures, sometimes as many as three or four but usually only one more.

I knew an employee at the Royal Ontario Museum, by the name of Donald Porter, a skilled cabinetmaker, who, among

233

62 Paul Kane *Indian Encampment, Winnipeg River* 1846

other things, designed, constructed, and repaired cases used for displays in special museum exhibits. I told him about my probable discovery, and he told me to come in the next morning. I brought the canvas to the museum under my arm, and proceeded down to the basement with him. We began to check through the racks where the Paul Kanes were stored, and, sure enough, we soon discovered a painting of the identical subject. This was all I needed to confirm my belief that we were indeed the possessors of an original work by this artist, the title of which, we were to learn later, was *Indian Encampment, Winnipeg River*.

Kane's work was and still is so rare that in all our years in business, even up to the present time, the total number of Paul Kane paintings we have bought and sold remains at no more than fifteen. I well remember in 1951, Tom Baskett and myself, on our first trip to Winnipeg called on the grandson of the artist, also Kane by name, but he showed us on that occasion only a few small oil sketches and modest drawings. How many he possessed, all told, I do not know but he bitterly complained that his offer to sell the collection to the Government of Canada, through the offices of Mackenzie King for the sum of $100,000, was refused. Later, in the mid-fifties, the collection was offered to Eric Harvie of Calgary, and again turned down, but it was not long before the entire collection was quietly bought up and went to the United States where it remains today in the Stark Foundation, Texas.

In September 1963, I heard about an important winter scene with many figures outside a settler's log cabin by Krieghoff that was to be sold at auction in Los Angeles. I arrived in plenty of time for the sale and had a chance to examine the picture carefully. The canvas and the pigment had never been varnished, having been by chance hermetically sealed under glass in its frame for the ninety-one years of its existence.

It was a large and striking example of one of his *Return from the Hunt* series, a canvas of about 2′ x 3′, and as fresh and brilliant as the day it was painted. (Unlike so many artists, Cornelius Krieghoff retained his phenomenal sense of colour to the end of his life.)

It turned out that the painting originally came from Chicago and was signed and dated 1872. It is an historical fact that

Krieghoff was in Quebec for much of 1871, as that year he produced several of his major masterpieces. Perhaps through poor health, though who knows the true reason, he went to Chicago to live with his daughter, either late in 1871 or early in 1872. This picture was probably painted from memory and may be the artist's final work, as it is the only known painting signed and actually dated 1872. He died in Chicago in March of the same year. I can't help thinking how incongruous it would have been if he had signed this great Quebec subject – C. Krieghoff, Chicago, 1872.

I bought the picture at a pretty stiff price for those days. It turned out later that the under-bidder was one Dr. Armand Hammer, who introduced himself to me after the sale. Dr. Hammer was president of the Occidental Oil Company and is presently one of the biggest oil men in the world, a partner of the late J. Paul Getty and Lord Thomson, with interests in the vast North Sea oil fields as well as in those in other parts of the world. I only knew of Dr. Hammer by reputation in those days, but his brother Victor, owner of the Hammer Galleries, New York, had been a long-time friend. Anyway, on this occasion I was able to outbid the multi-millionaire because I had the specialized knowledge of Krieghoff and knew the market better than he did, and also because Hammer never gambled against the odds. Later, when Victor heard that I bought it, he gently chided me for not letting him know in advance of my interest in the picture since we could have bought it together in shares at a much lower price.

In 1965, I well recall, William M. Connor, an Ottawa washing-machine manufacturer, and successful pioneer in his business, decided to sell his large and fine collection of Krieghoffs. He had lost a son in the war and had no further ambition to collect. He asked a Toronto dealer in nineteenth-century paintings for his opinion as to the best place to do so. London was suggested, a mistake, as Canada would have been by far the better market. However, his decision worked out well for me.

There were twenty-two pictures by Krieghoff in the collection, the greater number of which I wanted to buy. Sotheby's had been selected as his auctioneer agent. So as not to force prices up artificially by open bidding, I wanted to buy anonymously and approached Sotheby's the day before the sale. "That's fine," they said, "we will give you a pseudonym." I chose Gilbert, my actual

63 Paul Kane *Drying Salmon at the Dalles, Columbia River* c.1846

first name. "Furthermore," they suggested, "when you are bidding keep your glasses on and when you remove them we will know you have stopped."

All the dealers present sat around tables arranged in a large rectangle, with the rostrum at the open end. There sat that master auctioneer, Peter Wilson, with his ivory hammer, knocking down each picture at a record high price. In half an hour, for that was all the time it took to sell them, I had the best eighteen of the twenty-two, and besides the auctioneer I am sure no one in the room was aware who the buyer was. The name Gilbert, however, was in the newspaper headlines the next day. Not only that, but apparently a photographer from *Life*, who was doing an article on Sotheby's and Peter Wilson, had been at the sale. When the piece came out, there I was, large as life, just having finished bidding on a Krieghoff, with my horn-rimmed glasses on the table beside me.

In October 1976, I was in Amsterdam. One of my Dutch partners, Nico de Jong, who had recently been in southwest England recuperating from an illness, mentioned he had seen an announcement, in a local newspaper there, of an auction sale to be held in a place called Crewkerne. Five pictures by Cornelius Krieghoff were to be sold. They had been found in a country cottage and the owner was an old lady who had no idea of their value and would have been pleased to receive any sum of money they might fetch in the sale room. I thought I was one of the lucky few to learn about the sale. But such hopes were soon dimmed because a day or so after I had arrived in London, a photograph of one of the pictures appeared in the *Times*, with the full story of their discovery. (They had originally been bought by an English sea captain in the early 1860s, from the artist himself in Quebec, and had remained in the same family for more than 115 years.) By now, of course, the art world knew about them; the story was also in the Canadian papers.

However, still in an optimistic and adventurous mood I drove down to Crewkerne in Devon the day before the sale with two of my English colleagues, John and Roland Williams, to examine the pictures. They were superb, though the surface of each was covered with discoloured varnish and the dirt of more than one hundred years. But from what we could see through the grime the painting underneath was pure and untouched. In some strange

64 Cornelius Krieghoff *Habitants Driving, Winter* c.1862

way, as happens with old pictures from time to time, the dirt and the old varnish had wonderfully protected the pigments, and the pictures looked to be in perfect condition. We drove happily the few miles back to Combe House, a marvellous Elizabethan mansion, converted into a hotel, set in beautiful grounds in the centre of East Devon. Here we dined and stayed the night.

Next morning we were off to Crewkerne for the sale. It took place on the second floor of an eighteenth-century building, once a town hall, in the main square of this old market town. The salesroom was crowded with dealers and their agents; they were even jammed in at the back of the room. Bidding was strong, but we bought the five for the equivalent of $90,000, one of which was *Habitants Driving, Winter*. Our slight gamble on condition paid off, the pictures cleaned up so well they looked as if they had been painted yesterday. When the sale hit the television news and the papers, everybody in England must have searched their lofts, because, unbelievably, during the next year, three more Krieghoffs turned up in the same Devon country, with much the same history. Another sale was organized and again we made the trip, this time in March 1977, and we bought the three for $60,000.

Few Krieghoff paintings now remain in private hands in England. All together from 1938 until 1977, we acquired nearly two hundred in that country alone. We were the first dealers in the world to hold exhibitions of Krieghoffs with all of the pictures for sale.

Especially in Krieghoff's great productive years, from 1851 to 1871, there was that wonderful clarity of colour, a high quality of detail, and those stunning large compositions. Even the faces of the small figures in his large canvases are alive and ready to speak. With some of his pictures there is a problem in the actual condition of the painting surface. Many have been neglected for over a century, and unlike the Crewkerne pictures, for instance, have suffered from storage in damp cellars or in outbuildings, such as gardners' sheds. Since Krieghoff's pictures were not always valuable and his name until recent years not all that well-known outside of Canada, many of his pictures were ruined by amateur restorers, who sometimes painted in a whole new sky just to hide a little tear in the canvas, or ruined the surface of the painting with a poor relining job. When a picture has been treated this badly noth-

ing can be done about it; you just do not buy it or offer it for sale. A picture that has been ruined by over-cleaning can never be put right again, and a trained eye c n immediately spot a badly restored one, just as the trained eye can immediately detect the qualities peculiar to a work by any artist.

For many years we had our Krieghoffs cleaned and restored in London by yet another master in his profession, Charles Hahn, of Albemarle Street. Many a time I sat down beside him at his easel and watched how miraculously he could clean a picture. With little deft touches here and there, he was calmly confident in his knowledge of the painter's work and the quality and chemistry of the pigments; he made it look so easy.

Through careless handling, an act of God, or both, I almost lost by water damage an important Krieghoff painting of a Quebec village. Preparing for an exhibition of paintings in western Canada during the autumn of 1963, I had pre-shipped six cases of paintings to Edmonton. When the shipment arrived at the showrooms in the MacDonald Hotel, one of the cases was soaking wet. The pictures had been packed in a wooden box between layers of foam rubber, fine packing material under dry conditions, but dangerous when moisture is present, as it soaks up water as fast as a sponge. To my dismay, when the box was opened the Krieghoff was lying closest to the top and the surface of the painting was wet; the paint was beginning to curl up and away from the original gesso-primed canvas. Even worse, the next layer of foam rubber below was also wet so the damaging moisture was in contact with the back of the canvas as well.

Besides careless restorers, the worst enemies of paintings are fire and water. The heat from fire frizzles the paint on the canvas or panel – many times I have seen this happen, and restoration is impossible. Water causes the paint to lift off the surface in patches, but if the damage is caught in time the picture can sometimes be restored. In the case of the Krieghoff, we had a good chance of succeeding. I quickly and carefully soaked up as much moisture as possible with blotting paper, luckily found on the desk, while keeping the painting away from the hot hotel radiators so as not to hasten the drying process and cause a dangerous contraction. It was vital to prevent any actual paint loss, and although some of the paint was curled up, we had to prevent it from falling

off. Having fixed the loose paint areas with tissue paper and a light paste to prevent those little pieces of paint from falling off during the trip, I shipped the canvas to Charles Hahn. Through his consummate skill and patience the entire surface of the damaged painting was transferred to another canvas; all the loose pieces were pressed into their original places without loss of paint and this painting became a near perfect picture. Such are some of the minor miracles that a great picture restorer can perform.

A dealer is often asked how he can tell if a picture is genuine. For example, how do I distinguish a real Krieghoff from a forgery? Krieghoff was such a well-trained and accomplished artist that although he painted many similar subjects, they are all beautifully finished and no two are exactly alike. In other words, he never slavishly copied his own work. With such an artist, besides the general quality of the picture in hand there are a few special aspects of his work to consider. The first and most obvious is the signature. Over a period of the nearly thirty years that Krieghoff painted in Canada his signature changed, but whatever form it took it was always precise and legible. He dated many of his pictures but not all of them and when painting in the Quebec City region he often wrote "Quebec" beside his signature, sometimes a date as well. I have seen few genuine Krieghoffs without a signature and these were poor early ones. I have also seen genuine Krieghoffs where the signature has been inadvertently removed by a careless restorer and then crudely replaced.

But in judging a painting's authenticity there are no hard and fast rules. Tom Thomson, for example, seldom signed his pictures at all. Estate stamps and history are frequently all there are to go on. Sometimes a perfectly authentic picture may have a wrong signature.

Early in 1977, a friend of mine heard a rumour that a Tom Thomson sketch painting was coming up for sale at a local auction house but mentioned there seemed to be a cloud of doubt over its authenticity. It was signed "Tom Thompson." When he brought me the little picture to examine I instantly recognized it from our 1937 exhibition. I looked up the catalogue and there it was, No. 59, *Spring Birches, Canoe Lake*, lent by Mrs. E. Whaley. Moreover, the name E. Whaley, a name which appears elsewhere in my story, was readily visible in large faded letters on the back of the birchwood panel.

The auctioneer, however, not having our catalogue information and being a prudent man, was extremely nervous about selling it at all. In the end he decided to do so but cautioned would-be buyers concerning the misspelled signature and refused any guarantee of authenticity. To have appeared at the sale in person or to have done my own bidding would have been a mistake so I had someone act for me. The picture was purchased under the hammer, for $8,000, a fraction of its real worth. The panel was dirty. The signature was neatly printed in ink in small block letters, but through a strong magnifying glass you could see that the letters were just sitting on the surface of the paint. I soaked a cloth in plain turpentine and let it stay on the surface for a minute or two. Then almost before I could blink my eyes the spurious ink signature disappeared, dissolved by the turpentine, leaving no residue or mark whatsoever on the surface of the painting. Whoever had printed that ink signature on the picture was either just plain ignorant in not knowing how to spell the famous Thomson name, or perhaps took a sardonic pleasure, hoping one day to confound and confuse the experts, which is exactly what happened. There must have been others at that sale who were willing to gamble on the picture's authenticity but since I was the only person who knew its complete history, I took no risk in buying.

The inexperienced buyer is always apprehensive about forgeries. Throughout the years there have been scores of art forgers, most of whom have been caught in the end. In Toronto in the early 1960s, we had several of our own charlatans, faking Tom Thomsons, J.E.H. MacDonalds, and Krieghoffs. The pictures were usually marketed through auction sales. Some unwary people were taken in, but in the end, the fakes were so crude and poor they were self-defeating. Van Meegeren, the Dutchman, was a notorious forger, who operated just before and during the Second World War. He specialized in faking the works of the seventeenth-century painter, Jan Vermeer of Delft. His early attempts were done with some skill and care; during the war there was little movement in works of art in Europe, and he was able to sell some of these pictures at good prices to people in high office (such as Hermann Goering, who possessed a huge art collection). But Van Meegeren grew careless and dealers and museum directors became suspicious. After the war I saw a collection of both his own original

243

compositions and his fakes together in one exhibition in New York, and was appalled to see just how bad they all were.

A few years ago there was the case of de Hory, whose copies and paintings "in the manner of" some of the twentieth-century School of Paris masters, such as Modigliani, Dufy, and Matisse, were sold in New York and Texas. Again they were exposed and again these pictures were neither good nor convincing to the trained eye. (De Hory claimed his fakes were signed by others but there is little doubt that he painted them to deceive somebody.)

Then there is the recent case of the boastful, cockney-shrewd picture restorer, Keating, an entertaining television performer and a cunning rogue, but a complete failure as an artist. "A mediocre little forger, who, while making a gesture against the mandarins of the art market achieved a disproportionate degree of publicity," was how one newspaper columnist described him. He claimed that dozens of his so-called "pastiches" of Krieghoff and other masters are floating around the art market undetected. These were done, he said, simply from small colour reproductions – an impossible accomplishment. I have seen none in Canada, nor has anyone else I know been able to track one down. From photographs I have seen they are so bad as to present no problem at all in their detection. Keating also tried to protect himself by claiming he never put another artist's signature on anything he painted, but Scotland Yard is now investigating the whole situation. He had a girl-friend accomplice to market them, by the name of Jane Kelly, whom the police say was smarter than Keating and the brains behind the marketing of his fakes.

It is difficult to explain, but after years of experience in building up one's knowledge, when you look at a picture your mind records an impression, an immediate one defined by a multitude of previously experienced details, and a swift reaction follows. It is that initial response to which I pay the most attention. I seldom change my mind. I would rather trust a knowledgeable dealer's opinion in his own field than that of any gallery curator or academic art historian. The dealer puts his money down on the table when he buys and cannot afford errors in judgment. As my father often said, "If you have the slightest feeling in your mind, any little cloud of suspicion or doubt about a picture do not buy! Let it go!" However, in spite of this keen instinct, forgeries do appear from

time to time in the most unexpected places and in surprising cir-
cumstances.

On April 2, 1974 I was in London when a small but fine
collection of French paintings were coming up for sale at Sothe-
by's. They were owned by the Santamarina family of Argentina,
and were said to have been in the family for some sixty years or
more. I particularly liked a Monet river landscape, of a row of
poplars along the banks of the Seine at Argenteuil. It had been
painted some time between December 1872 and February 1873,
when the Seine was in flood. I liked the colour and especially the
composition, reminiscent of the aerial perspective of the famous
Hobbema *Avenue of Trees*, which I often went to see at the National
Gallery in London. The other picture I liked was a lively but tiny
little Degas panel, measuring 4¾″ x 3¾″. It bore a signature, but it
was probably a stamped one, and depicted several jockeys wheel-
ing their horses before the start of a race. With my Amsterdam col-
league Jan de Jong sitting alongside me I bought the Monet for the
equivalent of $130,000 and the Degas for $160,000, a world record
price for so small a nineteenth-century French painting. I was
pleased enough with my acquisition and although I had no special
customer at the time, was content to keep them a while myself.

Several weeks later, my partner Peter Eilers was in Paris
and in the course of a conversation with Philippe Brame, a well-
known dealer who, together with his father, Paul, were long-time
friends of ours, mentioned my purchase of the Degas. Philippe be-
came most agitated, saying that he did not believe the picture to be
a genuine one, and that he would not add a photograph of it to the
official supplement he was preparing on the work of Degas. (He
was in the process of cataloguing the Degas paintings discovered
after the original catalogue prepared by P.A. Lemoisne in 1946.)
Furthermore, he said he had discovered in his father's files a box of
photographs marked "Fake," one of which was a photograph of
my panel. Peter immediately passed this disconcerting bit of infor-
mation on to me, and suggested I take the panel to Paris, so that
Philippe could examine it again, and show it to two or three other
Degas experts. In the meantime, through friends in Toronto, I had
been introduced to an important London legal firm, specifically to
one of the partners, Mr. John Charles (now Sir John). Seeking ad-
ditional counsel, John Charles arrived at the opinion that Sothe-

by's might not be legally liable, since it was a matter of "innocent misrepresentation." There was the further complication that the head of the Santamarina family had just died at an advanced age in the Argentine, and Sotheby's had already paid out the proceeds from the sale. I had by then obtained letters and signed photographs from three prominent French dealers, one of whom was Charles Durand-Ruel, grandson of the founder of Durand-Ruel, the first firm to show and sell the French Impressionists, and all three declared, in their opinion, the picture was indeed a forgery.

Under John Charles's professional handling of the affair, Sotheby's took a good look at the situation and agreed to return our money. We received a third of the amount in London and I went to New York to pick up the balance before the end of the year.

I have written at some length on how easy it is for an experienced eye to tell an authentic Krieghoff from a fake. But one cannot be an expert in all fields and I should have consulted an outside Impressionist expert before I bought the Degas. Now, in retrospect, I can see important missing elements in the presentation of the picture in the auction catalogue that should have made me wary. There was no reference to its having been exhibited outside of South America, quite enough to make one ponder, and no previous history. I found out later several French experts had been highly suspicious all along. The picture would not under any circumstances have appeared in a public sale in France, as it would not have been passed by the experts there who guarantee the authenticity of paintings sold at auctions.

Even the experts can be wrong, however, as the following story shows.

In 1966, there were several unusual auction sales at the King Edward Hotel in Toronto, mysterious in fact in the sense that I wondered where all the material came from, since the source was obviously not Canadian. It turned out that it had all come from Cuba, having been purchased from the Cuban government by Toronto-based furniture and antique dealers. Furthermore, these objects had been confiscated by Castro from wealthy Cubans, "enemies of the State," who had left the country rather than stay on to share his brand of communism.

In January 1967, a customer of mine and an antique

dealer friend, invited me to come along on a trip to Cuba to see what was left. The Cuban government had invited him, and he needed an art expert as an adviser and partner. So we chartered a small plane at Malton, hired a pilot, and were on our way. We left Toronto on a Thursday morning in mid-January and seemed to skip through the sky, in that little aircraft, always in clear sight of the ground except when we passed over Pittsburgh, which was almost hidden by the smoke from the great steel mills. We stopped in Atlanta to refuel and then flew on over Miami and the Florida Keys to the furthest point of land, Key West, where we stayed overnight, only some ninety miles from our destination. The trip was a delight.

The next morning we were checked out by the U.S. customs officials, who shook their heads in disbelief at our story that we were going to Havana to try and buy art objects, but they were pleasant enough and just reminded us to be sure to check in with them on our return to United States soil.

A few minutes after take-off we were within sight of the beautiful green and sand-white coastline of the island. The Havana district has two airports, one military and one civilian and commercial. I was sitting quietly next to the pilot, enjoying the view, as he headed for the military airport which was strictly out-of-bounds. A radio call from the tower ordered him to change course on pain of being knocked out of the air. The poor pilot was still shaking when we landed. The airport soldiers relieved us of our passports, thoroughly checked our baggage, and said our papers would be returned on leaving the country.

A Cuban official tucked us into a broken-down 1956 Oldsmobile and drove us into town, past countless posters featuring Fidel. We were to stay in a fine old Spanish-style stucco house, with tall, white pillars and a large, neglected garden, where some exotic flowers bloomed and where there was a large aviary without any birds in it. The mansion contained no furniture, the crystal chandeliers were missing, and there were no carpets or rugs on the polished marble floors. Each bedroom had a small bed and a little dressing-table on which sat a small radio. All stations broadcast in Spanish; you could not even tune in to Miami, a few miles across the sea. There was no one else in that empty house but a houseboy, detailed to look after us. Food was in short supply, but fortunately

one of our group, who had been in Cuba before, had made sure we brought in enough provisions to last us at least two days.

That same evening we were taken to the best restaurant and night club in town as guests of high officials of the government. We would like very much to meet Mr. Castro, we said. They said "Certainly, it would be arranged immediately," but nothing ever happened. The next morning a young Cuban drove us in another broken-down car over nearly empty streets to the old part of the city. We saw some impressive Spanish baroque buildings of the eighteenth century, and churches and monuments of even earlier times. Just before passing through the monastery gates I was struck by the sight of a dignified figure of an old negro man with gleaming white hair. He was trudging along the street with a heavy load of party propaganda newspapers on his shoulders, but he had a smile on his face and all the while was smoking a huge "Havana." There, I said to myself, goes one happy man in this town.

Our destination was an ancient grey stone monastery, with huge reinforced iron gates, that overlooked the great harbour of Havana. Three Russian freighters were moored there. The ground floor was the biggest warehouse I have ever seen. Dozens of crystal chandeliers hung from the ceiling in various states of disrepair. As well as every kind of furniture, there were hundreds of used stoves, refrigerators, and various other pieces of household equipment.

A creaking hydraulic lift took us slowly to the floor above. Here was a true Aladdin's cave, and just as dark. The barred lunette windows were so cramped and dusty that little daylight entered, and the electric light was dim. But through the murk could be glimpsed hundreds of pictures, antique tables loaded with old silver, Sèvres vases, and porcelain, carpets, and tapestries. Among the pictures I saw what was a certain early Corot landscape with a Kaganowich label on the stretcher. I asked the price.

There was no lack of attendants to consult; the problem was that each one acted like the boss. The system seemed to be for everyone to look over everyone else's shoulder. Finally three little men went away, came back, and said, "Those paintings are not for sale; they are going to the museum." Any good picture I enquired about was destined for the museum. I never did find out if there was a public art gallery in Havana. Anyway, it was clear that they

wanted to get rid of the junk and keep everything else. But I persisted, and after looking at many dozens more poor pictures, I saw, behind a wire cage, four that looked interesting. The attendants unlocked the metal door and I was able to examine them at close hand.

All were small. One was of a square in a Dutch town, with many little figures and buildings; I could see no signature but I was sure it was seventeenth-century Dutch. The second was another view of a street with buildings, a little beggar figure and a religious procession in the centre foreground. It had a monogram that looked like Jan van der Heyden's, which I could barely see in the dim light. On the back was a label, printed "Goudstikker, Amsterdam." The third was a view of a Dutch mansion on a canal, with several figures and four greyhounds on leashes. This one was signed "G. Berck Heyde, 1660." The fourth was a small panel in rich colours, of a travelling nobleman in a tall hat, on horseback, halting at an Italian roadside inn. A boy is pouring wine into the traveller's outstretched glass. It was signed and dated, "K. du Jardin, 1665, collection R. Holford, Dorchester House, London." That name rang a bell in my mind.

To my enquiry this time, a fellow with a wicked look in his eye came back and replied, "The price is $5,000 each." (Apparently they had had the pictures valued by French and Spanish experts.) My partner said, "The price is too high." I said, "Let's take a gamble."

The paintings were in their old original hand-carved frames. I removed them with the pliers I had taken with me and one of the Cubans wrapped them in a neat paper parcel for us to take back to our empty white mansion. To pay for them we had to go to an office which had a great bank vault in it. Still visible on the door of the vault in large gold letters was "First National City Bank of New York."

The frames were to come to Canada by ship, duly arriving some four weeks later; meanwhile the parcel of paintings fitted nicely into the hold in the nose of our little airplane. Back in Key West, the customs officer accepted a Havana cigar, "to smoke on the golf course," he said, and sealed the hold for the flight home.

Soon after my return to Toronto I had a visit from two New York art dealers whom my partner had met somewhere on his

travels and told of our purchases. These gentlemen examined the pictures carefully and at great length at our galleries and finally suggested they were merely school works, or by followers of the artists named. Furthermore, they announced, two of the wooden panels on which the pictures were painted had been cut by machine, not a handsaw – to me a ridiculous pronouncement. They offered $10,000 for the four, half the price we had paid, without considering expenses. My partner's immediate reaction to the news was to ask if I would care to buy out his share. This I did, giving him a profit; he was delighted to be out of the deal and in spite of my brave front I still did not know just how good the pictures were. So I sent photographs to two of the big art auction houses in Europe. The replies were most disappointing and the estimate of their values small; finally, after acquiring a new partner, I did my own research.

In the extensive Witt Library in London we found old photographs of all four paintings. The two van der Heydens had been owned by the collector Jan Six, friend and patron of Rembrandt. At one time they had been housed in a museum in Bavaria which was looted by Napoleon's armies. Napoleon gave them to his wife Josephine, who later gave them to Czar Alexander I of Russia. Later in the nineteenth century, the *catalogue raisonné* of the works of van der Heyden locates them in the Hermitage in St. Petersburg. How they ended up in Cuba I can only speculate upon. In the early 1930s the Russian government was selling paintings to raise money; the collection of the National Gallery in Washington contains some of these, bought by Andrew Mellon. The van der Heydens were likely sold at the same time. The Berck Heyde was once owned by a wealthy German munitions maker whose descendants now live in Switzerland, and the lovely panel by Karel du Jardin is listed in Wagramm's *Art Treasures of Great Britain*, and was sold in the Holford sale in 1928.

I am a salesman as well as a practical art dealer and on occasion I do use superlatives, but it is no exaggeration to say that these four paintings were the greatest single find of Old Masters in my life.

In 1977, during a trip to London, I was walking up St. James's Street towards Piccadilly and happened to notice, in the window of an exclusive Old Master dealer, a picture shown against

a dark velvet background, resting on an easel. It was the Karel du Jardin from Havana, which by then had been cleaned and looked magnificent. I gazed at it for a minute or two and walked in to enquire the price. The gallery attendant gave me a welcoming smile, opened her black stock record book, and cooed back, "Seventy-five thousand pounds." Just how many times the picture had changed hands during those ten intervening years would be interesting to know, but one sure thing is that every time the picture was resold it was at a higher price than before. With its added value, I must say, the picture looked more enchanting than ever.

65 Tom Thomson *Spring Birches, Canoe Lake* c.1915

Epilogue

Often, in thinking back to the past, there is the tendency to recollect with more clarity one's triumphs in life. The frustrations and defeats one has borne, recede safely and quietly into the background. This is why I have written more about the successful and happy events of my life.

I was fortunate in having had the opportunity to gradually build up knowledge and confidence in the art world as a member of an enterprise that was quite unique in its time, and I can now look back on my life in art with a sense of personal satisfaction and gratitude. It was just as much a matter of good luck as propitious timing that I found myself in a business which, although there were few indications at the time, would become fascinating and lucrative.

Our policy of promoting artists was a sound one in the early days, and the series of exhibitions we held in the thirties and forties was an important factor in establishing us as innovators and leaders in the field of art dealership in Canada. We held showings by artists almost unheard of or unknown at the time, but now famous, such as David Milne, J.E.H. MacDonald, Tom Thomson, A.Y. Jackson, Lawren Harris, and Emily Carr. We handled the work of artists already known, including J.W. Morrice, Horatio Walker, and Homer Watson, and we had many exhibitions by artists we thought showed early promise but whose names are unrecognized to this day.

But the buying of any kind of picture in those days was considered a luxury and it was indeed a miracle that the business survived at all, and that we lasted through those long years of economic stagnation, when there was little interest in art and so few buyers. The major credit for this belongs to my father, to his hard work and tenacious belief that a better world for art dealers lay ahead.

In recent years, it has taken the scattering of the all too few significant private collections of Canadian art, assembled from the 1920s to the 1950s, to make one realize just how scarce the good examples of our best artists have become. The Vincent Massey, Charles H. Band, J. Stanley McLean, Ernest E. Poole, Frederick

B. Housser, Walter C. and Robert A. Laidlaw, and the H. Ray Milner collections have all already gone to or are destined for public galleries, and now the estate of David Morrice, comprising nearly one hundred paintings by his famous uncle, James, has been broken up and distributed among public institutions throughout the country.

Other recent phenomena unique to Canada have been the growing number of small publicly-supported municipal galleries, all in need of pictures to exhibit, and the numerous new private dealers, some offering inferior pictures retrieved from attics and basements to a gullible public at remarkably high prices. Also, the proliferation of branches of the international art auction houses with their intensive search for pictures to sell "under the hammer," has provided furious competition. The great demand for pieces still available in the market place is having the effect of raising the value even of mediocre objects.

Perhaps the most highly visible feature of the market currently has been an expanding acquisition fever among speculators. For some years now there has been an increasing number of people for whom the investment and speculative aspects of buying art are a much stronger motive than any aesthetic pleasure to be derived from ownership.

The 1960s and seventies were boom years in the international art world and a golden era for the Canadian art market. A certain national pride has developed, particularly among a large recently created wealthy class who are learning and eager to appreciate artistic worth. A growing awareness and knowledge of Canadian art, gained through books, films, and exhibitions has been a further factor in the development of appreciation. This strong nationalism is by no means confined to Canada, however. It applies to other cultures the world over, especially Europe and the United States, where art is presently being recalled to its homeland. Dutch pictures, for example, are sought after by Dutch dealers for return to the Netherlands, and German paintings find their way back to Germany, and so on.

One result of the art boom has been the unbelievably high prices paid for works, as evidenced in public auction sales. Enthusiastic beginners follow the more knowing buyers, and it takes time for these same amateurs to realize and recover from

their earlier buying mistakes. Before long, however, most of them discover some of the pitfalls, and are then usually satisfied to place themselves in the hands of a reliable dealer.

What about the future of art dealing in Canada? I can only speculate. Like so many other things in today's world, the state of the art business is ever-changing, and as the supply of available works of the past continues to diminish and finally dry up, nearly every dealer of classical paintings will be obliged to augment his business by showing more works by contemporary and living artists. So long as we have artists living in the community, there will be a need for agents or dealers to market the products of their studios. Some artists feel uncomfortable dealing directly with the public, or dislike giving up valuable painting time to concentrate on sales, and are therefore satisfied to turn over the merchandising of their work to a dealer and allow a commission instead.

But however the climate of art responds to changing times and economics, the creation of works of art will endure as one of man's most hallowed achievements, and an appreciation of them will live on. Art, in whatever form it has taken in the past, and whatever guise it may assume in the future, will last as long as people exist on this planet, and will probably remain mankind's most glorious legacy.

Colour Plates

PLATE 18
Tom Thomson
Maple Saplings, October, c.1915
Oil on canvas, 36″ x 40″
Private collection

PLATE 19
Tom Thomson
The Poacher, 1915
Oil on panel, 8½″ x 10½″
Private collection

PLATE 20
Tom Thomson
Blueberry Bushes, October, 1916
Oil on panel, 8½″ x 10½″
Private collection

PLATE 21
Lawren Harris
Arctic Peaks, North Shore, Baffin Island, 1930
Oil on canvas, 32½″ x 42″
Private collection

PLATE 22
Lawren Harris
Autumn, Algoma, c.1919
Oil on board, 13¾″ x 10½″
Private collection

PLATE 23
Lawren Harris
Winter Woods, 1915
Oil on canvas, 47¼″ x 50¼″
Private collection

PLATE 24
Lawren Harris
Emerald Lake, Rocky Mountains, c.1925
Oil on board, 12″ x 15″
Private collection

PLATE 25
Lawren Harris
Black Birch and Maple, Algoma, c.1919
Oil on board, 10½″ x 13¾″
Private collection

PLATE 26
J.E.H. MacDonald
Maple Boughs, Algoma, c.1918
Oil on board, 8½″ x 10½″
Private collection

PLATE 27
J.E.H. MacDonald
Thornhill Village, 1915
Oil on board, 8½″ x 10½″
Private collection

PLATE 28
J.E.H. MacDonald
Flower Border, Ussher's Farm, York Mills, 1918
Oil on panel, 8½″ x 10½″
Private collection

PLATE 29
A.Y. Jackson
Georgian Bay Islands, 1919
Oil on double-painted panel, 8½″ x 10½″
Private collection

PLATE 30
A.Y. Jackson
Lake Shore, October, Algonquin Park, 1914
Oil on panel, 8½″ x 10½″
Private collection

PLATE 31
A.Y. Jackson
Yellowknife, Northwest Territories, 1929
Oil on canvas, 32″ x 40″
Private collection

PLATE 32
Maurice Cullen
Spring Breakup, Cache River, P.Q., c.1920
Oil on panel, 12″ x 16″
Private collection

PLATE 33
J.W. Beatty
Baie St. Paul, Winter, c.1920
Oil on panel, 10″ x 13¾″
Private collection

PLATE 34
J.W. Beatty
Kearney, Near Algonquin Park, c.1914
Oil on canvas, 28″ x 36″
Private collection

PLATE 35
J.E.H. MacDonald
Log Drive, Gatineau, 1914
Oil on board, 8″ x 10″
Private collection

PLATE 36
Clarence Gagnon
Yellow House, Baie St. Paul, 1910
Oil on canvas, 21″ x 28½″
Private collection

PLATE 37
Frank Johnston
Woodland Tapestry, Algoma, 1919
Tempera on board, 20″ x 14″
Private collection

PLATE 38
Emily Carr
Yellow Moss, c.1934
Oil on canvas, 27″ x 40½″
Private collection

PLATE 39
Emily Carr
Dawson City, Yukon, 1920
Watercolour on paper, 13¾″ x 10″
Private collection

PLATE 40
Emily Carr
Trees in the Sky, c.1934
Oil on canvas, 44″ x 27″
Private collection

PLATE 41
Fred Varley
Romantic Coast, B.C., c.1926
Oil on panel, 12″ x 14½″
Private collection

PLATE 42
Fred Varley
Barker Fairley's Daughter, Joan, c.1923
Oil on canvas, 17″ x 13″
Private collection

PLATE 43
Fred Varley
Immigrants, c.1922
Oil on canvas, 60″ x 72″
Private collection

PLATE 44
Arthur Lismer
October, Muskoka, 1915
Oil on board, 9″ x 11¾″
Private collection

PLATE 45
Arthur Lismer
McGregor Bay, 1933
Oil on panel, 12″ x 16″
Private collection

PLATE 46
Arthur Lismer
North Shore, Lake Superior, October, 1927
Oil on board, 12¾″ x 15¾″
Private collection

PLATE 47
James W. Morrice
A Café, c.1906
Oil on panel, 5″ x 6″
Private collection

PLATE 48
James W. Morrice
Le Pavillon de Flore, Paris, c.1906
Oil on panel, 5″ x 6″
Private collection

PLATE 49
A.Y. Jackson
A Street in Murray Bay, c.1926
Oil on panel, 8½″ x 10½″
Private collection

PLATE 50
Paul Kane
Clallam Indian Travelling Lodges, c.1846
Oil on paper mounted on canvas, 8½″ x
Private collection

PLATE 51
Paul Peel
Mme. Peel at Easel with Daughter, c.1891
 (unfinished)
Oil on canvas, 52″ x 42″
Private collection

PLATE 52
Cornelius Krieghoff
The Sugar Loaf, Montmorency Falls, 1852
Oil on canvas, 26¼″ x 38″
Private collection

PLATE 53
Lawren Harris
Rapids, Algoma, c.1919
Oil on board, 13¾″ x 10½″
Private collection

PLATE 54
Franklin Carmichael
Wild Cherry Blossoms, c.1932
Oil on board, 30″ x 36″
Private collection

PLATE 55
James W. Morrice
A Procession, Algiers, c.1922
Oil on panel, 5¼″ x 6¾″
Private collection

PLATE 56
James W. Morrice
Circus, Concarneau, c.1909
Oil on panel, 5¼″ x 6¾″
Private collection

PLATE 57
James W. Morrice
Campo San Giovanni Nuova, Venice, c.1901
Oil on canvas, 19¾″ x 21¼″
Private collection

PLATE 58
James W. Morrice
The Bull Ring, Marseilles, c.1904
Oil on panel, 9¼″ x 13″
Private collection

PLATE 59
James W. Morrice
Portrait of Léa in Tall Hat, c.1895
Oil on canvas, 22½″ x 15¼″
Private collection

PLATE 60
James W. Morrice
Promenade, Dieppe, c.1904
Oil on canvas, 19¾″ x 24¼″
Private collection

PLATE 61
James W. Morrice
View of the Beach from the Ramparts, St. Malo,
 c.1899
Oil on panel, 5″ x 6″
Private collection

PLATE 62
Paul Kane
Indian Encampment, Winnipeg River, 1846
Oil on canvas, 20½″ x 29½″
Private collection

PLATE 63
Paul Kane
Drying Salmon at the Dalles, Columbia River,
 c.1846
Oil on paper mounted on canvas, 8½″ x 13¾″
Private collection

PLATE 64
Cornelius Krieghoff
Habitants Driving, Winter, c.1862
Oil on canvas, 9¼″ x 11¼″
Private collection

PLATE 65
Tom Thomson
Spring Birches, Canoe Lake, c.1915
Oil on panel, 8½″ x 10½″
Private collection

Index

Note: *Numbers in italics indicate plate numbers.*

Poole, Ernest E., 32, 188, 253
Porter, Donald, 233, 235
Pretty, Olive, 37
Price, F. Newlin, 34, 36

Queen's University, 138, 140, 208

Reid, Dennis, 110
Reid, J.A. McNeill, 227
Richardson Brothers (Winnipeg), 182
Riopelle, Jean Paul, 32, 207, 210-11, 214
Roberts, Goodridge, 204
Roberts, Guy and Jinnie, 166
Robertson, Sarah, 116
Robins, John D., 20-21, 86
Robson, Albert H., 140
Rolph, Clark, Stone Limited, 41
Rouché, Jacques, 216, 217
Rous and Mann, 140
Royal Canadian Academy, 114, 226
Rubens, Peter Paul, 190, 191
Ryerson Press, 140

Savage, Anne, 115, 116
Scott and Sons, *see* William Scott and
 Sons
Seago, Edward, 172 ff.
Seymour, Peter, 174, 179
Shaw, James Byam, 171
Shima, Joseph, 33, 34
Shima, Vilma, 33, 34, 217
Sigmund Samuel collection, 194
Solloway, I.W.C., 118
Sotheby & Co., 236, 238, 245, 246
Southam, Gordon, 188
Southam, Harry S., 102, 118, 131, 132,
 156, 168
Speelman, Edward, 177
Stark Foundation (Texas), 235
Statten, Taylor, 73
Stern, Max, 130, 143 ff., 150
Stevens, Gerald, 133
Stevens Gallery (Montreal), 43, 133
Stevens, Gerald, 133
Stone, Charles, 187
Studio Building (Toronto), 24-25, 38, 40,
 67, 90, 92, 101, 109, 122, 123

Taylor, E.P., 31-32, 182, 197
Taylor, John Ross, 86, 106, 108
Taylor, Mrs. Oscar, 86, 108
Terbrugghen, Hendrik, 120, 122
Thesiger, Roderick, 194
Thomas Agnew and Sons Ltd., 168, 177
Thomson, George, 70, 73, 76, 77-78

Thomson, Roy (Lord Thomson of Fleet),
 199, 236
Thomson, Tom, 20, 22, 24, 25, 26, 32, 38,
 46, 67, 68, 70, 72 ff., 101, 102, 104, 106,
 110, 112, 114, 123, 124, 128, 131, 132,
 133, 140, 142, 157, 158, 182, 187, 197,
 200, 242, 243, 253; *17, 18, 19, 20, 65*
Tooth, Arthur, & Sons Ltd., *see* Arthur
 Tooth Gallery
Toronto Art Gallery, *see* Art Gallery of
 Toronto
Tough, George, 116
Tovell, Dr. Harold M., 73
Towers, Graham, 131
Trainor, Winnifred, 80-82
Tudhope, H.R., 31
Tyrrell, J.B., 31

University of Toronto, 14, 18, 20, 22, 49
Urquhart, Norman, 31

Vancouver Art Gallery, 94, 187
Van der Heyden, Jan, 250, 251
Van Gogh, Vincent, 48, 131, 167
Van Wisselingh Company, 166, 167, 168
Varley, Frederick H., 86, 93, 110, 154,
 157, 166, 204; *41, 42, 43*
Vaughan, J.J., 226
Vaughan, Murray, 228
Verner, Frederick, 192

Waite, J.H.C., 31
Waldie, Peggy, 220
Waldie, R.S., 31, 34, 36, 220
Walker, Horatio, 34 ff., 46, 253; *6*
Wallis, Harry, 34
Watson, Homer, 40, 46, 124, 253; *5*
Watson, William, 33, 43, 118, 166, 222
Webber, Gordon, 116
Webster, Captain George, 108
Weston, W. Garfield, 26, 198, 203
Whaley, E., 124, 242
Wilkie, D.R., 46, 136
William Neilson Company, 26
Williams, John, 238
Williams, Roland, 238
William Scott and Sons, 33, 43, 44, 83,
 118, 113
Williamson, Curtis, 19, 24, 38, 40, 46, 67,
 115; *7*
Wilson, Peter, 238
Winnipeg Art Gallery, 188
Woodley, E.E., 28
Wright, Harold, 171

Photographic Credits

Credit and thanks go to the following for colour photography:

Brian Merrett and Jennifer Harper, Inc. for *Habitants Driving, Winter* by Cornelius Krieghoff;

Ron Vickers for *Rapids, Algoma* and *Autumn Algoma* by Lawren Harris;

Michael Neill was responsible for photographing and providing transparencies for all other reproductions in this book.

The book was designed by Bob Young.